Scanning Negatives and Slides

Sascha Steinhoff

Scanning Negatives and Slides

Digitizing Your Photographic Archives

rockynook

Sascha Steinhoff

Editor: Gerhard Rossbach
Copyeditor: Diana Hartmann
Layout and Type: Josef Hegele
Cover Design: Helmut Kraus, www.exclam.de
Printer: Friesens Corporation, Altona, Canada
Printed in Canada

ISBN 1-933952-01-6
ISBN 13: 1-978-933952-01-7

1st Edition
© 2007 by Rocky Nook Inc.
26 West Mission Street Ste 3
Santa Barbara, CA 93101-2432

www.rockynook.com

First published under the title "Digitalisieren von Dias und Negativen"
© dpunkt.verlag GmbH, Heidelberg, Germany

Library of Congress catalog application submitted

Distributed by O'Reilly Media
1005 Gravenstein Highway North
Sebastopol, CA 95472-2432

Contents

Foreword

Dear Reader,

In order to get good quality digital images from your slides and negatives, not only does one need a good-quality scanner, but also the knowledge to operate it properly. A film scanner is just as complex as a Single Lens Reflex (SLR) camera: only when some time has been invested to become familiar with it will you be rewarded with beautiful images.

SilverFast and VueScan are third-party commercial programs that support nearly all current film scanners. Although manufacturers' scanning software is included with most new scanners, in most cases the software is quite poor. One noticeable exception is the Nikon Scan program, which is as good as VueScan or SilverFast. Nikon Scan will be used to represent the manufacturers' programs in order to discuss the key functions of the scanners.

With digital cameras as well as with scanners, today's trend is moving towards capturing images in RAW format – and for good reason. RAW data contains the unadulterated, full image information from the scanner's image sensor – or at least that's how it is supposed to be. The programs from SilverFast, VueScan, and Nikon actually differ in this point considerably.

If you are planning to scan a large number of slides or negatives, a chapter just on workflow is included to help you.

I'm looking forward to your feedback, which you can send to this address: scanbook@diasdigitalisieren.de

Sascha Steinhoff

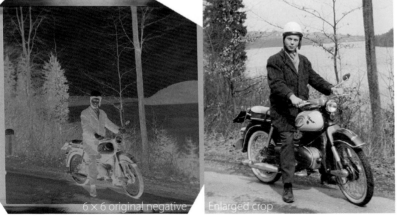

Image: Siegfried Gromotka, around 1960

6 × 6 original negative Enlarged crop

The darkroom is passé; with digital image processing, the awkward splashing around of chemicals can now be avoided. Even fifty-year-old negatives are still usable

The rather flat RAW scan is just the first step. The final image is developed by stretching the levels curve and by correcting the tonal curves.

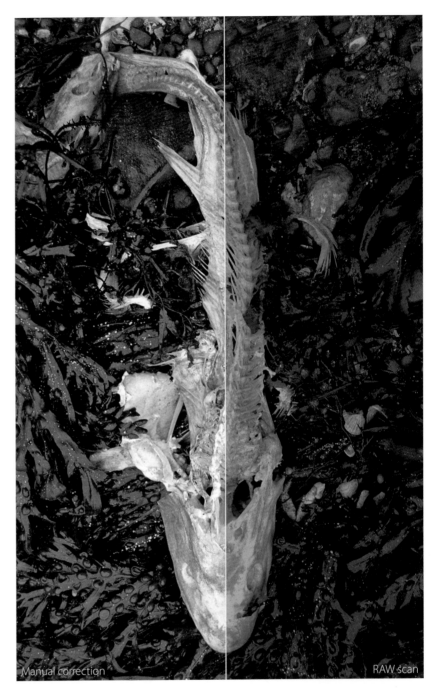

Manual correction

RAW scan

Preface

For some time now, the digital revolution has included photography; the presence of conventional cameras in photo shops is dwindling. Unjustly so, because photographers who want to continue to work with film can also enjoy all the advantages of digital image processing by using a high-quality scanner. Owners of an archive of slides or negatives can also benefit from digitizing their existing collection. Despite the omnipresence of digital photography, there are still good reasons to shoot on film. This chapter will compare the various working methods.

1

Content

Analog and Digital Workflows
Alternatives to the Film Scanner

Analog and Digital Workflow

Analog Workflow for Negative Film

Over years, or even decades, many photographers accumulate and boxes filled with countless negatives (although professional storage containers are available, too). The classic workflow for a negative film is as follows:

▸ Exposure – although this is not as critical as with slide film
▸ Developing and printing
▸ Proper archiving

However, there are some drawbacks to working with negative film:

▸ Negatives age and fade over time
▸ Negatives scratch easily
▸ Each trip to the lab causes new scratches, and wear and tear on the negatives
▸ It can be difficult to locate a particular image within a large archive
▸ Customized image processing is possible only in one's own darkroom

The lab work is crucial to the final result. But many photographers neither do their own processing nor do they deal with professional labs. Therefore, it is questionable whether the printed image meets their expectations. Even if the lab does a good job, there is still latitude for variations.

For negative film, the processing lab is the key factor that determines the result of the printed images.

Images: Nikon, Fuji.

The default settings of one-hour labs are generally suitable for typical snapshots from a holiday on the beach. It is a different story for photos taken in nonstandard lighting conditions. High-key, low-key, or sunset pictures often do not work well with the lab's default settings. Standard lab settings are adjusted for an average gray value, which can ruin the intended mood and render the prints unusable. Even when reordering a print from the same photo lab, rarely is the result identical to an earlier print.

Only in a custom darkroom can all the parameters be controlled to create the desired image. To make a long story short, only with a personal darkroom can one benefit from all the advantages of negative film.

The untreated negative shows inverted colors: on film the white signboard is black.

After inverting the colors the signboard becomes white, but there is still the orange masking.

When converting to positive, the color characteristics of the films need to be considered.

Analog Workflow for Slide Film

The typical workflow for slide film differs from negative film in a few important points. It looks roughly like this:

▸ Accurate exposure is necessary; slide film is not forgiving
▸ Film strips are cut and framed
▸ The framed slides are filled into slide trays
▸ The images can now be projected or viewed on the light table

This conventional practice has disadvantages:

- Slides age and fade
- Slides can get scratched, although they are a bit less delicate than negatives
- For frequent slide shows, duplicates are needed because slides fade easily in the intense light of the projector; this is especially a concern for Kodachrome slides
- It can be very time-consuming to find a particular slide in a large collection
- Rearranging a slide show takes a lot of effort; to run more than one slide show simultaneously, duplicates are needed
- It is almost impossible to post-process slides

The biggest problem with slides is that they can hardly be post-processed. Poor exposure or a color-cast can only be corrected with great difficulty. On the other hand, an underappreciated advantage is that the lab can do very little wrong during the processing of slides. The result is pretty close to what the camera produced. This tight control over the created image is a significant reason why ambitious photographers prefer slide film to negative film.

The film processing lab has no margin for variations: with slide film the result from the lab is exactly what the camera produced.

Images: Nikon, Fuji.

Hybrid Workflow: Shooting Analog, Scanning, Digital Processing

In recent years computer technology has advanced dramatically. Today, a standard PC actually delivers what the computer manufacturers promised more than ten years ago: high-quality digital image processing. For those who still shoot on film, the question remains how to best get the slides and negatives into the computer. A standard PC and a film scanner are all the hardware needed to achieve this, and the investment is manageable. The key to good-quality scans is in the skill of the user. Satisfying results can only be achieved with extensive study of the matter.

Of course a quick scan is possible, but the results generally will be of poor quality. Photographers who spend a lot of effort to take quality pictures with film cameras will be unable to avoid familiarizing themselves with the subject of scanning. Only then will they be able to transfer the quality of their film-based images to the digital world.

Home users can explore digital image processing with a desktop film scanner.

Images: Nikon, Fuji.

Just like the skill of taking pictures, the skill of scanning film needs to be acquired first, in order to get good results. Sufficient time for acquiring this skill should be allowed. This mixed workflow - shooting analog, scanning, digital processing – is also called "hybrid photography." It offers all the advantages of digital image processing:

▸ "Digital negatives" don't age, scratch, or fade
▸ A well maintained image database can retrieve images in a matter of seconds
▸ Digital images are easy to edit
▸ Digital images are easily turned into slide shows or galleries
▸ Digital images are easily sent over the Internet
▸ Digital images don't need to be touched up by the photo lab; the photographer has almost full control over the final image
▸ It is possible to make lossless backup copies of the images

However, there are a few disadvantages:

▸ Scanning is time-consuming and fairly complex
▸ The image information of the original film cannot be read without loss; unavoidably, there are losses in the transfer from analog to digital
▸ Scratches, dust, and other blemishes cannot always be removed from the film automatically during the scan (post-processing is a solution here)
▸ Not all types of film are equally suitable for scanning

To sum it up, there are many good reasons for digitizing your film material, so don't put it off much longer. The latest high-grade film scanners do a fine job in extracting the image information from the film material. Unlike with an analog workflow, all relevant parameters for image quality can be defined on the computer. When ordering prints from a lab, using digital images leads to significantly better results than working from negatives. In addition, there are no more annoying scratches and fingerprints, which usually further damages the negative with every trip to the lab.

Digital Workflow: Digital Shooting and Digital Editing

Purely digital workflow requires that images be generated and processed digitally. Technically this is desirable because it eliminates the potentially degrading analog to digital conversion between image and image file. However, for practical photography there are a few limitations:

▸ High-resolution digital cameras are significantly more expensive than analog cameras, although prices keep dropping (in addition, there are fewer analog cameras available)
▸ Existing equipment for analog SLR camera systems can only be used with certain restrictions
▸ There is still no common standard for a "digital negative"
▸ Image files can easily be lost in computer crashes

Still, the advantages are undeniable and have lead to the unstoppable success of digital photography:

▸ Digital images can be edited directly on the computer
▸ Subsequent quality-degrading steps of Analog/Digital (A/D) conversions of the picture are eliminated
▸ No more burning film - memory cards are less expensive in the long run
▸ The picture can be checked immediately after it has been taken - good cameras have a built-in histogram display for checking the exposure

Digital cameras no longer capture the image on film, but through either a CMOS or CCD sensor chip (here Nikon D2H). Sooner or later this technology will completely replace 35mm film.

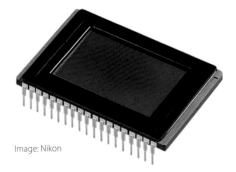

Image: Nikon

For anyone who needs the quick turnaround of pure digital photography – for example, press photographers – investing in an expensive Digital Single Lens Reflex (DSLR) camera is necessary. The typical hobby photographer needs to consider whether or not to wait another year or two before switching to digital. After spending a large sum of money on a DSLR, it can be frustrating when a greatly improved, newer model comes out shortly afterwards. In the rapidly developing market of digital cameras, new models with higher resolutions are continually being introduced. We are still waiting for the introduction of an affordable DSLR with a full-frame sensor. An often-underappreciated benefit of the hybrid workflow over the digital workflow is having a tangible piece of film. In addition to the digital image file, there is always the analog backup. As

long as there is no cross-platform standard for file formats and storage media, this is a major advantage over the purely digital workflow.

Image: Fuji.

From the digital camera or scanner directly to the lab: now most photo labs offer a digital printing service.

With technology constantly progressing, digital images must be periodically transferred onto different backup media. Neglecting this step can cause the data to become unreadable or completely lost. As an example, in the early nineties home computers had floppy disks, then came CD-ROMs, and now we have DVDs, external hard disks, and USB (Universal Serial Bus) thumb drives. A current computer system can no longer read the types of media that were common in the mid-eighties.

Images: Nikon, Lexar, HP

A digital workflow allows a lossless transfer of images from camera to PC.

Analog images must merely be stored dry and free of dust; no other measures are needed. However, if you store both a slide tray and a DVD with image files in the attic and thirty years later someone finds them, the chances are low that the image files on the DVD can still be used – provided that the DVD can still be read at all. The slides, on the other hand, will be slightly faded, but with recognizable images.

Alternatives to the Film Scanner

Scanning film strips with a film scanner is time-consuming and has a steep learning curve. Because not everybody has the time, knowledge, or hardware needed, let's discuss the possible alternatives.

Megapixel (MP) in Comparison: DSLR, Film Scanner, 35mm Film

Quite often, only the nominal resolution is considered when comparing DSLR, film scanner, and 35mm film. According to this criterion alone, analog cameras would come out on top. However, it is not that simple. For a DSLR, the sensor and the lens determine the resolution of the final image. This limiting factor is always the weakest link in the camera-lens combination: if you mount an inferior lens on an excellent DSLR, the sensor cannot utilize its maximum resolution. Only high-grade lenses have enough quality reserves for a good DSLR. The resolution of current 35mm DSLRs is between 6 and 16 MP.

Lens aberrations are very noticeable with DSLRs. Unlike with analog cameras, the digital image is usually examined at maximum size on the computer monitor. To notice such aberrations on a 35mm slide it would take a high-power loupe.

Nikon D2HS: only 4.1 MP, but 8 frames per second (fps).

Image: Nikon

Scanning film is a more complex issue. Here the image is generated in two steps: first the subject is shot on 35mm film, and then this image is scanned. Therefore, we have to look not only at the quality of the material to be scanned, but also at whether the scanner is capable of capturing the image adequately. For the resolution of the film – let's say a 35mm film – the combination of film and lens is crucial. A high-quality, fine-grain 35mm film has a resolution corresponding to 40–60 MP. Standard film has a substantially lower resolution, which corresponds to around 20–30 MP; but even that resolution can be achieved only with high-quality lenses.

Simple lenses achieve a resolution of approximately 10 MP; only high-grade lenses will surpass 20 MP. The popular amateur zoom lenses are typically inferior to the optical performance of comparable prime lenses. More than likely, the majority of amateur pictures have a resolution of less than 20 MP.

Image: Nikon

The quality of the lens essentially determines the effective resolution, both for film and digital cameras.

The effective resolution of a film scanner is potentially a bottleneck that can limit the resolution of the image. Currently most high-quality film scanners have a resolution of 4000 dots per inch (DPI or dpi), which corresponds to around 20 MP. If you choose a film scanner that not only promises this resolution on paper, but in reality can also scan it optically, then loss in image resolution will not be noticed.

There are already 35mm film scanners with 7200 dpi, which corresponds to a resolution of 70 MP. To fully utilize this dpi, the slide or negative has to be of excellent quality, which means a fine-grain film exposed with a very sharp lens. The same is true for the scanner. It not only has to have a high-resolution sensor but also excellent optics.

I am not aware of any current desktop film scanner that in actual use resolves more than 4000 dpi. Actually, for most of the source material a resolution of 2900 dpi would be sufficient. Also, keep in mind that file sizes get very large with increasing resolution, especially with medium and large format scans. With file sizes of over 200 megabytes (MB), image processing will be very difficult on a regular home PC. When choosing the suitable scan resolution, the entire workflow has to be considered.

Meanwhile, professional DSLRs have approached the nominal resolution of far less expensive analog cameras. For example, the Canon EOS 1Ds Mark II is fitted with a full-frame sensor, which has a nominal resolution of 16.7 MP. According to the tests in www.dpreview.com the actual resolution is only 2800 lines horizontally and 2400 lines vertically. Thus, the high nominal resolution translates to an actual, measured resolution of only 6.7 MP. A similar ratio between nominal and measured resolution applies to all models of digital cameras. Because the time-consuming scanning process is eliminated, very few professionals still shoot analog. For the amateur, speed is not a big issue, so there is no rush to switch to digital.

When comparing image quality between scanned analog images and digital images, it is not sufficient to only consider nominal resolutions. Whether scanning the film will cause quality losses, and to what degree, depends on various factors, such as scan density and film flatness. Even a 6 MP DSLR can be superior to a 4000 dpi scan, despite the nominally lower resolution.

*Looking just at the numbers,
for the near future film scanners will
remain far superior to amateur DSLRs
– as is the Nikon D70s.*

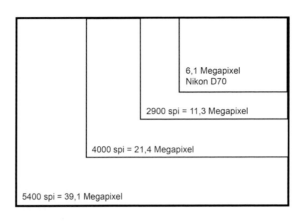

Digital Single Lens Reflex Cameras

As mentioned earlier, digital cameras are rapidly evolving and prices are finally coming down somewhat, providing yet more reasons to purchase a DSLR. However, even professional models have not yet matched their analog counterparts in a few areas. For one, the high power consumption of DSLRs is still not adequately solved. The purely digital workflow is clearly faster than the scanning of film, but that doesn't mean scanners will become obsolete in the near future. Many images from the past are only available on slides or negatives, and are therefore not on your PC.

*The sensor of a DSLR does not reflect
light the same way as film: shown
here is the Nikon D2H. For this reason,
the TTL metering of older flash units
does not work on modern digital
cameras.*

Anyone who has accumulated extensive analog camera equipment will be reluctant to exchange it for digital equipment unless there is a very good reason to do so. The switch is expensive because most of the components are incompatible. Sensors reflect light in a different way than film surfaces, so DSLRs need different flash units than film cameras. Additionally, most DSLR sensors are smaller than the 24 × 36mm frame size of 35mm film. Therefore, for many DSLRs, a focal length multiplier of 1.3x to 2x applies. With the EOS 5D there is finally a DSLR with a full-frame sensor that costs less than a compact car.

However, $3,000 is not exactly inexpensive, either. The current crop of amateur DSLRs, like Nikon's D70s or Canon's 20D, still haven't reached the quality feel and level of workmanship of the older film models like the Nikon F90x or F801s.

Images: Fuji.

Fuji's FinePix S3 Pro with Nikon mount is more computer than camera.

It will be some time before affordable digital cameras with full-frame sensors will enter the market. By then, the problem of the long shutter lag of digital cameras should be solved as well. Currently, this is especially bothersome to sports photographers, who have grown accustomed to the much faster reaction times of their old analog cameras. Nikon offers the D2H specifically for press and sports photographers. Its shutter lag has been reduced to a mere 37 ms. Other DSLRs are not quite as fast and respond noticeably slower to the shutter release button. Digital cameras are the best for product shots. For portraits, it is a different story. On the one hand, the skin tones of the digital image are rarely as expected; on the other hand, the faithful and accurate digital reproduction is not always flattering to the subject, since even the slightest skin imperfection will be precisely recorded. Therefore, in the area of portrait photography, many professionals still prefer film for its very particular, slightly grainy appearance.

There is an ongoing discussion in digital photography on the touchy subject of backup. In the hybrid workflow there is always the original filmstrip to go back to, but with digital photography all will be lost should the computer crash one day. It remains to be seen how "future-proof" digital images will be.

A fifty-year-old negative can still be processed today without any problem. This may not be the case for all of today's popular file formats. Image files without backup can be quickly and permanently lost in a computer crash. Because many users, and even IT professionals, are at odds with this topic, there is a separate chapter about backup in this book.

Upgrading to a Digital SLR: More Than Just a New Body

The typical amateur's equipment back in the nineties would consist of something like a Nikon F90s with SB24, a 24-50mm wide-angle zoom, and an 80-200mm tele zoom. The autofocus could be a bit faster, but otherwise this camera is by no means obsolete. When switching to digital, almost everything needs to be replaced. A new body (most likely D50 or D70s) and a memory card are mandatory. The existing flash SB24 must be replaced with a current SB600/800. Because the wide-angle zoom becomes effectively less wide due to the 1.5x focal length multiplier of the DSLR, a new wide-angle lens is appropriate. This is only affordable when selecting a DX lens for DSLRs. Only the tele zoom remains from the original outfit. Here one can enjoy the extended reach while maintaining the same maximum aperture. In this example, we had to invest $1,200–$1,900 for the upgrade to digital.

Flatbed Scanners with Transparency Adapter

Flatbed scanners have developed enormously over the last few years. They were originally developed for scanning documents. But, flatbed scanners have achieved a resolution which is unnecessary for scanning documents alone. There are many models with a transparency unit that allows the scanning of film. At present, this technology remains inferior to specialized film scanners. Although flatbed scanners advertise resolutions of up to 4800 dpi, tests show that this is incorrect. Flatbed scanners that boast a nominal resolution of 4800 dpi can actually only capture 1700 dpi from a transparency. At that resolution, a 35mm slide can only be enlarged up to 5" × 7" at 300 dpi. Also, the color and contrast do not come close to what you can expect from a good quality film scanner. Please compare the scanned files on the CD accompanying this book. Flatbed scanners are faster than film scanners – an advantage not to be underestimated.

For scanning medium- and large-format film, the maximum resolution is not so critical, since the film size is several times larger than 35mm film.

Average flatbed scanners have a glass stage for holding the originals. However, this glass plate reduces the optical performance of the scanner. In a dedicated film scanner there is no glass between sensor and medium.

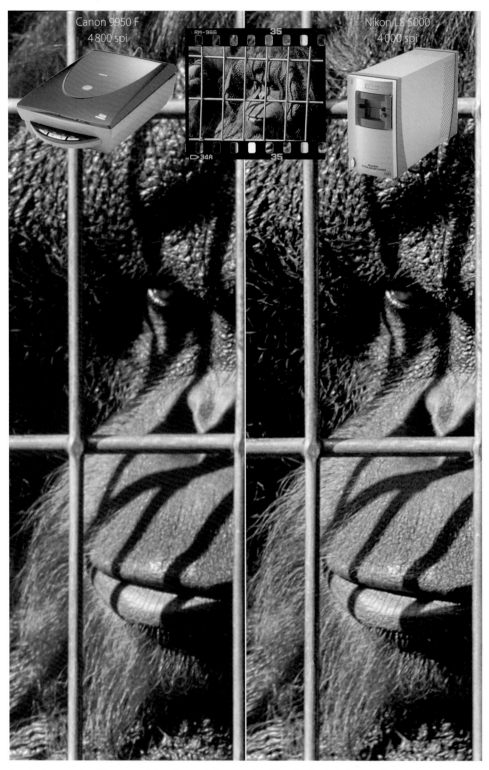

In a direct comparison it becomes obvious. The resolution actually achieved by the flatbed scanner is clearly lower than the film scanner.

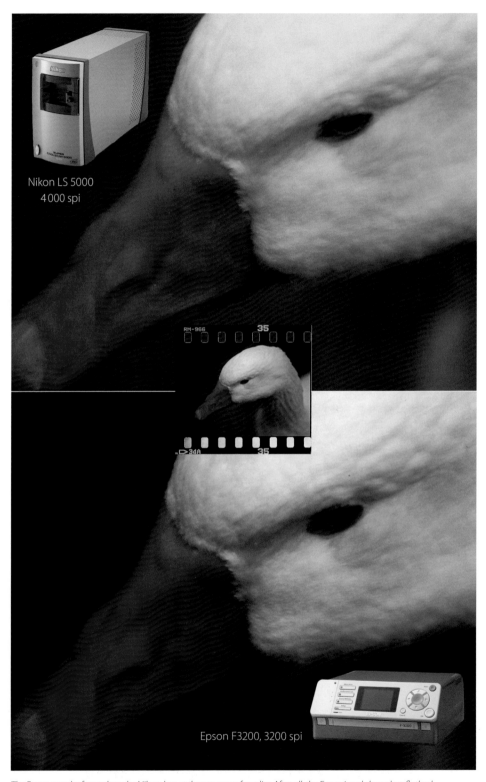

Nikon LS 5000
4 000 spi

Epson F3200, 3200 spi

The Epson may be faster than the Nikon, but at the expense of quality. After all, the F3200 is only based on flatbed technology.

With film scanners, additional layers of glass do not interfere with the scan. This is the reason that, for the foreseeable future, conventional desktop flatbed scanners will not match the performance of dedicated film scanners.

Epson tried to improve the unsatisfactory performance of flatbed scanners with a new design approach. The Perfection V700 has a separate lens for scanning film. It achieves an effective resolution of 1920 × 1770 dpi and a maximum density (Dmax) of 3.4, which is just below a good film scanner.

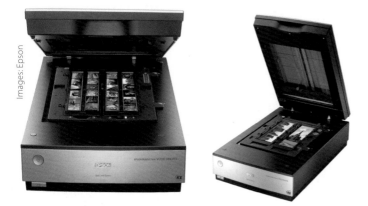

Images: Epson

The Epson Perfection V700 Photo is not quite as good as a film scanner, but is clearly better than a traditional flatbed scanner. For medium format, it is a viable alternative.

Scanning Prints

Occasionally, there are discussions on various forums about first making a print from a negative that is as large as possible, then scanning the print with a flatbed scanner. This method is one possibility – but the quality is noticeably worse than when scanning directly from the negative. Scanning the print is not inexpensive, either. Technically speaking, it is an analog-analog-digital conversion. The film is turned into a print, and then the print is scanned. With each step, some information gets lost, which is seen in the final image file. The additional step of printing causes some noticeable quality loss. It is equivalent to playing a song on a record player and then recording it with a microphone from the speakers. Although technically possible, it is not optimal in terms of quality.

The quality may be acceptable if the image size is reduced by scanning, but this method cannot match the quality of a scan from the original slide or negative. Scanning the original film – if it is still available – is definitely the better solution. If access to the original slide or negative is still available, it should be scanned directly. Even though this can yield enlargements up to poster size, enlarging scanned prints should be avoided. Reductions in size usually yield better results than enlargement; even a 1:1 scan of a print is not ideal.

As can be seen from the following images, fine details get lost when scanning from a print. This is clearly evident in the texture of the leaves. Compared to a scan from a negative, a scan from a print suffers a noticeable loss of information. The print was scanned at 1200 dpi; the negative, at 2900 dpi. Again, the print should be scanned only if neither slide nor negative is available.

Scan of a 4″ × 6″ print.

Scan of the corresponding negative.

Shooting a Projected Slide with a Digital Camera

Another option is to project a slide onto a wall and photograph it using a digital camera. The image will then be digitized. The concept is a good one, though not new; it was already being discussed in the old analog days. The idea is to project two slides on top of each other to create a sandwich slide. This way, one would not have to invest in a dedicated slide duplication attachment. Today, as they were in the past, the results are rather poor. The images are flat, dark, and soft. The slide loses a large degree of its sharpness when projected onto a wall. Therefore, for good-quality digitized slides, this is not a suitable method.

Duplicating Slides with DSLR and Slide Copy Attachment

A good DSLR with a macro lens and a slide duplicator can indeed be used to digitize slides. A bellows can also be added. However, the quality of the images resulting from using this combination does not match that of using a film scanner. In addition, there is no hardware-based scratch and dust removal available. For now, this is not a real alternative to a film scanner. If you need to digitize slides only occasionally and already have suitable equipment, it is worth a try, especially since a slide copy attachment is relatively inexpensive. Although this technique is still in its infancy, it does have potential. It is blazingly fast - no film scanner comes even close.

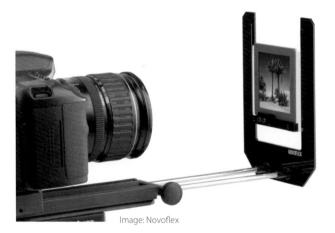

Novoflex slide duplicator: suitable for 35mm and medium format.

Image: Novoflex

Film Processing with Photo CD

The most convenient way to generate files from a film is through a Photo CD, because the lab does all the work for you. Photo CDs are offered inexpensively with film processing. Even if you do your own scanning, it can make sense to add a Photo CD to your developing and processing order. For a small charge, you get an overview of the images, and can select those images that are worth rescanning at a higher resolution. It saves time, and the image quality is sufficient to let friends and relatives have a quick print made from the images.

Photo CDs from Kodak

A picture CD is very inexpensive, but only provides images with a resolution of 1024 × 1536. An entire roll of film adds up to around 25 MB, so a disk can hold twenty-six rolls. Even though the quality is only good enough for 3R to 4R prints, for this small extra cost you can check whether any images are worth scanning yourself at a high resolution. Picture CDs are typically offered only when developing a negative film. The cost is around $2.50 per roll of negative film and about three times that for slides.

Inexpensive at an adequate quality:
Kodak Picture CD.

Image: Kodak

For more demanding needs the Photo CD is a good option. It is more expensive than a Picture CD and is available for slides and negatives. The image format used is *Image Pac*. This format is supported by most image editing software, either directly or through plug-ins. The images are stored at five different resolutions simultaneously, ranging from 128 × 192 to 2048 × 3072 pixels. A Photo CD costs around $5.

The Pro-Photo CD, which costs around $11 per CD, is geared more toward professional use. With its high resolution of 4096 × 6144, it nearly matches the quality of the original. The lab devotes a greater processing effort compared to the Photo CD. However, currently, only around twenty-five images fit on one Pro-Photo CD. Even third-party service providers can scan images onto Kodak's Photo CD. They typically charge per scan.

Kodak Photo CDs are an established standard and can be displayed on most DVD players, which is handy for displaying images on TV without much effort. You can find more information about Kodak Photo CDs at www.kodak. com and www.tedfelix.com/photocd. However, with the continuing spread of digital cameras, it seems inevitable that the intricate Kodak formats will be replaced before long.

Fujicolor CD

Fuji can produce scans from 35mm or Advanced Photo System (APS) negatives in JPEG format. The resolution is 1024 × 1527 pixels with a color depth of 24 bits. The cost per Fujicolor CD is around $2.50. It is a moderately-priced counterpart to the Kodak Picture CD, and therefore is also not for the quality-minded.

Comparison: Photo CDs vs. Manual Scan

With all current formats of photo CDs, photos undergo extensive processing. Although the trouble of processing is spared, control over critical parameters of image capture is given up. Since the possibility of post-processing JPEG images is very limited, you have to accept the results you get if you do not want to rescan images yourself.

For shots in normal lighting, the results from the photo CDs are generally usable; but scanning yourself can yield much more from the originals. The images on the following pages clearly show how much image information gets lost in a standard scan from a chain lab. In the example shown, the lighting wasn't even difficult.

The scan from the lab is of only moderate quality, because the tonal range is clipped. This is especially noticeable in the foliage in the background, which disappears in a featureless blackness. This cannot be rectified, since the compressed JPEG image from the CD doesn't respond very well to image processing. Also, the possibilities for enlarged crops are limited due to the small resolution (1536 × 1024 pixels). Only a manual scan will reveal all the unused image information in the original, but it takes a correspondingly large amount of time. Using standard corrections such as setting the black/white/gray points and the analog gain before the scan, and following that with the shadow/highlight filter in Photoshop, can give a much better looking result.

Professional Scanning Services

Subsequent scanning of film material for improved quality is time-consuming and bothersome. There are good arguments for using professional services, such as www.slidescanning.com, www.digmypics.com, www.imagerylab.com, and www.gemega.com. These services usually only scan processed film, since they don't have their own photo labs. Although the cost for a single image may be manageable, if you have a large number of slides or negatives to scan, total costs can add up to a substantial amount. Prices for processing can vary markedly, as can the quality of the results. Before placing a large order, a small sample order is recommended to evaluate the quality. Unlike the photo CDs offered by photo labs, specialized professional services support many different resolutions and file formats. Almost anything is possible, but the price increases with resolution.

Photo CD: the fine details of the slide get lost in the scan from the drugstore. With JPEG, even post-processing can't recover anything.

Only a manual scan can bring out the full details of the original. The tonal range is fully utilized because it isn't restricted by any automatic mode.

Special Case Kodachrome

Not all scanning services can handle Kodachrome slides with good results. Special scanners are required for Kodachrome; with regular scanners, the resulting images will be less than appealing.

The standard file formats TIFF and JPEG are common. Output of high-resolution images in TIFF format are of high quality and are well-suited for post-processing. RAW formats are not offered, since no dominant standard has emerged so far. For now, using RAW data is only an issue for do-it-yourself scanning. A scanning service should automatically remove scratch and dust with Image Correction and Enhancement (ICE) or Film Automatic Retouching and Enhancement (FARE). Some companies also offer correction schemes to revive the colors of faded originals.

Scanning services are a good choice if you do not have the time or the inclination to deal with a scanner yourself. This would be the case if you want to completely digitize your old stock, and intend to shoot all new images digitally. To limit costs, you should sort through your archive beforehand with a light table and a loupe. Many photo enthusiasts have a collection of 10,000 or more slides. Only in rare cases would all images be good enough to justify digitizing an entire archive. If only a few hundred originals need scanning, then buying a scanner would not be cost-effective.

The scanning costs per single image add up to a substantial amount for larger quantities.

Performance Characteristics of Film Scanners

This chapter discusses all the essential parameters for evaluating a film scanner. Apart from the numerically definable aspects such as resolution and dynamic range, the not so easily quantifiable quality of the optics is critical. Because specifications on paper rarely match actual performance, test reports should definitely be read before purchasing a scanner. The DVD for this book contains sample scans from almost all current film scanners. These can be used to compare scanners directly, or for an overview of the different quality levels of the various models. Detailed test reports can be found at www.filmscanner.com.

Content

Key Specifications of a Film Scanner

Nominal Resolution

The resolution of a film scanner defines its ability to record even the smallest details of the original image scanned. Usually it is defined in pixels per inch (PPI or ppi). Occasionally the units DPI and SPI may also be used. Hence, a film scanner with 4000 ppi can resolve 4000 pixels per inch. The higher the resolution of the film scanner, the larger the generated images will be. This is a good thing, because high-resolution images can still be reduced any time. However, the higher the resolution, the larger the image file becomes. A modern 35mm film scanner produces 16-bit TIFF files with more than 110 MB per image. If you scan a few thousand images, storage requirements will grow accordingly. Even if you do not plan to use the maximum resolution for normal scanning, it should still be as high as possible to allow for tight crops.

The original size of a 35mm slide is only 24 × 36mm, but you can print posters from it as large as 12" × 18".

With a print resolution of 300 dpi, a 4000 spi scan can be printed up to 12" × 18". Only the scanner's actual optical resolution is of interest. Catalogs often state the interpolated resolution, which is considerably higher. Interpolated resolutions are meaningless; the optical resolution of the scanner is only mathematically up-sampled, resulting in artificially inflated image files. Yet, they only contain information that the scanner can physically record with its optical resolution. If you want to print at a larger size, you should use an image editor for up-sampling. For that, you do not need a special scanner. It is not recommended to interpolate the scan data directly in the scanning software. It is better to scan at the scanner's native resolution, at which it delivers the best image quality.

Hands-on Tip: With Small Formats, Determine Output Size First

If the scanner automatically scales the image, the film grain will often look more pleasing than that produced from a high-resolution scan down-sampled to the desired size in an image editor afterwards. This effect is very pronounced with Nikon scanners.

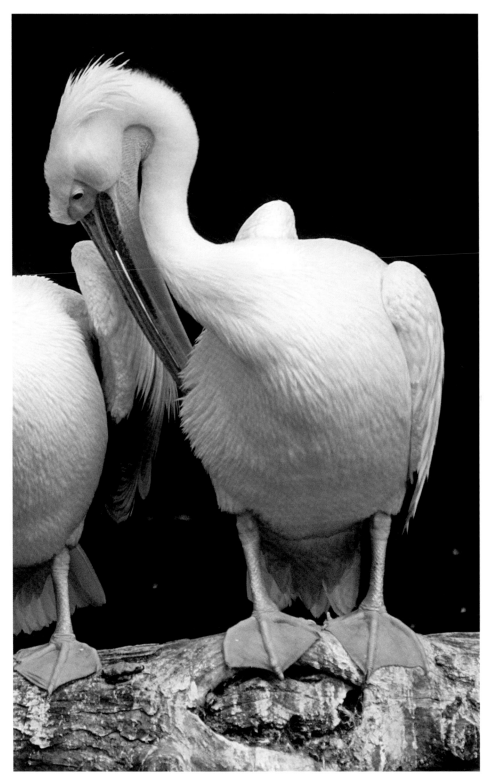

4000 spi scan – maximum crop for a full-page print at 300 dpi.

PPI, SPI, and DPI: Units for Resolution

A scanner's resolution is specified in PPI, SPI, or DPI. All these terms are units for resolution per inch. Which one to use depends on the field to which it refers.

PPI = Pixels per Inch

This unit refers to an image display on a monitor. It describes the number of pixels for every inch of the image on the screen. A pixel is the smallest unit the monitor uses to represent an image.

SPI = Samples per Inch

This unit refers to the number of samples (scanning points) per inch on the original that the scanner can record. A sample is the smallest image spot the scanner can detect.

DPI = Dots per Inch

This unit refers to the resolution of a printer. It defines the number of printed dots per inch the printer can deposit on the print medium. For an inkjet printer, one dot corresponds to its technically smallest possible ink droplet. The printer cannot deposit less than one droplet. Consequently, a high-resolution inkjet printer must be able to generate very small droplets.

Unfortunately, few people adhere to these textbook definitions. In this book, the terms are used according to common practice. It is only of academic concern whether the resolution of a scanner is quoted in ppi, dpi, or correctly in spi. Even popular image editors commonly confuse the terms.

Since resolution is the most prominent feature of a scanner and is crucial to a customer making a purchasing decision, some manufacturers resort to printing unrealistic resolution specifications on their boxes. There are clear standards for measuring resolution, but certification is not mandatory for the manufacturers. Test reports are better for providing information about resolution, since such reports measure advertising specifications against harsh reality. If a manufacturer promises 3600 dpi, but in reality the scanner only resolves 1800 dpi, then you not only get just half the promised resolution, but - adding insult to injury - you also have to suffer large file sizes of 3600 dpi. Storage space is wasted without getting better pictures. For high-grade film scanners the difference between advertised and actual resolution is usually quite small, somewhere in the range of 10 percent. Flatbed scanners with transparency units are a different story. With typical resolution reported at around 4800 dpi, on paper they surpass many film scanners; but the current crop of flatbed scanners – at the time of this printing – only resolve 1700 dpi in transparency mode.

Determining the Actual Resolution with USAF-1951 Test Chart

You will need a USAF-1951 test target to determine the actual resolution of a scanner by yourself. You can order such targets from www.sinepatterns.com or www.appliedimage.com. They come in different sizes; to test a film scanner you will need a 35mm target. Typically the targets are delivered as unframed transparencies. They can be used with film scanners as well as flatbed scanners with transparency adapters. After mounting the target in a slide frame, it fits into a film scanner without problems. The target contains black bars of different sizes on a clear background. The bars are aligned horizontally and vertically because the scanner can attain different resolutions in horizontal and vertical directions. Set the scanner to its optical resolution and save in a lossless file format, such as TIFF. Do not apply any image corrections or filters as they would distort the results.

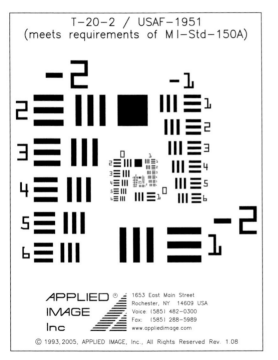

Counting bars with the USAF-1951 test target from Applied Image. Although the target is not as accurate as required by the ISO standard, it works well for finding differences in the quality of scanners.

Open the image file in a viewer and set the zoom factor to 100 percent. Then interpret the displayed target elements using the lookup table that comes with the target.

Exact Measurement of Scanner Resolution: ISO 16667 vs. ISO 14773

ISO 16667 is used to measure actual resolution. ISO 14773 is not conclusive, since it merely determines nominal resolution.

Color Depth of Scanner

As will be shown later in Chapter 4 on the topic of file formats, maximum color depth is an important criterion for evaluating a scanner. Common color depths of scanners are 8-, 12-, 14-, and 16-bit. These correspond to the following grayscale values:

▸ 8-bit color depth: 256 (2^8) grayscales
▸ 12-bit color depth: 4,096 (2^{12}) grayscales
▸ 14-bit color depth: 16,384 (2^{14}) grayscales
▸ 16-bit color depth: 65,536 (2^{16}) grayscales

In Red, Green, and Blue (RGB) mode each image point is generated from three values (one each for red, green, and blue). The number of bits refers to each of the three color channels. These correspond to the following number of possible colors in RGB mode:

▸ 8-bit RGB $= 2^8 \times 2^8 \times 2^8 = 2^{24} =$ 16,777,216 colors
▸ 12-bit RGB $= 2^{12} \times 2^{12} \times 2^{12} = 2^{36} =$ 68,719,476,736 colors
▸ 14-bit RGB $= 2^{14} \times 2^{14} \times 2^{14} = 2^{48} =$ 4,398,046,511,104 colors
▸ 16-bit RGB $= 2^{16} \times 2^{16} \times 2^{16} = 2^{64} =$ 281,474,976,710,656 colors

Obviously, the numbers of colors for RGB are somewhat unwieldy, which is why bit-depth is more commonly used for expressing color depth. It is important to keep in mind that a 16-bit file only uses twice as much storage space as an 8-bit file but offers an exponentially higher color depth. Storing the files in RAW format makes the best use of your hard disk space. Storing the images in TIFF can take up more space, except for 8-bit and 16-bit scans, which are directly supported by TIFF. The only lossless way to save 12-bit and 14-bit scan data in TIFF is in 16-bit color space. This way either $4/16^{th}$ or $2/16^{th}$ of the storage space will be wasted.

Color Depth in Image Processing: 8-Bit or 16-Bit?

Many image editing programs work only in 8-bit, but a few also work in 16-bit color depth. A 16-bit color depth is technically the better solution, but the question is whether or not it is worth the effort. Working in 16-bit is very demanding. Not all image editors support 16-bit throughout. Furthermore, 16-bit images occupy twice as much memory as 8-bit images, which are already quite large.

For image output, 16-bit offers no advantage. That is, the human eye cannot detect any additional image information with 16-bit. It is a different case, however, for image editing. If you modify color curves, change contrasts, or adjust brightness, a 16-bit source file can contain the decisive bit of extra information to allow for certain adjustments without visible degradation. If you are not planning to do any extensive post-processing on your scanned images, 16-bit unnecessarily wastes time and storage space.

This slide has been scanned at a 16-bit color depth and output as a 16-bit TIFF file.
The only other processing was unsharp masking.

The same slide saved as an 8-bit TIFF file. There is no noticeable difference in the prints.

Density Range

Apart from resolution and color depth, density range is an important criterion for selecting a scanner. Density range describes the difference between the area with the maximum density (Dmax) and the area with the minimum density (Dmin). It is the difference between the darkest and the brightest image points that the scanner can differentiate from pure black or white, respectively. The higher the density of the original, the more brilliant and contrasty the image will be. If the film scanner has a lower density range than the original, the scan will suffer some quality loss. Not all nuances in color and grayscale can be captured entirely. The scanner cannot record all details in the highlight and shadow areas simultaneously. Either the shadow details will drown in darkness or highlight details will be bleached away. Especially for slides, a high Dmax of the scanner is essential for a good image quality.

If the density range is too low, it has a deteriorating effect on difficult subjects, such as night scenes on slide film. The file will consist of featureless blackness, without showing subtle differences in tones. For scanning paper originals a density range of 2.0 D should be enough. Negatives need at least 3.0 D; for slides, 3.6 – 4.0 D or higher is recommended. These values are just a rough guideline and are not written in stone. Desktop flatbed scanners have a clearly lower dynamic range when compared directly with film scanners.

Density Range = Tonal Range

The density range is also measured as tonal range with the unit D (for Density). It can be clearly determined with the ISO 21550 standard.

The sample image with the bird demonstrates the obvious disparity in quality between different scanners. However, in both cases the density range published in the specification sheets are to be taken with a grain of salt. Regardless, the Nikon Coolscan 5000 undoubtedly has the higher tonal range, which shows in the image result. While the Minolta scan appears flat, Nikon brings out the brilliance of the slide nicely.

Of course it is unfair to compare a current and high-priced scanner like the LS-5000 to the Scan Dual II, which is already out of production and in a lower price range than the Nikon. In both cases the manufacturer's software was used for scanning. Comparing different scanners is like comparing apples and oranges, because the result depends not only on the hardware but also greatly on the software used. The brilliance of a slide can translate into a good scan only if the scanner has a high actual density range. Fallacious numbers from the specification sheet will be exposed quickly.

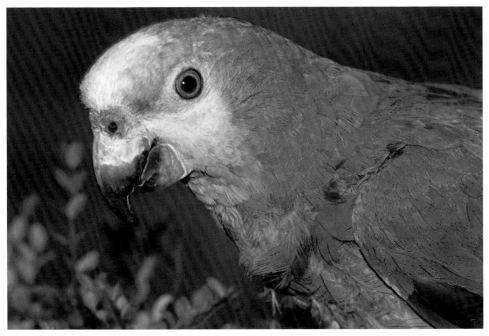

Scan of a color slide with Minolta Scan Dual II (3.2 D)

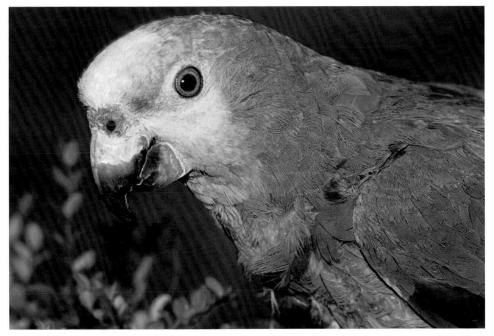

Comparison with Nikon Coolscan 5000 ED (4.8 D)

Scanning Speed

Scanning speed is a limiting factor when digitizing film. Generally, it takes longer to scan negative film than slides because the scanner needs to invert the negative, which requires additional computing time. For a complete scan of a single negative frame, even the fastest desktop film scanners need around one minute per frame with scratch removal enabled. Unfortunately, substantially longer times are the norm. If the scanner supports bulk scanning, this is still acceptable, since the scanner can work unattended. However, if you do many single scans, a fast scanner is a must. You can find extensive test reports for most of the film scanners on the market at www.filmscanner.info, including detailed information about scanner processing speed.

Most film scanners are not set up to let you quickly digitize a few pictures. Scanning takes quite a bit of time and can test your patience. Resolution and image quality of modern film scanners are already very good, but there is still plenty of room for improvement as far as processing speed is concerned. If you need a fast system now, you will have to dig deep into your pockets for the scanner and a computer powerful enough to adequately support the scanner. Currently, the fastest scanner is the Nikon Coolscan 5000 ED. You should use at least a PC in the 3-GHz class with enough RAM to run the scanner at its optimal speed.

Implemented Image Corrections

Modern film scanners employ special correction methods for removing dust and scratches, and for equalizing film grain. These technologies are not a luxury but rather a basic requirement for turning good originals into high-quality image files. In addition, it is possible to boost colors of faded originals and to correct shadows and highlights at the scanning stage.

The best methods for dust and scratch removal involve inspecting the film surface with an infrared beam. This method cannot be replicated in software with equally good results. Apart from this, all other image corrections can be performed afterwards with an image editor. Color restoration and grain reduction can be done either in Nikon Scan or in a Photoshop plug-in (which you have to buy separately). The general advantage of image corrections in the scanner and scanning software is that they happen during scanning, and therefore require less time-consuming post-processing in the image editor. In most cases the corrections will be firmly embedded in the image file, even when using RAW. Time can be saved by making sure the scanner is set up properly. If you want to change the level of correction afterwards, you must scan again, which can be a pain.

A Must: Scratch Removal in Hardware

State-of-the-art film scanners have an infrared detection for dust and scratch removal. Scratch removal in software is inferior and tedious. It is mainly used for black and white film.

Supported Film Formats and Bulk Scanning

You should already know before you purchase a scanner whether you want to scan 35mm, APS, medium format, or large format film. Currently, there is no affordable scanner for processing all formats in good quality. All common desktop scanners can handle 35mm negatives and slides, but support for additional formats varies.

Images: Nikon

Nikon Super Coolscan 5000 ED with adapter for single slides

Nikon Super Coolscan 9000 ED for 35mm and medium format

For example, Nikon's Super Coolscan 9000 ED scans 35mm and medium format from 4.5 × 6cm to 6 × 9cm. There are even adapters for such exotic formats as 16mm film, 24 × 65mm panoramas, medical slides, and electron microscope film, but they are all rather expensive.

Another important feature is the scanner's capacity for bulk scanning. For that, you load the scanner with material, configure the scan, and let it run unattended. It is almost impossible to digitize an extensive image archive without powerful bulk processing. It is simply unrealistic to digitize several thousand slides one by one. The slide feeder SF-210 lets you run stacks of up to seventy-five slides (with thin mounts) through your Coolscan LS-5000 without supervision. This vastly reduces your workload - as long as no slides jam.

Coolscan 5000 ED with slide feeder for a maximum of seventy-five slides, depending on the mount thickness.

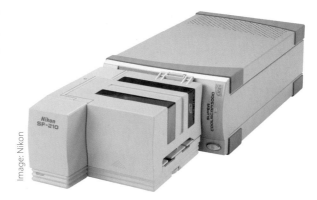

Image: Nikon

A film scanner should support bulk scan at least for negative strips. A motorized filmstrip adapter is now a standard piece of equipment. Here the mechanical quality of the scanner is important, so that the film is advanced precisely to the next frame after every scan.

Two configurations of the 5000 ED: on the left with filmstrip adapter for filmstrips with 2-6 frames, on the right with roll film adapter

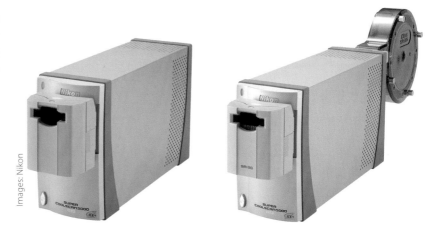

Images: Nikon

Bulk scanning requires high mechanical quality hardware. If the film transport or the slide feeder frequently jams and requires manual interaction, the feature becomes useless. Scanners such as the Reflecta DigitDia 4000 can scan entire slide trays even in their basic configuration. Nikon has a different approach. Mounted slides, filmstrips, film rolls, slide stacks, and APS film can be scanned, but the scanner only comes with the slide mount and filmstrip adapters; any other adapter must be purchased separately. A film roll adapter alone costs far more than a basic film scanner. At that price, you get a slightly modified filmstrip adapter and a large film spool for winding up the film nicely.

Using a sophisticated adapter is unnecessary and is not economical, if you scan film rolls only occasionally. The Reflecta ProScan 4000 provides a simpler solution: A second opening in the scanner lets you feed long filmstrips. Nikon offers no solution for scanning slides directly from the slide tray. You have to manually insert stacks of slides into the slide feeder. If you do not

want to do that, you can get the DigitDia 4000 mentioned earlier, which is structurally identical with the Braun Multimag SlideScan 4000.

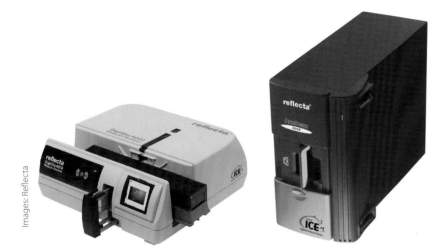

Left: the Reflecta DigitDia 4000 can scan slides from their trays.

Right: the Reflecta ProScan 4000 can also scan uncut film rolls

Images: Reflecta

Scanner Light Sources

The scanner's light source greatly affects the scanning process. Traditional lamp technologies for scanners, such as halogen or fluorescent lamps, require a certain warm-up time before they can deliver a stable light. Meanwhile, newer technologies are taking over: for example, modern LED light sources provide stable lighting and therefore do not need any warm-up time. They also don't heat up, which is an advantage when scanning delicate originals.

For their current generation of scanners, Nikon and Konica-Minolta use LED lights. There are separate LEDs for each individual color channel. The disadvantage of LEDs is that they produce harsh lighting.

With damaged originals, such as scratched black and white negatives, every scratch shows up prominently. This will make post-processing more time-consuming. A simple sheet of diffusing film placed in front of the scanner's light source can greatly reduce this unwanted effect.

Alternatively, you can insert a special translucent plastic plate, such as the Scanhancer (see www.scanhancer.com).

Diffusers soften the light, which makes the scratches appear less prominent. This reduces touch-up effort considerably.

Scanners with soft lighting produce better images from black and white material. The comparison pictures show a black and white negative scanned first with a Nikon Coolscan 5000 ED and then with an ArtixScan 120tf. The Microtek is a somewhat older design and has no LED light source. The manual does not specify what kind of lamp is used, but it seems to be a cold cathode fluorescent lamp. Similar lighting is used in light tables.

The harsh LED lighting of the Nikon Coolscan IV emphasizes scratches and makes them very visible. With color originals, you can compensate for this by using ICE, but black and white originals have to be touched up manually.

The softer lighting from the fluorescent lamp of the Microtek ArtxScan 120tf makes the scratches barely visible and requires less touch-up work than with the Nikon.

While the Nikon image clearly needs touching up for the obvious scratches, with the Minolta scanner the scratches are hardly noticeable. This shows how a scanner's design determines for which type of film it performs best.

Harsh lighting adversely affects not only how scratches are handled but also how the film grain shows in the image. Soft lighting generates a much more pleasing image of the grain. Of course, having a scanner that does not emphasize the grain is better than performing grain reduction afterwards in software. As demonstrated, you should be aware that, for technical reasons, one single scanner model couldn't produce equally good results for all types of film.

It's All in the Lens

A scanner lens projects the width of the film onto a CCD line sensor. This lens has to meet optical requirements typical of a top quality 35mm macro lens. State-of-the-art scanners have sophisticated lenses such as seven-element designs with exotic low-dispersion glass. Multi-format film scanners are even more demanding: the Coolscan 9000 ED has a lens with an astonishing fourteen elements. Poor lenses are the main reason that scanners perform below their advertised resolution.

Ultimately you can always tell from the scans how much went into the design and manufacture of the film scanner. Please look at the test images on the included DVD. You will find big differences between scanners that have the same nominal specifications.

A good film scanner can read enough information off of 35mm film to enable high-quality 11" × 17" enlargements. Just as in the case of conventional photography, the lens is crucial for image quality. Only high-quality optics can generate a good image. You should consider this when comparing scanners. If the scanner's lens is of poor quality, good values for color depth and scanning speed are useless. Ultimately, only the final image results count. Please look at the sample scans on the included DVD. There you can see clearly which manufacturers have configured their scanners properly.

Scanhancer

Originally Erik de Goederen developed the Scanhancer for the Minolta DiMAGE Scan Multi PRO. It is available at www.scanhancer.com and consists of a small polymer plate that is placed between the scanner lamp and the film. The idea behind the Scanhancer is to diffuse the scanner's light source, which de-emphasizes film scratches and also makes film grain appear more subdued. I have tested the Scanhancer on a Nikon Super Coolscan 5000 ED with a slide mount adapter MA-21. My test results apply only conditionally to other scanner models. While the 5000 ED works fine with the Scanhancer, problems have been reported frequently with older models such as the 4000 ED. The

Scanhancer was optimized for the DiMAGE Scan Multi PRO, which is still based on cold cathode fluorescent lamps. The image samples on the Scanhancer website were scanned using this scanner.

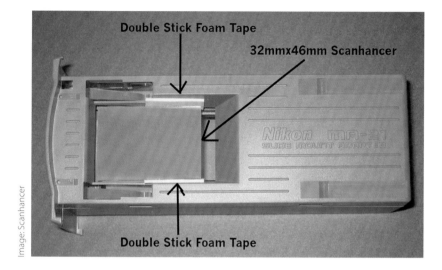

Nikon slide mount adapter with installed Scanhancer

The above picture shows that the polymer plate was shortened for the MA-21. This enables calibration; otherwise it would cause error messages. Calibration does not happen directly through the Scanhancer, but must be done separately. Also, after the conversion the scanner no longer automatically detects when a slide is inserted. This automatic function, which starts a prescan after a slide is inserted, no longer works. Scanning times become noticeably longer with the Scanhancer, but in return it can be done without the processor-intensive GEM. When starting the software with the Scanhancer, the following error message pops up:

Initially the scanner is a little annoyed with the Scanhancer

However, just click to remove the error message and the scanner will continue to work nonetheless. These are the unavoidable side effects experienced when modifying the scanner's hardware. For that reason, it is recommended to use the Scanhancer only when it is really needed. For Nikon it is not installed in the scanner body but rather in the slide mount adapter. Therefore, it is convenient to get a second MA-21 adapter for a quick change between scans with and without a diffuser, whichever is needed.

Scanhancer with Black and White Negatives

A common complaint about scanning black and white negatives on standard Nikon scanners is that the results are less than ideal. So, I was curious to see whether using a Scanhancer would improve this weakness of the LED technology.

In my test, removal of scratches and dust particles worked properly. However, as with all good things in life, there is a catch - there is a loss of contrast and fine details. Unprocessed black and white images without using the Scanhancer seem more contrasty and sharper. This becomes very obvious when comparing enlarged details. You have to decide whether this is worth the time you save in post-processing.

Scanhancer suppresses many scratches and specs of dust, but at the expense of resolution and contrast.

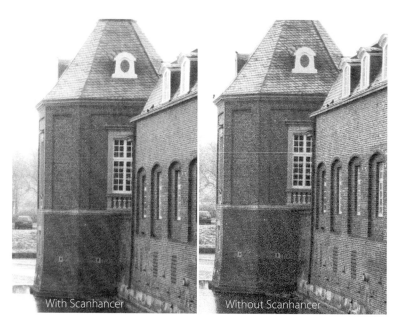

With Scanhancer Without Scanhancer

Scanhancer with Color Slides

With color slides scratches and dust are not a big problem thanks to ICE, even though ICE does affect sharpness. But there is also the dreaded pepper-grain effect, which can somewhat spoil the fun with scanning. When enlarging tight crops, quite often slide film looks like somebody has sprinkled ground pepper over it. The film grain causes the little black dots, which are especially distracting in skin and sky areas. With grain reduction such as GEM, this effect can be mostly eliminated. Depending on the amount of GEM correction, the image can get the plasticky look of digital photos. You have to decide whether this appeals to you; a finer representation of the grain would be better. This is where the Scanhancer is supposed to help. It does help, but not exactly as planned. In the scanning program's preview window you can see dramatically different colors. The colors become more muted and the image becomes generally darker with a noticeable color-cast. The grain texture, however, is actually improved.

When using the Scanhancer for color slides, the colors will be off.

The image samples show a slide film with relatively large grain. Do not expect any miracles from Scanhancer, but it does do an acceptable job of smoothing the grain texture. With fine-grain films like Fuji Velvia the Scanhancer smoothes the grain perfectly, but it alters the colors so badly that I chose to quit using the Scanhancer. Films with less saturated colors may produce better results.

Scanhancer with Kodachrome Slides

Similar to normal color slides, Kodachrome slides will also exhibit a color-cast with the Scanhancer. However, since Kodachrome slides have less vibrant colors than Fuji's Velvia, the effect is not as bad. The color-cast can be removed later in Photoshop. The Coolscan 5000 ED scanner has no ICE function specifically geared for Kodachrome. The only scanner with this function is the rather expensive 9000 ED. With the 5000 ED you can apply ICE to Kodachrome, but it removes image details that should actually be kept. In the sample image you can see a cord that has been mostly shredded by ICE. This will not happen when using the Scanhancer. The conventional ICE (not optimized for Kodachrome) in combination with the Scanhancer can be recommended unconditionally. The scratch and dust removal through ICE no longer comes at the expense of details.

The slide was scanned without Scanhancer and without ICE. Tiny specs of dust spoil the image.

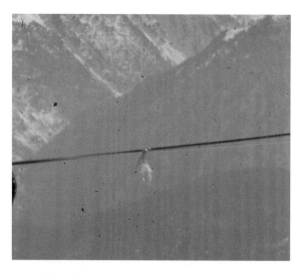

Without Scanhancer but with ICE: the dust has disappeared, but the cord has suffered badly.

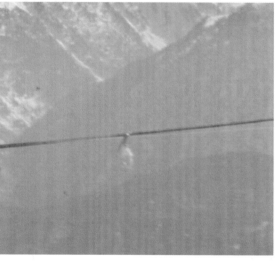

With Scanhancer and ICE: the dust has disappeared and the details are still there.

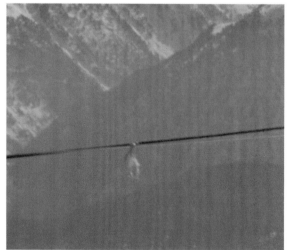

Scanhancer and Color Calibration

As already mentioned, the use of a Scanhancer causes a different color representation. It would therefore make sense to calibrate the scanner to compensate for this effect. This requires scanning software that supports IT8 scanner profiles. Although VueScan and SilverFast support it, Nikon Scan does not offer this feature.

The images in the example have been scanned with a Nikon Coolscan IV and the scanning software SilverFast Ai. Without correction the Scanhancer cannot be used for color films. Most colors will be significantly off and the scan will have only experimental value, so this is not a practical solution for productive use. Theoretically, calibration should rectify this, since the calibration process compares a test chart to a reference file. However, you can see from the images below that only the basic color-cast will be eliminated. The color characteristic modified by the Scanhancer still differs from the reference scan. As can be seen from the individual color patches, tampering with the scanner hardware cannot simply be rectified with calibration. For certain color tones there will still be deviations. Consequently, this solution is currently not recommended for color material. This is true at least for the Nikon scanners I tested; other scanners may be different.

Without Scanhancer:
reference scan of an IT8 calibration slide.

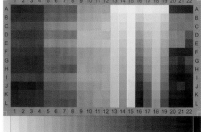

With Scanhancer and without re-calibration:
there is a major color shift.

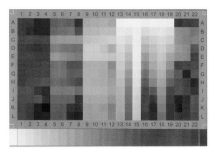

With Scanhancer and re-calibrated: the main
color-cast is gone, but there are still some color shifts.

Interfaces: Connection between Scanner and Computer

Data is transferred from the scanner's internal processing to the computer for storage. For this purpose, both scanner and computer must have a common external interface. The usual types of interface for scanners are SCSI, USB, and FireWire. Current models are offered almost exclusively with either USB 2.0 or FireWire. A PC can be upgraded with inexpensive expansion cards if the required interface is not included in the basic package.

SCSI

In the days before USB 2.0 and FireWire, SCSI was the fastest external interface. Older scanners still use SCSI, but modern units are equipped with the more user-friendly FireWire or USB 2.0. Unlike SCSI, they support plug-and-play.

USB 1.1 and USB 2.0

The Universal Serial Bus can connect practically any peripheral - keyboard, mouse, printer, scanner, and many other devices - to the computer, with the exception of the monitor. USB is a bus that allows for many devices to be connected in a tree topology, whereby USB hubs form the junctions for connections that branch out. To utilize full bandwidth, connect the film scanner directly to a USB socket on the rear panel of the motherboard. If you place a USB hub in between, it could become a potential bottleneck for the high data transfer rates typical of film scanners.

Theoretically, 127 USB peripherals can be connected to a PC, but they have to share the bandwidth of the bus. If you not only connect the scanner, but also printer, keyboard, mouse, and maybe even an external USB hard disk, the film scanner will not be able to use the full bandwidth of the interface. This can slow down the scan.

Do not hook up USB 2.0 devices to older USB 1.1 hubs.

Image: DLink

There are two versions of the USB standard: USB 1.1 with a maximum bandwidth of 12 Mbit/s and USB 2.0 with a nominal bandwidth of 480 Mbit/s. Don't be fooled by the misleading terms "full speed" and "high speed" for USB 2.0: "High speed" delivers the full 480 Mbit/s, whereas "full speed" crawls at

FILM QUICK REFERENCE

35mm	12	24	36
1-Hour Premium	9.04	14.08	19.12
Extra Sets	2.40	4.80	7.20
3-day Premium	7.99	9.95	13.95
Extra Sets	1.70	3.40	5.00
Professional 3-day	9.76	15.52	21.28
Extra Sets	2.40	4.80	7.20
Medium Format	10	12	15
Professional 3-day	10.00	11.40	13.50
Extra Sets	3.50	4.20	5.25

PREMIUM PROOFS: Prints made at time of processing are individually adjusted for excellent print quality. Printed on our d-Lab.2. Color or B&W negs.

PROFESSIONAL PROOFS feature even more critical colour correction for our most discerning clients.

FILM ENLARGEMENTS

MACHINE REPRINTS & ENLARGEMENTS

	35mm	120	APS (ix240)	SLIDES (35mm)
2x3 (4up)	1.50		1.50	2.00
4x5 / 5x5		1.25		
4x6	.75		0.85	1.50
4x6 Pro	1.25			
4x7				0.85
4x12	1.50		1.50	
5x7	3.00	3.00	3.00	4.50
6x8	5.00			
8x10/8x12	8.00	8.00	8.00	9.00
11x14	12.00	12.00	12.00	15.00
12x18	15.00		15.00	17.00

DIGITAL CONTACT

4x5	5.00
8x10	16.00

Digital contacts are made from oddsize film with no correction or cropping. Custom prints are suggested for high quality applications.

FILM PROCESSING & PROOFING

NEGATIVE PROCESSING

	Colour	True B&W
35mm	4.00	6.00
120	3.00	7.00
220	6.00	9.00
ProSleeving - Add $1.00/roll		

SLIDE PROCESSING (E-6)

	24-Hr	1-Hr	Un Cut
24Exp	7.00	8.00	6.00
36 Exp	9.50	11.00	7.00
120			6.00
220			8.00
PUSH PROCESSING - ADD $2.00			

INDEX PRINTS (CONTACT SHEETS)

	@ Time of Proofing	Full Roll (Uncut)	Digital / Cut Film
4x6 Index	1.00	3.00	5.00
8x12 Index	4.00	5.00	7.00

The fast and inexpensive alternative to contact sheets!

PROFESSIONAL PROOFING

		1st	+
35mm	4x6	.48	.20
	5x7	1.00	.65
120	4x5/5x5	1.00	.50
	5x7	1.25	.65

PREMIUM PROOFING

		1st	+
35mm	4x6	.42	.20
	4x12	.75	.40
APS	4x6	.48	.20
	4x7	.55	.25
	4x10	.80	.40

DIGITAL MEDIA PROCESSING

Applies when printing **all** images on a CD, digital camera media, or FTP transfer.

DIGITAL PROOFING - 4"x6"

	Uncorrected	Pro
1-5	65c	75c
5-200	40c	60c
200-1000	35c	55c
1000+	30c	50c

MEDIA TRANSFER to CD

CD-R Setup per disk	5
DVD-R Setup per disk	10
up to 256MB Transfer	5
up to 512MB Transfer	10
Per GB Transfer	10

DIGITAL ENLARGEMENTS

DIGITAL ENLARGEMENTS	Uncorrected	PRO
2x3 (4up)	1.50	1.50
4x6	See Digital Proofing	
4x12	1.50	1.50
5x7	2.00	3.00
6x8	3.00	5.00
8x10/8x12	6.00	8.00
11x14	8.00	12.00
12x18	10.00	14.00

UNCORRECTED PRINTS: Our best value, uncorrected prints are run directly through the lab *without any* adjustments. Great for clients who wish to manage their own colour. Must fit stanard sheet sizes.

PRO PRINTS The best option for most images, PRO prints are all individually adjusted to ensure excellent colour

PROFILES All images automatically profiled. Images without embedded profiles will be processed as sRGB.

ACCEPTED FILE FORMATS

Formats for Uncorrected & PRO machine enlargements

RGB JPEG only.
File size should not exceed 300dpi at final print size (maximum 12x18")
Incorrectly formatted files may be subject to delay or a surcharge for conversion.

Formats for CUSTOM Prints & Wide Format output

BITMAPS: 8-bit RGB TIF, PSD & Max Quality JPEG are preferred.
Submit files at 180, 240, or 300dpi if possible - please DO NOT upsample images.
PDF & EPS must have all fonts converted to cuves & all elements in US Web Coated SWOPv2 Color space for maximum consistancy. Please include a hard copy or low res JPEG proof. Contact our imaging department before submitting your file.

FILE SUBMISSION / UPLOAD

DIGITAL MEDIA

CD/DVD..............PC formatted closed-session media only
Media Card..........All common card types supported

UPLOAD: FTP & EMAIL

Visit our website for upload instructions: **www.prismimaging.ca/upload**

Web Upload.......... www.prismimaging.ca/upload
eMail*................ orders@prismimaging.ca (**5MB** Maximum for total order)
FTP*.................. **Address:** prism.tzo.com **login:** upload **Password:** digital
FTP ORDERS MUST INCLUDE AN EMAIL WITH INSTRUCTIONS to orders@prismimaging.ca

***IF YOU DO NOT RECEIVE A CONFIRMATION EMAIL WITHIN 24 HOURS, PLEASE CONTACT US TO ENSURE ORDER WAS RECEIVED. Rush orders must be confirmed by phone (regular service is generally 3-week days)**

PRO SCANNING

Scans are made on either our **Imacon 848** at up to 8000 optical ppi, or **Fuji Finescan 2750**. Imacon scans exceed drum scan performance in most cases. APS film is not supported. Larger originals & Higher resolutions available. CD-R $5. DVD-R $10

PROSCAN RAW

Scan Size (MB):	3.5MB	10MB	24MB	40MB	85MB	200MB
Up to 11"x17" original	5	6	10	15	20	30
11"x17" to 17"x22" original			20	30	40	60
17"x22" to 20"x30" original			40	50	60	80

Raw scans require cropping, retouching & colour correction. Suitable for advanced users.

PROSCAN COMPLETE

Scan Size (MB):	3.5MB	10MB	24MB	40MB	85MB	200MB	
Up to 11x17 original	10	12	20	30	40	60	
11x17 - 17x22 original			30	40	50	60	80
17x22 - 20x30 original			50	60	70	80	100

Complete scans are print ready for most applications and include reasonable dust removal, colour correction, and cropping. Colourmatching is not included.

Typical scan size requirements for print sizes from average film.

Scan Size (MB):	3.5MB	10MB	24MB	40MB	85MB	200MB
	screen	<5x7	8x12	12x18	24x36	huge

d-Lab.2 Roll SCANNING

Our d-Lab.2 features a state-of-the-art film scanning system featuring Digital ICE dust and scratch removal (for negatives only). Slide film *rolls* are not supported at this time.

		UNCORRECTED Std. (4.5MB) 1024x1536*	UNCORRECTED High (18MB) 2000x3000*	CORRECTED Std. (4.5MB) 1024x1536*	CORRECTED High (18MB) 2000x3000*
NEG	Uncut Roll	8 /roll	15/roll	10 /roll	18 /roll
	Cut strips (equivalent to roll)	10 /roll	18/roll	12 /roll	20 /roll
	Individual frames	1.50 ea	2.50 ea	2 ea	3 ea
	Single cut frames	3 ea	5.00 ea	3 ea	5 ea
SLIDE	35mm Mounted slides (ea)	1.50 ea	2.50 ea	2.00 ea	2.50 ea
	35mm Mounted slides (20+)	1 ea	1.75 ea	1.50 ea	2.00 ea
CD-R MEDIA		$5ea			
DVD-R MEDIA		$10ea			

* Scan resolution will vary by film format - quoted resolution is for 35mm film equivalent.

COPY WORK

COPY SLIDE OR NEG FROM FLAT ORIGINAL

	7-19	20-99	100+
35mm Film (Standard Size original)	3.00	2.25	1.75

Minimum order $21 Maximum size original: 11"x14". Original must lie flat.

DUPLICATE SLIDES (35mm dupe from 35mm original only)

	10-24	25-99	100+
35mm Dupe	2.00	1.50	1.25

Minimum order $20 From 35mm mounted slides only.

CUSTOM DIGITAL & WIDE FORMAT PRINTING

Improve your image in ways traditional printing cannot equal. We scan, enhance, and output your image on a range of archival, photographic, display, and fine art media to suit your needs. Pricing applies to most prints from negative, transparency, print, or digital media. Originals larger than 11x17 require scan purchase.

SAVE YOUR SCAN to CD for half off. (see ProScan RAW Pricing) Scans are kept on file for two weeks in-lab.

RETOUCHING & LAYOUT is available and will be quoted in advance for your project. Please ask for an estimate.

CUSTOM DIGITAL & WIDE FORMAT PRINTING

	PHOTO		MEDIA 1 ((minimum $30))		MEDIA 2 ((minimum $30))	
	1ST	2+	1ST	2+	1ST	2+
4X6	10	.75				
5X7	12	3				
8X10/12	16	8	25	20	30	22
8.5x11	18	10	28			
11X14	20	14	32	25	42	35
11X17	22	16	35	28	45	38
12X18	26	18	40	35	50	42
16X20	38	30	48	40	60	50
16X24	43	34	55	45	68	58
20X24	50	38	60	50	75	60
20X30	60	48	70	55	90	80
24X30	75	55	85	70	105	85
24X36	85	70	100	90	120	100
30X40	110	85	130	110	160	140
40X50	160	135	210	185	255	225
40X60	200	166	250	225	305	270
Larger	12sq'	10sq'	14sq'	12sq'	18sq'	16sq'

NOTE: Colour and contrast will vary by media. Certain media may have size limitations, and/or may require additional finishing. Minimum orders apply to specialty media. For fine art Giclee reproductions, see our Giclee price list.

MEDIA OPTIONS

PHOTO:
Lustre Photobase
Dreamscape
Banner Vinyl
Adhseive Vinyl

MEDIA 1:
Watercolour roll
Glossy Film
Clear PSA Film
Fabric Banner
Bulldog Canvas

MEDIA 2:
Artists Canvas
Watercolour Sheet (Arches/Torchon)
Backlit Film

We stock a wide range of materials not listed above. Ask our imaging experts for advice

ACCEPTED FILE FORMATS for Custom Prints & Wide Format output

BITMAPS: 8-bit RGB TIF, PSD & Max Quality JPEG are preferred.
Submit files at 180, 240, or 360dpi if possible - please DO NOT upsample images.
PDF & EPS must have all fonts conveted to cuves & all elements in US Web Coated SWOPv2 Color space for maximum consistancy. Please include a hard copy or low res JPEG proof. Contact our imaging department before submitting your file.

FILM RECORDING

SLIDE OUTPUT FROM FILE

	1-5	5-20	20-50	50+
35mm Slide (4k burn - 2666x4000)	7	6	5	4.50
120 (8k burn 6x7 6000x8000)	40 (1st)	10	8	6
MINIMUM ORDER	21			

FILE SETUP: Files should be supplied as TIF or Powerpoint.
For **TIF**: RGB only, no layers, no compression, no alpha channels. Maximum resolution 2666x4000 pixels. For **Powerpoint**, ensure presentation is formatted for slides. Do not use text below 18points, avoid light backgrounds.
Incorrectly proportioned files will print with black strips on the edges.

MOUNTING, LAMINATION & EDGING

We laminate and mount in-house for photographic, display, or commercial use using some of the best UV films and substrates available. Please consult with our imaging department to discuss your requirements or for volume/commercial estimates.

MOUNTING & ProTRIM EDGING

	Board #3 or #6	3/16 Foam Core	3/16 Gator 3mm Sintra	Block (Standard)	ProTRIM Edging
5X7	5	5	8	18	8
8X12	7	7	10	22	10
8.5x11	7	7	10	24	10
11X14	8	8	12	28	12
11X17	9	9	14	28	13
12X18	10	10	16	30	15
16X20	12	12	20	39	18
16X24	13	13	24	44	20
20X24	15	15	30	47	22
20X30	18	18	36	56	25
24X30	20	20	45	65	27
24X36	25	25	50	76	30
30X40	35	35	75	104	35
40X50	N/A	70	120	190	45
40X60	N/A	85	142	200	50
Oversize	N/A	5/sq'	8.50/sq'	quote	50c/ui

FLOAT MOUNT - Add $10/original - Minimum order $25

LAMINATION

	ULTRAMatte 5MIL MATTE	LUSTRE 3mil Optima LIQUID (Min order $15)	SUPERGLOSS 4mil ULTRAMatte 15MIL (Min order $15)	ENCAPSULATION: 3mil Gloss 2sided (min order $15)
5X7	5	5	10	5
8X12	7	7	12	5
8.5x11	7	7	12	5
11X14	9	9	14	6
11X17	10	10	15	7
12X18	12	12	17	8
16X20	14	14	21	10
16X24	16	16	23	11
20X24	18	18	25	13
20X30	21	21	28	15
24X30	25	25	34	17
24X36	30	30	38	20
30X40	42	42	60	27
40X50	70	70	85	42
40X60	84	84	100	50
Oversize	5/sq	4/sq	6/sq	3/sq

SPECIAL FINISHING

We offer a wide range of materials and services not listed in this guide. If you would like to discuss your project in more detail to determine what we can offer, please contact a sales agent or our imaging department.
Services include Banner Taping, Grommeting & Installation and more
Materials include any flat substrate such as Stainless Steel, MDF, Coroplast, etc.
Laminates include heavy textures, floor graphics, optically clear adhesives, etc.

PRISMIMAGING.ca
YOUR COMPLETE PHOTO AND IMAGING SOURCE

GENERAL PRICE LIST
AUG 2007

TEL **250.386.7787**
FAX **250.386.1901**
TOLL FREE **1.877.523.3456**

email: info@prismimaging.ca
web: www.prismimaging.ca

791 Fort St. Victoria, BC, V8W 1G9 (Corner of Fort & Blanshard)

12 Mbit/s. Newer PCs are equipped almost exclusively with USB 2.0, which is backward compatible. USB 2.0 devices can also operate in USB 1.1 mode.

One side effect is that a single USB 1.1 device will slow down an entire USB 2.0 channel to USB 1.1 speed. Current computers typically have four to six USB ports. You should dedicate one port just for the film scanner and avoid connecting any other devices between PC and scanner.

Don't Restrain Your USB 2.0 Scanner

If your scanner supports USB 2.0, you should also connect it to a PC with a USB 2.0 port. You will slow it down unnecessarily by connecting it to a USB 1.1 port. This also applies if a USB 1.1 peripheral is connected to the same hub as your USB 2.0 scanner, or if the scanner is daisy-chained to a slower device. A common mistake is to install a USB 1.1 driver even though the motherboard supports USB 2.0. In the Windows Device Manager you can see whether the correct driver is installed. In some cases you may also have to check your BIOS settings to see whether USB 2.0 is enabled.

USB supports Hot Plug and Play, which lets you plug and unplug devices while the computer is running. The computer no longer has to be switched off before connecting a new peripheral. Still, the scanner programs I know require the scanner to be turned on before launching the program. Not all USB cables support data transfer at the maximum speed of USB 2.0. To be on the safe side, it is best to use the original cable supplied with the scanner.

IEEE 1394b: FireWire

The IEEE 1394b standard is marketed under th names FireWire, i.Link, and Lynx. They are a based on the same technology. There are two type of connectors: 4-contact and 6-contact. The differ ence between the two types is that the 6-pole con nector also provides power for the bus.

With a maximum of 400 Mbit/s, FireWir has supported high data transfer rates long befor USB. FireWire is a mature technology. Despit that, the USB standard promoted by Intel ha widely prevailed. New scanners are more likely t come with a USB 2.0 rather than an IEEE 1394 interface.

A PCI extension card for upgrading to FireWire

Image: Western Digital

The advantage of FireWire over USB is that devices cannot slow each other down. FireWire always gives each device full bandwidth, whereas devices on a USB bus have to share the bandwidth.

Life After the Purchase

Learning Curve

Film scanners and their related software are complex. Just like you would not expect to learn how to use an SLR camera in one evening, you should allow sufficient time to get the hang of your scanner and its software. If you unpack your scanner and try to start off without basic knowledge, you will yield only moderate results. At least one weekend should be dedicated for the first steps. This time is needed to become familiar with the scanner and the software. Once you have familiarized yourself and figured out a workflow, scanning will be a breeze. If you change to another scanning program, you will have to learn the system over again. If you can't or don't want to invest that kind of time, you should consider giving your slides to a scanning service instead.

Which PC is suitable?

There is no simple answer to the question as to what the requirements are for a PC to enable you to work comfortably with a film scanner. Apart from the scanner model, the answer depends on the scanning software and its activated options. For example, enabling ICE will roughly double the scan time. The manual for Nikon Scan version 4.0.0 specifies a 300 MHz Pentium with 512 MB RAM as a minimum requirement. So, I figured I was pretty well equipped for my first attempts at scanning with a 1.6 GHz AMD Athlon, 768 MB RAM, and a 120 GB hard disk.

An up-to-date PC is essential for a smooth operation.

Image: HP

Now I know that my system at that time was rather underpowered for a film scanner. The processor usage during scanning is maxed out almost continuously at 100 percent. The computer runs constantly at its limit, which greatly prolongs the scan times. Also, the hard disk fills up quickly when image files are upwards of 110 MB each. Older systems are fine for experimenting. For

scanning large numbers of images at a reasonable speed, you'll need a computer with at least the following configuration:

▸ 3 GHz CPU
▸ 1024 MB RAM
▸ Fast, large hard disk (e.g., 200+ Gigabyte, 8 MB cache, 7200 rpm)
▸ USB 2.0 or FireWire interface

The above is just a rough guideline, since the resources needed for a scan depend on many different factors. Even with a fast computer, the scan ties up almost all resources. Thanks to multi-tasking it is possible to do some other work in parallel, but only very slowly. If you suspect that the processor is fully occupied during scanning, you can check the Windows Task Manager. Under the Performance tab the CPU usage is shown in a graph. Apart from a powerful, high-quality computer, it is also worthwhile to invest in a high quality monitor. Both CRTs and high-end LCD monitors are suitable for image processing. Since the monitor is the main user interface, you should not skimp here. Good image processing is not possible on a bad monitor.

Noise

The first time you use a film scanner, you may wonder what on earth it is doing with the film. The buzzing and screeching noises coming from the scanner do not bode well. Only when the scanner spits out the unharmed original will you realize that this is actually the normal sound of operation! As far as I know, there is no film scanner on the market with a pleasantly low operating noise level.

Customer Support

Scanners are complicated machines, so occasionally hardware or software can malfunction. This applies to systems from all manufacturers equally. For that eventuality good customer support is essential. You should consider only those manufacturers who continually maintain their products and issue bulletins about bugs and incompatibilities. For repairs you will have to rely on qualified service centers. Before buying, check for the following on the Internet:

▸ Is there a support hotline? Can it actually be reached?
▸ Is there an FAQ listing where you can find help for certain scanner models?
▸ Is there an updated, fully-searchable knowledgebase?
▸ Does the homepage offer updated drivers, software, and firmware updates for download?
▸ Is there a service center or a manufacturer-certified repair shop in the US?

You can google the Internet for a scanner model and related key words to find user reports. They are often very subjective, but you can easily find out whether a specific model has many problems. Customer support is costly for manufacturers, and only rarely can the costs be passed on to the consumer. Therefore, many companies provide only very limited support or a toll number for telephone support. The manufacturers try to filter out the majority of the inquiries with FAQs and a knowledgebase. This is an acceptable solution if they are user-friendly and well maintained.

Firmware Updates

Film scanners are controlled by firmware. This is software that handles the basic functions inside the scanner. The user cannot see the firmware, but rather interacts with the scanner via other applications, such as the scanner software. The scan program can only work optimally if the firmware is up-to-date. Every now and then, there are updates for the firmware to correct known problems. It is recommended to check the manufacturer's website regularly for such firmware updates and to install them. With Nikon Scan, the scanner's actual firmware version is displayed in the title bar of the scan window.

Firmware updates for Nikon scanners are available at nikonusa.com.

Software Support

Most scanners come with a scan program. The difference in program quality among scanners is quite considerable. Although the scan program from Nikon has a very good reputation, there are good reasons for using third-party software such as VueScan or SilverFast instead. If you want to run your scanner with a particular program, you should check for compatibility beforehand. Standard products such as SilverFast and VueScan support almost all popular

scanners, but surprises are possible since they do not adapt equally well to all scanner models. There actually is a difference whether SilverFast/VueScan is used with scanner model A or B. A look at the compatibility list will clarify whether your scanner is supported at all, but it does not tell you how well the program was implemented. Before you buy one of these programs, you should ask for a demonstration with a few sample scans.

Not even the manufacturer's own software may support all its scanners. For example, Nikon Scan may not support all Nikon scanners. Apart from the current generation, it runs on only one previous generation. Older models require older software. Apart from Nikon, I have tested almost all current 35mm film scanners and a few flatbed scanners in researching this book. Be they HP, Epson, Microtek, Canon, Plustek, Reflecta, or Braun, they should do the customer a favor and include a current copy of either SilverFast or VueScan. In all cases the software normally included is barely adequate.

There is no substitute for VueScan or SilverFast: the included programs have lots of buttons, but only few useable functions.

Wish List for Future Film Scanners

The current generation of scanners is already very good as far as resolution and image quality are concerned. However, there are areas where future technical advances will hopefully make the user's life easier. As there are often misleading ideas about the capabilities of the units, it is important to address a few points.

Scanning Speed

For many scanners the speed of the scanning still leaves room for improvement. The norm is several minutes wait per image, which obviously slows down work. Faster scanning would be preferable. Scanning times of around one minute per image with image corrections turned on would clearly make scanning more enjoyable. With the current state of scanner technology, one weekend will not be enough to scan an archive of a few hundred films. Several weeks would be more realistic. The fastest desktop film scanner I know is the Nikon Super Coolscan 5000 ED. Hooked up to a powerful computer, it allows for speedy work. Scanning a slide with activated ICE takes around one minute, which is quite acceptable. However, GEM and ROC further increase this time. Other scanner models are substantially slower. Scanning times of up to nine minutes for one image with ICE correction surely will not allow you to work efficiently.

Dust and Scratch Removal for Black and White

Once you have learned to appreciate the benefits of ICE you will no longer want to do without it. Without much user interaction slides will appear free of dust and scratches. Unfortunately, there is still no process supported by scanner manufacturers that also works for traditional black and white film. Especially with high-quality scanners, black and white negatives produce less than ideal results. The soft lens of a bad scanner makes some of the smaller blemishes disappear; yet, a good scanner scans not only the film but also every grain of dust on it and even the tiniest scratch with merciless precision. Depending on the type of light source and the quality of the scanner lens, this effect will show up more or less pronounced. You can remove the dust and scratches with software, but it is very tedious and cannot attain the results of ICE for color film. Scanhancer is a good tool to generally suppress dust and scratches. However, there is still no sound solution. Since all scanner manufacturers have frozen their development budgets, this problem will remain until this changes.

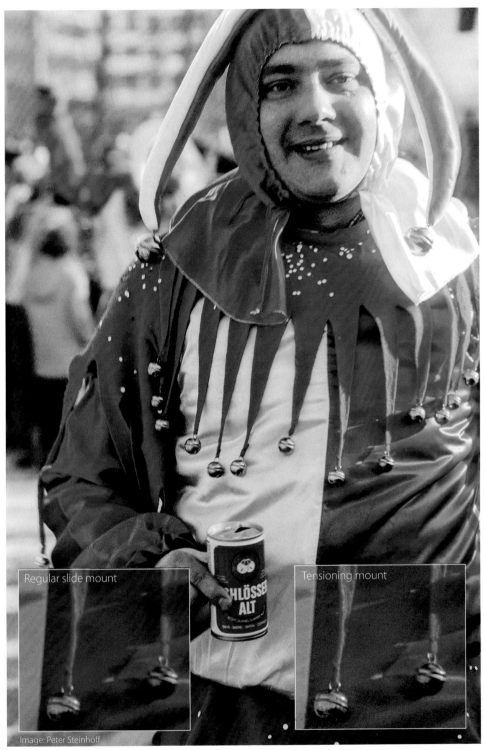

Snapshot of the 1980 carnival in Düsseldorf. The scanner was focused on the eye.
Left crop: the bell on his stomach is blurry when using a regular slide mount.
Right crop: The same image detail looks clearly sharper with a tensioning mount.

Depth of Field

In my scans the depth of field issue has often reared its ugly head. The color of the scan is fine, but the sharpness is often limited to certain areas of the image. This problem always happens with warped originals. In such cases, one has to choose whether to focus on the image center or the edge. A certain loss of sharpness toward the corner of the image is a natural characteristic of any camera lens, so the film is already less sharp there. Unfortunately, the limited depth of field of the scanner lens further adds to the softness in the picture, and ultimately this leads to visibly blurry portions in the scanned image. This problem varies with the different manufacturers. Nikon scanners are infamous for their shallow depth of field. Originals are not always sufficiently flat in order to scan them equally sharp from center to edge. The images on the previous page demonstrate this nicely.

At first, a curved slide was scanned. It was not possible to maintain even sharpness across the entire image; the eyes and the bell on the jester's stomach cannot be sharp at the same time.

Then the slide was remounted into a Wess slide mount with a tensioning feature, which pulls the film reasonably flat. With reasonably flat film, the sharpness extends across the entire area. In both cases the focus point was the left eye of the jester. ICE was deliberately disabled, since it causes slight blurring.

Tensioning slide frames is too troublesome and expensive for a large number of slides (the Wess website has not been accessible for some time now, so the company may be out of business already, but you still might be able to find some of their frames). Furthermore, it is not common to frame negatives, although it is possible for the purpose of scanning. Keep in mind that, once the negatives are cut, they are no longer accepted at photo lab chains.

Nikon has not found an ideal solution for curved filmstrips either. In my opinion, Nikon's filmstrip holder FH-3 still has plenty of room for improvement. Wavy filmstrips become a little less wavy, but a proper flatness is not achieved. Unfortunately, I don't know of any better film adapters from other makers. In the twenty-first century it ought to be possible to build a film holder that can pull curved film flat.

Ergonomics

Anyone who has used a film scanner before will understand why the issue of ergonomics is brought up here. Many models produce buzzing and chattering noises, which can be unpleasantly loud. You have to be very indifferent to noise if you want to run a scanner in your living room and do other things at the same time. Flatbed scanners are better in that respect; their noise level is usually more agreeable.

Scanning Film

3

Scanned images cannot turn out better than the original film which was scanned. Every defect on the film will be recorded by the scanner as an image detail. It can be frustrating to start with an image that appears satisfactory as a 4" × 6" print, only to find noticeable image defects when the same image is viewed on the monitor. One must check whether such defects are caused by the scan or originate from the film. Quite often a poor original is to blame. If an image is scanned at 4000 dpi and viewed at full size, even the smallest defects become visible. The film should be checked with a good loupe. In many cases the film is fine, but the scanner is poorly focused. Even the best scanning method cannot compensate for a blurry original on film.

Content

Handling Film

Curled, wavy film

Curled or wavy filmstrips are a problem that is commonly encountered when scanning. A good scan requires a flat original. For example, high-end film scanners have a very shallow depth-of-field – a curvature of just 1 mm can cause a blurry scan. Some film holders manage to minimize this curvature, but they are generally clumsy. Whenever possible, it is best to start with flat film stock.

Various factors determine the flatness of films. Non-curling layers in the film base can reduce excessive curvature of the material. However, a certain amount of curvature is required, allowing the film to stay in good contact with the film pressure plate inside the camera, and to avoid arching toward the shutter. Unfortunately, there is no binding standard for this concave curvature; manufacturers use their own internal guidelines.

Film processing and storage methods can also have a major influence on film flatness. Mistakes made in processing and storage can cause trouble later. For that reason, it does make a difference whether films are developed by a professional lab or by a discount processing service. If the film does not get dried according to instructions for that particular type of film, it will curl more strongly.

Though standard processes are used for all common color films, the results of processing can still vary greatly. The key processing factors for each lab are in how well they manage their quality control and how closely they follow the film manufacturers' processing guidelines. Ideally, the result of high-quality processing is that the film is flat after processing and can be scanned without difficulty.

How to Deal with Curled Film

There are limits as to how much film curvature can be corrected. The film base tends to return to its original shape by virtue of a memory effect. The simplest method to correct curvature is to store the negatives pressed between book pages. (Note: If this method is used, the negatives should be kept in their protective sleeves to avoid direct contact with the book's ink.) Also, a press could be used for storage. If the film is badly warped, it may help if the film is washed and dried once more. Unfortunately, there is no guarantee that any of these methods will truly keep the film flat.

Apart from lab processing, film storage is also a key factor in dealing with film curling. Storing films rolled up in a film canister may make it difficult for them to ever be flat enough for scanning. Often a flat filmstrip is fed into the scanner's film gate only to reemerge curved and curled lengthwise, like a pig's tail. This is most likely related to mechanical stress during the motorized film advance.

Whatever the reason, labs do not always deliver flat film stock. Typically, a mechanical fix is required to produce flat film. The best solution is to use slide mounts with a tensioning feature, such as the mounts available from Wess. These keep the film flat even when the negatives are very badly curved. However, to use slide mounts, the negative strip must be cut; once this is done, the negative can no longer be processed at most large labs (for example, when ordering reprints).

Physically Removing Dust

Before scanning, all dust and dirt particles should be removed from the film. The dirtier the original, the worse the resulting scan. The better the scanner, the more clearly even minute contaminations will be recorded. Although these can be removed to a certain degree with Digital ICE or FARE, it is better to first clean the film properly. If a large speck of dust obstructs a part of the image on the film, then even the best algorithm cannot adequately reconstruct the image.

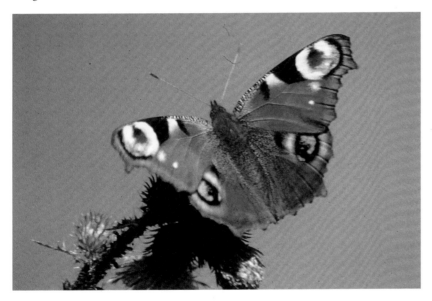

High-grade film scanners capture even the smallest fiber or dust particle. Often, such defects can be seen even at standard magnification, as is the case here on the antenna.

When cleaning with a normal cloth, there is a danger of statically charging the filmstrip. This has the undesirable effect of attracting even more dust to the strip. It is best to clean filmstrips with an aerosol dust remover or a blower. Avoid using air from a compressor, since the air may contain traces of oil. Blowing away the dust with your mouth is also not advised, since breath contains too much moisture, which can lead to Newton rings in the scan. If the film is statically charged, even cleaning with an aerosol dust remover will not be very successful as the film will attract new dust particles from the surroundings; having just cleaned the film makes almost no difference.

If negatives are kept in plastic sleeves, they should not be pulled out of the sleeves quickly. Pulling them out quickly generates a static charge and causes more dust to gather on the film surface.

Dust Reduction with Agfa Films

For several years Agfa has included anti-static layers in their films. Because of this, Agfa films stay cleaner than conventional films. Dust can still deposit on Agfa films, of course, but without static charge dust will not be actively attracted by the film base.

Inserting Film Correctly

When film is inserted into the scanner, it is important that the film be oriented correctly. Film has two different sides. The *emulsion* side contains the image information. The emulsion is a thin layer deposited onto a high-gloss film base. It is the emulsion side which must be scanned for best results. Of course, film is transparent – if it is scanned the wrong way, there will be only a minor loss in quality.

Finding the Emulsion Side

You can identify the emulsion side of film by holding the film at a steep angle against a strong light. The film base is glossy and smooth, but the emulsion side shows relief lines from the image details. Slides have very visible relief lines. For negatives, however, it is not so obvious; the less glossy side is the emulsion side. Every filmstrip also features frame numbers which can help you to determine the emulsion side: if the numbers are mirrored, then the emulsion side is facing you. (Note: for best scanning results, the scanner should read the emulsion side.)

Scanning with Correct Film Orientation

For an upright standing Nikon scanner, the emulsion side of the film must face downwards. If you can read the frame numbers properly from the top, the film is oriented correctly.

Handling Film Strips

It is very important that film be handled and stored with proper care. Slides are easy to handle as they can be grabbed by the wide frame of the mount.

Negatives are more delicate and difficult to handle. Avoid touching negatives with your bare hands. Fingerprints damage the film surface and are tough to remove from scanned image files afterward. It is better to remove fingerprints beforehand with film cleaners such as Tetenal and Hama. You

can also safely handle negatives with thin cotton gloves, or use tweezers with slanted tips to remove the strips from their archival sleeves without damaging them. These tweezers are relatively inexpensive and can be found in shops catering to stamp collectors. It is recommended that negatives be stored in either glassine (matt) sleeves or archival-quality clear sleeves. If you store negatives in a ring binder and organize them carefully, you will have a tidy archive. Be sure to keep your film archive free of light, dust, humidity, and heat.

Destroy Originals after Scan?

After a successful scan the original file is no longer needed; yet, it is a good idea to keep your slides and negatives on hand. Future generations of scanners may produce better results than currently available scanners; and in case of data loss, as a last resort, you can always go back to the original film and rescan your images. Data formats and storage media are constantly changing and must be converted on a regular basis to stay compatible with current systems. For example, a data carrier from the seventies cannot be processed on a current computer – if you can even find a computer that can read it at all. In the case of 35mm film, the situation is somewhat better; even negatives as old as fifty years can be used for printing or scanning without any problems.

It can make sense to rescan certain images. Results of scanning depend, among other things, on the skill of the user. That is, if you have gained more experience, and you rescan an original at a later date, you may get a better quality image. The best recommendation, therefore, is to never discard your analog originals (although it does make sense to sort out and discard any bad shots to reduce your archive).

Film Types

Color Negatives

Color negatives are not very troublesome for shooting or for scanning. Even an inexpensive scanner can yield acceptable results when color images are scanned. One disadvantage is that the film base for color negatives is susceptible to scratches. You can get good scans from color negatives only if you use a scanner with good hardware-based scratch removal.

When looking at the inverted filmstrip with the orange masking, it is difficult to predict how the final image will appear. Even proper exposure and sharpness are difficult to judge. This shows that it is not easy to sort out unusable shots.

The characteristics of film emulsions are as manifold as the offerings of color negative films. The data read by the scanner must be interpreted accordingly, and the result of scanning depends greatly on the settings of the scan-

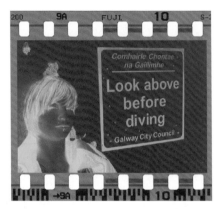

ning software. Matching the original film, in this case, is much more difficult than it is for slides. The scanning process for negatives takes longer than for slides because conversion from a negative to a positive image requires more processing effort. The color correction of scans from negatives can be automated in scanning software, which supports film profiles. SilverFast and VueScan ship with a large number of profiles for common film types. Nikon Scan has only one standard profile for negatives.

Color Slides

In a purely analog workflow, slides offer the maximum obtainable image quality. Slides offer a much more vivid image than do color negatives; their contrast

range is clearly higher. However, slides demand accurate exposure from the photographer as there is little margin for error. Even a small exposure error affects the image. In comparison, one has much more leeway with exposure when using color negative film. The processing lab has little impact on the image result when working with slides. With negatives, it is a different matter. Slides are superior to negatives because they have finer grain, more contrast, better color depth, and a much better density range.

For scanning, slides are more demanding than negatives. For example, scanning slides using low-end scanners often leaves much to be desired, since such scanners cannot typically handle the wide range of colors, contrast, and density inherent in the slides.

On the other hand, a great advantage of scanning slides is that the image on the monitor can be compared directly with the original. Scanning slides is also faster than scanning negatives since there is no need for processor-intensive image conversion when slides are scanned.

Image: Peter Steinhoff, about 1970 in Greece

Coolscan IV: scanned with a setting for standard slide film, this Kodachrome slide has a blue color-cast.

Coolscan IV: the same slide, but scanned with a setting for Kodachrome, this slide has neutral colors.

Setting a Coolscan 5000 to Kodachrome produces the most vivid colors.

Kodachrome Slides

Kodachrome films are color transparency films that have been on the market for more than half a century. They are not developed with the common E-6 process, but rather they require the special K-14 process from Kodak.

There are still good reasons for professional photographers to use Kodachrome:

▶ With proper storage (in darkness), Kodachrome colors can remain stable over decades. However, under projection, they tend to fade faster than E-6 slides.

▶ Colors within the Kodachrome family of films are consistent, which is an advantage when different films are mixed in a slide show.

▶ Kodachrome films have very fine grain.

Scratch Removal for Kodachrome

At this time, the Nikon Super Coolscan 9000 ED is the only system offered specifically for Kodachrome with a version of ICE scratch removal.

These films cannot be scanned in the same way as the common E-6 color slide films. They can be scanned like normal color slides, but with only modest results. You will get a good scan only if the scanning software offers a special setting for Kodachrome. If you scan Kodachrome with an E-6 setting, the images will have a bluish cast, and generally the colors will be less than satisfactory. Hardware-based scratch removal systems such as ICE or FARE, which were developed for E-6 and C-41 films, work for Kodachrome, but only partially. If you use scratch removal anyway, expect some loss in image detail.

Black and White Negatives

In general, scanning black and white negatives is problematic. As with color negatives, black and white negatives suffer from dust and scratches; but in this case, hardware-based scratch removal does not work at all. Neither ICE nor FARE function properly for black and white negatives; they actually degrade image quality. The only alternative is to employ software-based scratch removal, which is tedious and inferior in quality to hardware-based scratch removal.

However, ICE and FARE work for black and white films based on the C-41 developing process. These films are closer in technology to color film, there-

fore, the infrared beam used in ICE and FARE can scan the surface for dust and scratches. These films are also called "chromogenic" color films, such as the Ilford XP2 Super, Kodak BW400CN, Konica Monochrome VX 400, Tura BW-C41, and Fujifilm Nexia Sepia. Traditional black and white films such as the Kodak T-MAX family are silver-based; ICE does not work with those films for physical reasons.

The Ideal Film for Scanning

Opinions are divided about the ideal film for scanning, but it is certainly not black and white negative film. Black and white does not allow dust and scratch removal with ICE. In a purely analog workflow the qualities of good black and white films remain unsurpassed, but the annoying problem of scratch removal makes it difficult to take advantage of those qualities in digital processing. High-quality scanners reproduce even the smallest scratch, which can actually degrade a high-resolution image. Theoretically, you can use image-editing software to touch up scratches, but doing this is very tedious and time-consuming and is not practical for scanning a large number of images.

The advantages of using color negative film for scanning are wide exposure latitude and limited contrast range. Even with a low-cost scanner, quite passable scans are possible with color negatives. It can be difficult to visually match the scanned image with the negative. Orange masking makes it difficult to judge image sharpness, and it takes a lot of experience to guess the colors hidden underneath. Still, with matching film profiles you can easily produce scans with good colors. Negative film is more prone to scratches than slide film, but in most cases these scratches are handled automatically with ICE. For average quality needs, color negative film is a good compromise.

Slides have more vivid and vibrant colors and a wider density range than negatives. Only superior film scanners are able to read out such image information with high quality. Matching a scanned image with a slide is straightforward. Correct exposure is more critical for slide film and requires more caution during shooting.

The best stock for good scans is a slide film with fine grain; the finer the better. While expensive drum scanners used by professionals can handle almost any film stock, desktop film scanners used by amateurs and semi-professionals are more limited. Before the digicam boom, large film manufacturers developed several films optimized for their ability to scan. If you are still shooting film and are scanning by yourself, you should use film with this

newer technology. The difference is obvious; with older film you will usually get inferior results.

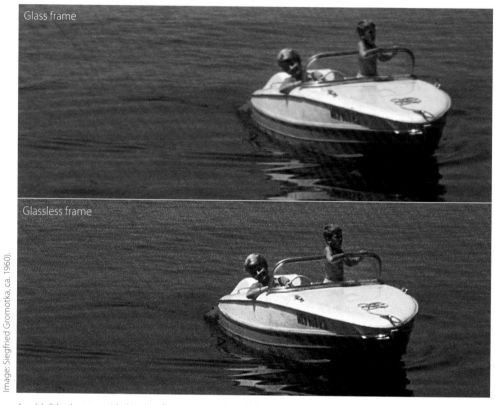

Glass frame

Glassless frame

Image: Siegfried Gromotka, ca. 1960).

An old slide: the scan with the glass frame causes a loss of sharpness.

Granularity of Film

The familiar root-mean-square (rms) granularity values have been gradually replaced by print grain index. While rms granularity is an absolute value, print grain index varies with print magnification. There is no direct correlation between the two. An rms granularity of less than 10 and a print grain index of less than 25 (35mm film enlarged to 4" × 6" print size) represent a very fine grain.

Uncut transparency strips are perfect for batch scanning.

Slide Mounts: Glass and Glassless

The type of slide mount has a big effect on the quality of the scanned image.

Glass Mounts

Slides mounted behind glass stay flat, which at first glance seems equally advantageous for both projection and scanning. However, for scanning, the glass layer is an additional obstacle when it comes to image quality – even more so with anti-Newton glass mounts. If you want a good-quality scan of your glass-mounted slides, it will be necessary to remount your slides into glassless frames. This applies to single, as well as double-sided glass frames. Unlike slides that are projected, slides will not "pop" in modern scanners since they do not heat up when scanned.

Glassless Mounts

Glassless mounts are ideal for scanning, since there are no troublesome glass layers involved. In many cases, however, flatness of the film is a problem. Mounts are necessary to ensure good flatness. Machine-mounted slides from the lab are usually firmly fixed and do not buckle. Other mounts, such as those used with the Hama DSR system, do not offer any locators for the film. Wess has addressed this problem and has developed several mounts with a tensioning feature; but they are all rather expensive and may be difficult to find.

Improving Flatness for Negative Films

If a negative strip cannot be scanned properly, it can be cut and mounted. Tensioning slide mounts produce a superior flatness than typical film holders. Note that once the strip is cut up, labs will no longer handle it. This is basically not a problem, however, since you have a high-quality image file once the negative is scanned.

Granularity of 35mm Kodak Film			
Film Designation and ISO Sensitivity	RMS-Granularity	Print Grain Index (enlarged to 4" × 6")	Remarks
Color Negative			
Portra 160NC	n/a	36	Portrait film for natural colors
Portra 160VC	n/a	40	Portrait film for vivid colors
Portra 400NC	n/a	44	Natural colors and high speed
Portra 400VC	n/a	48	Vivid colors and high speed
Portra 800	n/a	40	Finer grain than Portra 400 films
Portra 100 T	n/a	33	For tungsten light (3200K)
Elite Color 200	n/a	32	General-purpose standard film
Elite Color 400	n/a	39	For action shots
Gold 100	n/a	45	Standard consumer grade film
Gold 200	n/a	47	Gradually replacing Gold 100 as standard film
Gold 400	n/a	49	Standard film for point-and-shoot zoom cameras
Color Transparency			
Ektachrome E100G	RMS 8	n/a	Extremely fine grain
Ektachrome E100GX	RMS 8	n/a	For warmer colors
Ektachrome E100VS	RMS 11	n/a	Vivid, saturated colors
Ektachrome E200	RMS 12	n/a	Can be pushed to ISO 800
Elite Chrome 100	RMS 8	n/a	Universal fine grain film
Elite Chrome 100 Extra Color	RMS 11	n/a	Extra high color saturation
Elite Chrome 200	RMS 12	n/a	All-purpose film, fine grain for ISO 200
Elite Chrome 400	RMS 19	n/a	For low-light and action shots
Kodachrome 64	RMS 10	n/a	Proven veteran of several decades; uses K-14 process. Color characteristic noticeably different from modern films.
Kodachrome 200	RMS 16	n/a	Quite a bit faster than Kodachrome 64, both films need to be processed in one of three remaining centralized labs in the world. Future support for 35mm is unclear; for Super8 and 16mm film it has been discontinued in 2006.
B&W Negative			
T-MAX 100	RMS 8	n/a	B&W film with extremely fine grain
T-MAX 400	RMS 10	n/a	Still fine grain despite higher speed
T-MAX 3200	RMS 18	n/a	The ISO-wonder: can be pushed to 25,000
Tri-X 400	RMS 17	n/a	Good for pushing, has characteristic grain
Tri-X 320	RMS 16	n/a	Slightly finer grain, otherwise like Tri-X 400
PX 125	RMS 10	n/a	Very sharp with fine grain
BW400CN	n/a	<25	Extremely fine grain, uses C-41 process

Source: www.kodak.com

File Formats

The quality of scanned images depends greatly on the choice of the right scan file format and corresponding resolution. Which file format offers the best quality, is supported by most companies, and requires the least storage space?

The following chapter will help you to decide on the ideal image file format and the best resolution for your purpose. Only formats relevant to film scanners will be discussed here. For good reasons, scanners currently tend to use RAW format. Just as digital photographers do, scanner users have to deal with certain incompatibilities between image and file formats.

4

Content

Digital Negative

Color Depth in Image File Formats

Important Image File Formats in the World of Scanning

RAW: Proprietary Image File Formats

The Right Image Size and Resolution

Digital Negative

Differences between Digital Cameras and Film Scanners

RAW files are considered to be the "digital negatives" for digital cameras. High-end cameras offer the option of saving images in unprocessed RAW format. RAW is analogous to negatives or slides in the analog world. Each manufacturer uses its own RAW format, which can even vary among a manufacturer's different models.

With film scanners, it is a bit more complicated. Good scanning software also offers RAW as an option, but the type of RAW format depends on the combination of film scanner and scanning software. There is a big difference, for example, between generating RAW files from a Nikon scanner with Nikon Scan or with VueScan. Furthermore, if you have selected correction techniques such as Digital ICE before the scan, such corrections will be permanently applied to the image. Therefore, the meaning of a "digital negative" is not so clear when it comes to film scanners.

The definition of a digital negative needs to be extended in comparison to digital cameras. The digital negative is the source file upon which all further processing steps are based. It must never be modified, unless the processing steps are reversible.

Analog originals (slides or negatives) must go through a film scanner to become an image file. This is where analog to digital conversion occurs. A file is generated from the analog original. Inevitably some image information gets lost in the process. During scanning, the goal is to extract as much image information as possible from the original and save it as a digital negative – the master file. Only then can the best image quality be achieved in post-processing. If any modifications to the image information contained in the digital negative are irreversible, the image would have to be rescanned to restore the original master file.

RAW comes closest to an ideal digital negative. If the scanning software does not allow you to save in RAW, you can use another lossless format such as TIFF as your digital negative. Whichever format is used, it is important that the full extent of the image information obtained with the scanner is preserved in the file.

Working with Digital Negatives

Image files are easily corrupted. Unlike an analog negative, the image file can be quickly and easily modified, and image information will be subsequently lost. If, for example, you crop a TIFF file and save it to a file with the same name, the cropped portions of the original image are gone. Nikon Capture Editor handles this situation better than most with their Nikon Electronic

Format (NEF): the selected crop is saved in a configuration file as opposed to the image file, without changing the underlying image.

This allows one to revert to full image size later, if necessary.

Conventional Image Editors

Conventional image editors offer less control. For example, when working with Photoshop, one usually works on different copies of a file to avoid losses. With the right plug-in, Photoshop can open RAW files, including NEF files, but modifications to an image can only be saved in a different format, such as TIFF. In this case, the digital negative - the master file – remains intact. If your source file is TIFF, on the other hand, the editor can overwrite the original with a modified version and permanently discard cropped borders. Therefore, modifications should be saved as copies, even though this costs additional storage space and can make it easier to lose track of versions.

Image Processing at RAW Level

It is more elegant to edit images at the RAW level; the way Nikon does it with the Capture Editor. All editing steps are saved to a configuration file and can be undone completely or individually. There is no need for an additional work-in-progress copy. There is also no risk of losing image information by editing. However, editing at RAW level can not yet offer all of the powerful functions available in Photoshop. Functions such as layers, retouching, or filters are supported. Hence, RAW editors are well suited for creative image editing.

Although Photoshop does have functions similar to adjustment layers, image handling with Photoshop cannot compete with NEF. For each correction (for example: levels, curves, or color balance) a new layer must be created, and seemingly simple operations like reversible cropping are not possible.

RAW: The Best Format for a Digital Negative

If you are not sure what format to use for a digital negative, scan in RAW. It can always be converted to another file format, but not the other way around. Be sure to keep the required converters together with your RAW files. Without converters, RAW files cannot be opened. The type of RAW file produced depends on the combination of scanner and scanner software used. Not all scanner programs support saving in RAW format and editing RAW files.

Color Depth in Image File Formats

An important criterion when choosing an image file format is the supported color depth. This determines the number of possible colors for each pixel (expressed in n bits). More bits mean more colors, but also increased storage requirements. The number of colors that can be displayed for a given color depth equals $2^{\text{color depth in bit}}$.

1-Bit Color Depth

With a color depth of 1 bit the computer has only a single bit for each pixel available, which translates to only two colors (i.e., black and white). This makes sense for text and line art only.

8-Bit Grayscale

This is a common standard for many file formats. Each pixel can have one out of $2^8 = 256$ levels.

8-Bit in RGB Color space = 24-Bit Total

With a color depth of 1 byte, the computer gets 8 bits per color channel of each pixel. There are three color channels, one for each of the primary colors: red, green, and blue. Thus, the number of displayable colors is $2^8 \times 2^8 \times 2^8 = 2^{24} = 16,777,472$ colors. Although each color channel has only 256 colors, the combination of the three channels makes over 16 million colors. It would be more correct to call it a 24-bit color depth or 8 bits/channel, but it is often called 8-bit, which can be confusing.

The color depth of an image file is not permanently fixed and can be changed in the editor. This can easily lead to loss in image quality. Typical image editors work with either 8-bit or 16-bit color depth.

Maximum Color Depth for Maximum Flexibility in Editing

Images should be scanned in the highest available color depth. Only then will all the image information that was captured by the scanner into the image file be available to be used for further processing.

Two displayable colors: there is only black and white.

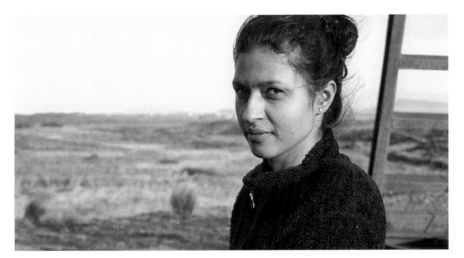

Sixteen colors: the colors appear unnatural and subtle tones are missing.

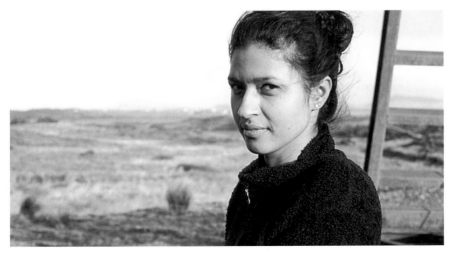

16.7 million colors: the 8-bit color depth of the RGB color space delivers natural color gradations.

Important Image File Formats in the World of Scanning

JPEG – Compact, but Lossy

The JPEG format uses a lossy compression. This process reduces the RAW data from the scanner to a fraction of its original size. When opened, the file is decompressed and the image expands in RAM. The small file size has many advantages: more files fit on a data carrier, and files can be easily sent over the Internet. Furthermore, JPEG is a popular standard and is supported by practically all image viewers and editors. But, it has one major flaw: with compression, much of the image quality gets lost permanently. The degradation depends on the chosen compression ratio. The smallest file size requires the highest compression, which in turn causes the greatest loss of detail.

A JPEG file in digital photography could be compared to a print from the lab in analog photography. The quality of the result depends on many factors, most of which are out of your control. There are few possibilities to enhance the image afterwards; you have to accept it the way it is. JPEG is poorly suited for processing in an image editor. If your goal is high image quality, JPEG should be used only at the very end of the image editing chain.

JPEG only supports 8 bits per color channel, which is perfectly acceptable for the intended purpose of this format. However, as a file format for scans, JPEG is not ideal. It is fine for simple, quick scans; but if you want to post-process your images, you will quickly run into limitations using JPEG.

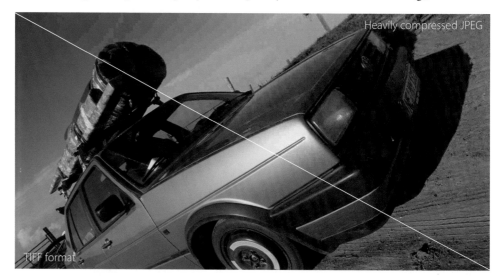

In a direct comparison with a TIFF image, the blocking artifacts of a heavy JPEG compression become clear. Here the sky shows banding due to JPEG.

JPEG 2000 – Lossless Compression

Compared to TIFF or NEF, JPEG achieves very good compression rates, but at the cost of detail and image quality. It has been more than fifteen years since JPEG was invented, and its successor, JPEG 2000, is waiting in the wings to replace it. JPEG 2000 allows high compression rates with less degradation than with JPEG, and it even offers a lossless compression option. You can choose between lossy and lossless compression. It mostly avoids loss of sharpness and some JPEG compression artifacts. While JPEG is not at all suitable as a digital negative, JPEG 2000 is basically acceptable. However, it is too early to recommend this new format since too few programs support it at present.

TIFF – Lossless Compression

TIFF is a general file format that accommodates many internal formats, several different compression methods, and different color depths – ranging from 1-bit to 32-bit. 16-bit TIFF files from the scanner contain the maximum image information the scanner can produce. Since many scanners produce RAW data with 12-bit or 14-bit color depth, storage space is not fully utilized with a 16-bit TIFF file. A 12-bit scan must be saved as a 16-bit TIFF file. A corresponding RAW file would be more compact and use fewer system resources during editing and storage.

Most image editors support TIFF, but not always all of its many versions. In the analog world, a TIFF file would be comparable to a slide: with proper exposure the ideal (analog) result is obtained. Carried over to the scanner world, exposure would correspond to the setting of the scanner software and the converter. Initially the scanner always generates RAW data. Afterwards, the data are converted to TIFF, which is a potential source for errors. For example, if you have selected excessive sharpening for the scan, it will be almost impossible to fix it in TIFF. At RAW level with NEF this would be no problem, but after converting to TIFF you have lost the ability to correct the sharpening features.

Lossless compression of TIFF files is achieved in some image editors with Run Length Encoding (RLE), ZIP, or Lempel Ziv Welch algorithm (LZW) compression. Photoshop also offers JPEG-compressed TIFF, but a few scanning programs do not support it. For scanning, only the uncompressed 8-bit and 16-bit versions are of interest.

Difference between RAW and TIFF

The scanner generates TIFF files in a lossless conversion from RAW data. Therefore, it is a first-class file format. The difference between TIFF and RAW is that all the image corrections from the scanner program and converter are permanently applied to the TIFF file; the unmodified data from the scanner is only available with RAW.

CMYK-TIFF

CMYK-TIFF is different from the previously described RGB-TIFF format in its use of the CMYK color space – each pixel is described with four color values (Cyan, Magenta, Yellow, and black (Key)). Storage requirements for this format increase accordingly. This mode is needed only for prepress, and conversion from RGB to CMYK should only occur at the end of the job. There is no simple way to reverse this conversion from RGB to CMYK without loss, so the RGB original should always be kept.

BMP (Windows) and PICT (Macintosh)

The BMP format is only relevant for Windows. The Mac counterpart is PICT. Both formats support neither 16-bit color depth nor color profiles. Therefore, they play no role in high-end image processing and should not be used for scanning.

RAW: Proprietary Image File Formats

RAW files are the internal data formats of particular scanners. They are not standardized – each manufacturer has its own format. Adobe's push to establish a standard with the DNG format has not had any overwhelming success – at least not with scanners. Neither Nikon, VueScan, nor SilverFast RAW files can be opened with Camera RAW and converted to the DNG format. During scanning, the exact format of the RAW file will be determined by the combination of scanner and scanning software. RAW files from VueScan cannot be processed with Nikon Scan, and vice versa. Also, SilverFast HDR is not compatible with the other formats. Note: SilverFast HDR has nothing to do with what Adobe means by "HDR".

In order to display and edit RAW files in conventional editors, the files must first be converted. The converter is the interface between RAW file and image editor.

Conversion is another source of potential degradation, since there are quality differences between converters. It is best to back up unconverted RAW files. Conversion normally works only in one direction. Photoshop CS can automatically convert a RAW file from a Nikon scanner and edit the opened file. Now the program is working not with the RAW file, but with a converted copy. Photoshop cannot save the edited image as a Nikon RAW file; it has to use alternatives such as TIFF. True RAW editors such as Nikon Capture Editor work differently; here both editing and saving are performed at RAW level.

Meanwhile, there are RAW converters that have "write access" to RAW files, but only for camera RAW files. I don't know of any converter that can do that with scanner RAW files. This is a problem in that all RAW formats are proprietary and most applications need a suitable converter to open them. If

you have a scanner and several different digital cameras you will probably have to deal with at least three different RAW formats and the corresponding converters. You can avoid this problem if you work with JPEG or TIFF.

NEF – Nikon's RAW Format

NEF is a proprietary RAW format developed by Nikon. This format is a bit ambiguous. Files with the ending .nef can belong to one of four different categories. Nikon has created a seamless workflow for NEF files with its own programs Nikon Scan, Nikon View, and Nikon Capture Editor. The following chart shows the substantial differences in file size between uncompressed NEF/TIFF files and highly compressed JPEG files.

File Sizes of 35mm Scan @ 4000 dpi (Resolution 5292 × 3509 Pixel)	
JPEG-RGB	
Highest compression	626 KB
High compression	1,385 KB
Best compromise	2,269 KB
High quality	4,664 KB
Maximum quality	20,111 KB
TIFF-RGB	
16 Bit	111,159 KB
8 Bit	55,728 KB
NEF-RGB	
8 Bit	56,365 KB
12 Bit	84,548 KB
16 Bit	112,730 KB

VueScan RAW Files

VueScan is another program that can save in RAW format. Unlike Nikon, VueScan did not create a new RAW format, but rather uses special TIFF files. To use this format, you have to select the output option RAW file. These RAW files can only be properly displayed and edited with VueScan. The scanning program also works as a RAW editor. Unlike data in the Nikon NEF format, these are true scanner RAW data; no image corrections are applied to the file. This allows you to perform dust and scratch removal after scanning.

SilverFast RAW Files

SilverFast's own HDR files are also special TIFF files. Although HDR files are similar to the VueScan RAW files, the two formats are not compatible. HDR files generated by the scanner software SilverFast Ai are best edited in SilverFast HDR. SilverFast RAW is less consistent than VueScan, because ICE is applied to the data. All other corrections can still be done afterwards.

RAW Files in Detail: Nikon's NEF Format

NEF I: Original NEF

Uncompressed NEF files, which are created by digital cameras, are called Original NEF files. They can vary from camera to camera.

NEF II: Compressed NEF

NEF II refers to compressed NEF files from Nikon digital cameras. The afore-mentioned Original NEF offers maximum image quality. Unfortunately, these files are big and quickly fill up expensive memory cards. Also the writing cycles in the camera are relatively long, which can slow down continuous shooting. Good cameras can continuously shoot in the much smaller JPEG format without interruption, until the memory card is full. When shooting NEF, the buffer fills up quickly and the shooting has to pause. Nikon has addressed this problem with the Compressed NEF format. The files are about half the size of the Original NEF files, and according to Nikon there is no visible difference between them and Original NEF. But, it is obviously not an entirely lossless compression. So far only a few camera models can generate Compressed NEF files. This format is not relevant for scanning.

NEF III: Scanned NEF

NEF III are RAW data files generated by a Nikon scanner and saved with the program Nikon Scan. The software lets you select a color depth of 8-, 12-, 14- or 16-bit. Scanned NEF is a lossless format. With Nikon Scan several types of changes can be made to the Scanned NEF after the scan, such as the settings for brightness and contrast. Using this format affords image editing at RAW level with all its advantages.

Nikon Scan 4 can edit any type of file it has generated. However, post-processing Scanned NEF files with Nikon View or Nikon Capture Editor will change the files irreversibly.

Scanned NEF: Post-Processing Can Cause Crash

This example demonstrates a reproducible way to crash your scanner software: Take a scanned image in Scanned NEF format and rotate it with the editor, which comes with the free Nikon View (not to be confused with Nikon Capture Editor, which you have to buy). Save the image. Now any attempt to open this file in Nikon Scan will crash the program; you can only open it with Nikon View, Nikon Editor, or Nikon Capture Editor.

Apart from this minor nuisance, the NEF format comes closest to the ideal of a digital negative among all the formats introduced here. For an analogy in the world of analog photography, it is like a color negative which you can develop in your own lab. You have control over all key parameters and still can tweak it to a certain degree afterwards. This is the advantage NEF has over TIFF. Strictly speaking, Scanned NEF files are not real RAW files; image corrections like Digital ICE, ROC, GEM, and DEE are applied to the data during scanning. If you want to change any of the settings, you'll have to rescan. In a true RAW file, all corrections are still possible afterwards without having to rescan. Unlike with VueScan, where you always have to create an additional image file from the RAW files first, you can open, edit, and save NEF files directly. Therefore, with NEF a single file is in many cases sufficient; image and negative are one. Changes are saved in configuration files in addition to the image data and thus can be reversed if necessary.

NEF IV: Converted NEF

Existing JPEG or TIFF files can still be converted to a NEF file. All advantages of editing at RAW level are available, but you will not get real RAW data. Still, Converted NEF is a good way to protect files against accidental changes.

Consider the following example: you scan a slide as TIFF, whereby the scanner extracts the image information from the slide in RAW form. This RAW data gets converted, which means the converter's changes and manual changes – if any – will be firmly applied to the TIFF file. This TIFF can be turned into a Converted NEF. This Converted NEF file does not contain the original RAW data, but merely the image information of the TIFF file. The original RAW data was lost in the first conversion.

Scanned NEF and Grayscale

Nikon Scan offers the choice of scanning in RGB or grayscale mode. Grayscale saves storage space, which makes it an obvious choice for scanning black and white negatives. Black and white negatives can always be scanned in color, but then the images contain the color-cast of the original. Neither Nikon View nor Nikon Capture Editor can open the grayscale scans since they do not support this color space. Editing at RAW level is only possible with Nikon Scan.

Consequently, image editors that use the NEF plug-ins packaged with Nikon View also cannot open these files. Alternatively, you can scan black and white negatives as RGB-NEF. Doing this uses up three times as much space, but it enables all possibilities of NEF processing. Any color-cast can be removed by adjusting the chromaticity in the LCH-Editor of Nikon Scan, or in Photo Effects of Nikon Capture.

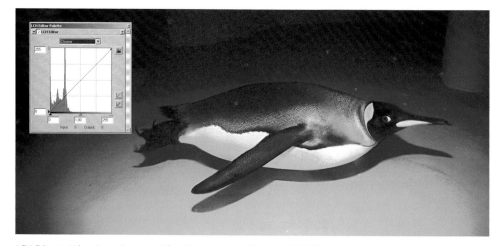

LCH-Editor in Nikon Scan: the unmodified Chroma curve of the initial RGB file.

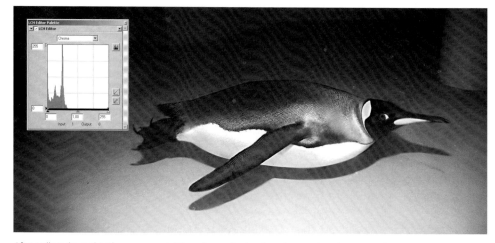

After pulling down the Chroma curve in Nikon Scan all colors have been reduced to grayscale.

The Right Image Size and Resolution

Scanning film is normally done at the maximum optical resolution of the scanner. Even a scanner with 2900 dpi can produce 4100 × 2700 pixels from a 35mm negative. At 48 MB, the resulting file in NEF format is rather unwieldy and too large for many uses, such as sending it by email. The resolution should not be changed in the scan file (your digital negative), but for certain purposes it is unavoidable to have copies with lower resolutions.

Absolute Resolution, Relative Resolution, and Output Size

For printing, the image resolution is expressed in dpi. A resolution of 100 dpi means that 1 inch of paper width will depict 100 picture elements. This is a relative resolution, since the number of pixels relates to the physical print size. It can be changed at will without quality loss (just make sure to uncheck the option "Resample Image" in Photoshop, which by default is on). More important is the absolute resolution, which is expressed in pixels. For instance, reducing the absolute resolution will result in loss of detail and should never be done in the digital negative. The absolute resolution of a desktop wallpaper would be 1024 × 768 pixels. From the absolute resolution and the relative resolution the output size in inches can be calculated. Most viewers and editors calculate this automatically for you. In Adobe Photoshop you can define each parameter separately, and the program will adjust the other parameters accordingly.

What's the Ideal Resolution for Printing?

Let's say you want to make a 5" × 7" print at 300 dpi. What image size in pixels do you need for the image file? You simply multiply the size in inches with the print resolution in dpi and you will get 1500 × 2100 pixels. (Note that 300 dpi is the best relative resolution for printing.)

The output size of an image depends on the resolution of the output device. In our case the output devices are monitors, home printers, or the photo lab printer. To stay with the example of desktop wallpaper: if you display it on a 17" and a 19" LCD monitor, and both are set to a resolution of 1024 × 768, then you'll get one image displayed with a 17" diagonal and the other with a 19" diagonal. As we can see, the output size depends on the output device, or rather on its relative resolution.

Depending on the chosen output device, the image requires different minimum relative resolutions in order to look sharp. Magazines, books, and prints from the lab use a print resolution of 300 dpi; inkjet printers use 200–300 dpi. Considerably lower values will result in soft images.

Film Scanner Resolution and Maximum Print Size

Once you have bought a scanner, you'll want to make prints from the image files either with your own printer or with the help of a service provider. You'll want to know how far you can push the quality of your scanner. The size of the scanned file (in pixels) depends on the optical resolution of the scanner (in spi, or as is more commonly used, in dpi). From that you can calculate the maximum print size in inches. It is no problem to down-sample a large file, but the other way around it is not possible without quality loss. Therefore, scanning is the key process that determines the quality of the image that can be achieved.

Here is an actual example in three simple steps:

▶ First consider the negative size. The nominal negative size of 24mm × 36mm is often a little smaller than 24mm × 36mm. For a Nikon F801s it is 35.95mm × 23.61mm. And to be on the safe side, it needs to be cropped a little to avoid black borders, since the scan preview is not completely accurate. Let's say we have now only 35.7mm × 23mm for scanning, which is 1.4055" × 0.9055" (1" = 25.4mm).

▶ Next take the optical resolution of a Coolscan IV with 2900 dpi and multiply this by the cropped film size: this gives an image size of 4075 × 2627 pixels.

▶ To get the print size, divide this image size by the intended print resolution of, say 300 dpi (which has become the established print resolution for magazines and labs). This gives a print size of around 13½" × 8¾".

Improve Image Quality by Discarding Pixels

Here is a simple trick to improve image quality: set the scan resolution to the optical resolution, e.g., 4000 dpi, and the scale to 50 percent (= 2000 dpi). This effect cannot be reproduced afterwards in an image editor; it has to be done during scanning. If you want to improve the optical resolution of the image, this method will not help; you will have to resort to the more time-consuming multi-sampling mode.

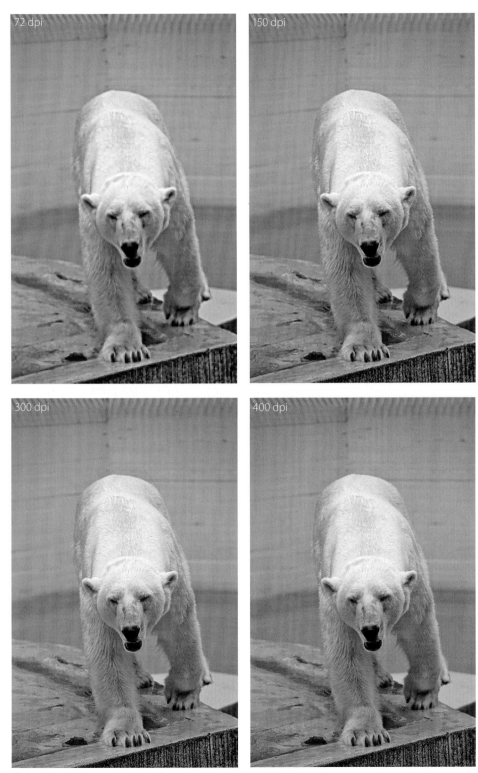

The same image, but printed at different resolutions:

From 300 dpi upwards the image looks sharp. It is not necessary to use even higher resolutions for printing.

Crops Need High-Resolution Scanners

Even if you are not printing posters, you'll need a high resolution scanner. In case you want to enlarge tight crops, scanners with 4000 dpi or even 5400 dpi quickly reach their limits. Keep in mind that you'll also need high grade negatives or slides.

With a 4,000 dpi scanner you can print as large as 12.6" × 18.9" at 300 dpi. A 5400 dpi scanner lets you print up to 17" × 25.5" at 300 dpi. In practical use, an upgrade from a 2900 dpi film scanner to a 4000 dpi film scanner makes a big difference for large size printing – provided the scanners are otherwise comparable and the film stock is of very good quality. Much higher resolutions, such as 7200 dpi, make no sense since the film material cannot match that resolution.

Resolution of Scanned Image		Print Resolution	Print Size	Standard Lab Print
Size in Pixel	Equivalent Megapixel of Digicam			
1,606 × 2,409	3.9 MP	300 dpi	5.35" × 8"	5" × 7"
		150 dpi	10.7" × 16"	
1,701 × 2,551	4.3 MP	300 dpi	5.67" × 8.5"	5" × 7"
		150 dpi	11.34" × 17"	
2,740 × 4,110	11.3 MP	300 dpi	9.13" × 13.7"	
		150 dpi	18.26" × 27.4"	
3,024 × 4,535	13.7 MP	300 dpi	10.08" × 15.12"	
		150 dpi	20.16" × 30.24"	20" × 30"
3,402 × 5,102	17.4 MP	300 dpi	11.34" × 17"	
		150 dpi	22.68" × 34"	20" × 36"
3,780 × 5,669	21.4 MP	300 dpi	12.6" × 18.9"	16" × 20"
		150 dpi	25.2" × 37.8"	20" × 36"
5,102 × 7,654	39.1 MP	300 dpi	17" × 25.5"	18 × 24"
		150 dpi	34" × 51"	
6,803 × 10,205	69.4 MP	300 dpi	22.68" × 34"	24" × 36"
		150 dpi	45.35" × 68"	

Color Management in Theory and Practice

An image passes through various devices on its way to final output.
First the scanner reads the film into the scanner program.
Then the scan is viewed on the monitor, processed in the image editor,
and finally outputted on the printer. Each of these devices represents
colors differently and has a different color gamut. Unintended color
shifts are unavoidable without color management. This chapter explains
what it takes to maintain consistent colors throughout the workflow.

4

Content

Why Color Management?

A basic problem of digital image processing is that there is no absolute color definition across the entire workflow. In an ideal world, it would be possible to scan the color of the original accurately, display the scan on the monitor, and print it in true colors. Unfortunately, the current workflow cannot do that. The various links in the chain of digital processes represent colors in very different ways. This can give your image a color-cast if you edit the image on an uncalibrated monitor and accidentally make modifications for what only seems to be a color-cast.

Such problems can be avoided only with a solid color management system. Therefore, some basic knowledge of color models and color spaces is useful even for the photo enthusiast; for professionals, it is a must. This chapter will explore the topic of color management from the viewpoint of scanning film. Some theory will be introduced to help better understand the topic.

The goal of the color management process is to interpret and reproduce colors consistently in every step of the digital workflow. An entirely correct representation of colors is not possible, since each device creates colors differently and therefore the color gamut of the devices used can visibly differ. It is a further goal of color management systems to adjust the gamut as closely as possible.

Basics

The Relative Definition of Colors

In an 8-bit RGB image file, each pixel is described with the three basic colors; red, green, and blue, with 8 data bits for each. This allows for $2^8 = 256$ different colors for each pixel. Thus, a red pixel can have 256 levels of red. A numerical value of 0 describes a complete absence of red, whereas the value 255 describes the fullest red that can be displayed.

At this point a problem is already encountered with relative color definition: given two monitors, it is very unlikely that both will display the color red exactly the same way. For printing, it will be even more complicated. Take a look for yourself: take Photoshop and generate a uniform red area with the color values of red 255, green 0, and blue 0. Compare this area with the printed example on the opposite page. Due to the printing and the CMYK color separation, you will notice an obvious color difference, even though these patches have been generated with the exact numbers stated above in RGB mode.

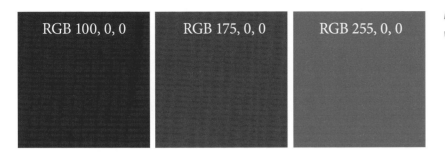

RGB 100, 0, 0 RGB 175, 0, 0 RGB 255, 0, 0

In RGB mode, the red tones are defined with explicit color values.

Gamut

The range of colors that a particular device can reproduce is called its "gamut" or "color space." Theoretically, you can compare the color gamut of your scanner, monitor, and printer, and from the intersection generate a new color space in which each device would be able to represent every color. However, doing this would greatly underutilize the capabilities of each device.

In the example mentioned above with the film scanner, monitor, and printer, the monitor displays fewer colors than the scanner can record. There are also some print colors that the monitor cannot display; but the monitor can also display many colors that the printer cannot handle. Using the smallest common color space would eliminate colors that could be scanned as well as printed.

This is the reason that a device-independent color space is used as an interface between devices. However, at the various stages of the workflow, this color space has to be transformed several times. ICC profiles are used to keep the color representation consistent despite the transformations.

Gamma

Gamma controls the ratio of input to output signal in a display system (for example, a monitor). In the Windows world, a gamma of 2.2 has become standard; for Mac, it is 1.8. The gamma value controls how the mid-tones of an image file are displayed. The perceived brightness of a monitor depends on this value. For scanning you should use the standard gamma value of the operating system, which will be used later for editing and displaying the images.

Scanning, Viewing, Editing, and Printing

For a typical workflow, the first step is to scan the original with a film scanner. The resulting image file will be examined on a monitor. The monitor is the graphical interface to you, the operator. Based on the monitor image, you decide what corrections are needed. Once you are happy with the result, you can save the file with the changes, and optionally print it. Usually the colors in the print will not be identical to the colors on the monitor. This discrepancy is due to the different color models used by the various devices in the digital

workflow. The monitor works with the RGB color model, whereas the printer works with the CMYK color model. Inevitably, these differences cause color deviations. Unfortunately, even with color management these differences cannot be completely eliminated. After all, the monitor can display colors that the printer cannot generate, and vice versa. What color management can do, however, is match most colors, maintain a consistent color representation, and create at least a very good facsimile of the image.

Color Models

Color models are used to describe and classify colors. Color models also describe the method of generating colors. This method defines the palette of colors as a combination of a few primary colors. The RGB color model, for instance, generates all possible colors as combinations of the primary colors red, green, and blue. When all three color components take on maximum value, the result is the color white.

With color models, it is not necessary to have a separate ink for every printable color tone. Actually, it would be impossible to provide a separate ink for every conceivable color tone. Instead, the entire color spectrum is covered by mixing a few basic colors. In this way, in combination with the basic color of the medium, all colors can be generated. For a monitor, the basic color is black; for printing, it is the white paper.

Additive Color Model RGB

In the RGB color model, all colors are created from different amounts of the primary colors red, green, and blue. This model is called an "additive" color

RGB: The three basic colors add up to white.

system. When all three colors are at their maximum, they produce white. Black is created by setting all three color components to zero; it is the absence of any light. Monitors and film scanners work with the RGB color model. A monitor that is turned off is therefore always black.

For printing image files, the RGB color model has to be converted to CYMK. For professional printing, this happens in prepress. For printing on your home computer, this is taken care of by the printer driver. That means manual conversion to CYMK can usually be omitted. In fact, manual conversion should be avoided, since important image information is lost that can be important for further processing. You should not convert images from RGB to CMYK without a good reason to do so.

Subtractive Color Model CMY(K)

The CMY color model consists of the three primary colors cyan, magenta, and yellow. It is a "subtractive" color model. The sum of these three colors yields black. If all color values are zero, no ink will be printed and the result will be white – assuming the printing paper is white. The problem with the CMY color model is that a proper black can be obtained only from absolutely pure primary colors; cyan, magenta, and yellow. Even though three expensive layers of ink are put down, one usually gets only a dirty black-brown instead of pure black. It is considerably less expensive and better to add black as a spot color to the primary colors. This combination is called the CMYK color model (the "K" stands for "Key"). In this fashion, a single layer of ink can generate a deep black.

In the CMY(K) color model the sum of the three primary colors is black.

Lab

The Lab color space contains all colors that can be seen by the human eye. The three values L, a, and b define the color in a precise way. "L" stands for luminance, "a" stands for the red-green component, and "b" stands for the blue-yellow component – which is not very intuitive for most people. The color spectrum of the Lab model contains all colors of the RGB and the CMYK color spaces. Lab can therefore define colors precisely.

The Lab color model exactly defines colors mathematically.

Unlike RGB and CMYK, the Lab color space is device-independent. However, it has to be converted first to either RGB or CMYK in order to be displayed or printed on any device. Without an output device such as a monitor or a printer, the user cannot do much with abstract color information. One practical use of the Lab color model is for describing color deviations precisely; for example, when calibrating devices. Also, the Lab color space is used as a transfer color space for converting images from one color space to the other. In that case, image files are first converted from the original color space to Lab, then from there to the target color space.

Color spaces

No device can display all colors visible to the human eye. That is why there are color spaces; they represent a limited section of a color model. For example, the sRGB color space is just a subset of the RGB color model.

A color model can cover several color spaces. Therefore, there is not just one color space, but several color spaces per color model, each of which has its specific purpose. You should choose a color space just large enough to fit within the color space of the device. If the color space substantially exceeds the color range of the device, the bit values for non-displayable colors will be wasted. This means that you will give up intermediate tones in the range that can actually be reproduced.

Considerations for Selecting a Color space

You can choose among many color spaces. However, there is no ideal solution; it will always be a compromise. Color spaces differ in the color gamut they can reproduce: the larger the color space, the larger the number of displayable colors and the more flexibility for editing. However, not all devices have a large gamut. Therefore, before output, images have to be adjusted to the gamut of the output device. If you use a color space with a smaller gamut, such as sRGB (optimized for monitors), you will not have this problem. The colors can be reproduced on most output devices without problems, and the colors appear more vivid. You pay for the adjustment, however, by giving up some colors.

sRGB, Adobe RGB, etc.: Color spaces for Gamma 2.2

The sRGB color space is the general standard color space for display monitors on Windows PCs. It does not describe the gamut of a particular monitor, but rather an average for most monitors. Originally, it was intended as the standard color space for the Internet.

At first sight, it looks like an ideal solution for digital image processing, but there are disadvantages: the scanned original can contain colors that are not included in the sRGB color space. If these colors are within the gamut of the scanner and the printer, then using the sRGB color space will waste them just because they cannot be displayed on an average monitor. sRGB is ideal for users who do not do post-processing and who only display their images on a monitor. The disadvantage of sRGB is its small gamut. In comparison to other color spaces, this can have a negative effect for printing.

The following are just a few of many other color spaces in the RGB color model:

- sRGB
- Bruce RGB
- NTSC (1953)
- Adobe RGB (1998)
- CIE RGB
- Wide Gamut RGB
- Wide Gamut RGB (compensated)

The above color spaces are listed in order of progressively larger gamut: sRGB has the smallest and Wide Gamut RGB (compensated) the largest. Apart from sRGB, Adobe RGB is also very widely used by photographers. It has a distinctly larger gamut than sRGB and offers more possibilities for editing and printing.

Apple RGB, etc.: Color Spaces for Gamma 1.8

In the Apple world, everything is a little different from the Windows world. This also applies to color spaces. Apple color spaces use a standard gamma of 1.8. Following is a list sorted by gamut:

- Apple RGB
- Color Match RGB (Gamma 2.2)
- Apple RGB (compensated) (Gamma 2.2)

Apple RGB has the smallest gamut and Apple RGB (compensated) has the largest gamut.

Conversion between Color Spaces

Since every device has a different color space, the color space has to be converted several times in the workflow. The RGB color information generated in a scan depends on the gamut of the scanner. This device-dependent color space should be converted to a standardized working color space, such as sRGB. The working color space is used for editing the image, provided that the image editor is configured accordingly. In order to print the image, another conversion to CMYK is needed. On a home computer, the printer driver takes care of this conversion without any user intervention. In every case, there will be several conversions between color spaces in the course of the workflow. The conversions go from device-specific to device-independent, and vice versa. By using color management systems with ICC profiles, the results of the conversions will not be arbitrary, but can be controlled.

The color management module of the color management system converts the color spaces and provides consistent colors among different devices.

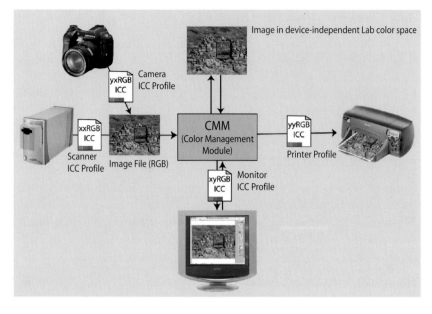

ICC Profiles

Purpose of ICC Profiles

The International Color Consortium (ICC) has worked on the problem of how to transform images between different color spaces with the least possible quality loss. The result is an industry-wide standard based on so-called "ICC profiles." As already mentioned, these profiles control the transformations between color spaces. There are three different types of profiles:

▸ Input profiles
▸ Output profiles
▸ Display profiles

Input profiles transform the scanned color information – which at this point still depends on the scanner – into a device-independent color space. The transformation does not require ICC profiles; these are optional. ICC profiles are used to compensate for device-specific deviations. The measured deviations from standard values can be ironed out with the help of ICC profiles. Devices are calibrated to standard values. With calibration, one can ensure that a particular color value will be recognized by the device as such.

Definition of Calibration and Profiling

The terms "calibration" and "profiling" always come up in discussions about color management. Often they are used synonymously, although they are actually two different processes. For scanning, calibration means simply measuring the deviations against a certain standard. Usually an IT8 calibration target is used to accomplish that.

Knowing that the scanner has some color deviations does not do much good by itself, but the data obtained by the calibration process can be used to profile the device. With a device profile, any deviations between measured values and standard values can be corrected. For scanners, ICC profiles are used. Since in common usage the terms "calibration" and "profiling" are not clearly separated, I will use them interchangeably in this book.

Input Profiles

Input profiles are used for input devices, such as scanners. A scanner input profile enables color values extracted from the scanner to be translated to device-independent CIE Lab color values. The scanner is usually delivered with some color shifts due to normal production tolerances. Generally, it is not possible to scan the film with a high level of color accuracy. The scanner will recognize red as red, but it is rather unlikely that a precisely defined standard value will be recognized as exactly that value. In practice, small errors are unavoidable.

To get exact readings of the deviations, one can scan a so-called IT8 target, which is a tightly controlled color chart on either transparent or reflective stock. The image data from the scan can then be compared with the reference file supplied with the target. Most likely there will be some deviations, and these will be captured in the ICC profile. If a scanning program that supports ICC profiles is used, these deviations will be automatically corrected. True-color scanning requires individual profiling of the scanner.

Output Profiles

Output profiles for the output device are the counterparts of input profiles for the scanner. Output profiles enable colors from a device-independent color space to be translated to the color space of an output device, such as a particular printer.

Apart from the printer itself, the key factors for the color characteristic of a print are the ink and paper consumables used as well as the settings in the printer driver for print resolution and other parameters. An ICC profile for a printer is valid for only that specific combination of parameters. For profiling, a reference file is printed – a printer target – and the printed colors are measured with a spectrophotometer. The ICC printer profile is calculated from the differences between the nominal values of the file and the measured values from the print.

This profile adjusts the differences encountered when an image file from the device-independent color space is converted to the device-specific color space. Without an ICC printer profile, accurate colors cannot be printed.

Display Profiles

During editing, the monitor is the output device. To be displayed on the monitor, the color information of the image file has to be translated to the device-specific color space. The monitor gives important feedback to the user during editing and can even act as an input device when coupled with a touch screen. The image can be checked and modified, and then the result saved. After editing, the device-dependent color space has to be transformed back into a device-independent color space. For this reason, display profiles are also called "internal profiles".

Color Management Modules in Operating System and Application

Microsoft and Apple have each integrated a color management module into their operating systems. Microsoft calls it *ICM*; Apple calls it *ColorSync*. The role of this module is to link the device profiles. Integrating the module into the operating system allows for speedier processing of processor-intensive conversions.

Applications can also use their own color management module. The Adobe Color Engine (ACE) is one example of a module tailored specifically to Adobe applications. Other applications normally use the resident operating system's module.

Download ICC Profiles or DIY?

Many manufacturers supply ICC profiles for download or include them on the CD packaged with the device. So, do you actually have to create your own ICC profile? After all, it takes time and money to do so. The advantage of using the manufacturer's ICC profile is obvious: you simply download and install it. However, the quality of these profiles varies quite a bit.

Devices change their color characteristics as they get older. For that reason, you should refresh your self-made profiles regularly. Apart from aging, there are also manufacturing tolerances that the manufacturer's profiles cannot cover. A manufacturer's ICC profile is better than no profile at all, but you will only get optimum color accuracy with an individually-generated profile, which must be regularly updated.

Monitor Calibration in Practice

Software Calibration vs. Hardware Calibration

Without a calibrated monitor, image editing is rather difficult or almost impossible. It is difficult to judge whether you are trying to correct a flaw in the image file or whether you are being misled by an erroneous display on the monitor. There are various hardware and software tools for monitor calibration. Hardware-based tools consist of a measuring device and special software. In the case of software tools, the human eye serves as the measuring device.

Truly accurate results are only possible with a hardware tool. Such a tool measures screen colors, compares them with nominal values, and calculates the ICC profile from the differences. For consistent quality, calibration and profiling should be repeated monthly.

Software solutions rely on your eye. Software calibration methods are far less accurate than hardware calibration methods, since the color adaptation of eye and brain depends on the ambient lighting conditions. Color and contrast adjustments are done directly on the monitor's controls without generating the ICC profile. If you do not want to spend money for a hardware-based calibration tool, with software you can at least improve some settings.

Monitor Calibration via Software

DQ Tool is a good (and free) software tool for monitor calibration, but it is only available in German. QuickGamma is another freeware application that is available, but it is very basic and does not really adjust colors, only their gamma. DisplayMate is more sophisticated. This tool costs $69 – it is strong on diagnostics, but weak on calibration.

Monitor Calibration via Hardware with ColorVision Spyder 2

ColorVision offers solutions running under Windows and Mac OS that work for CRT monitors as well as for LCD monitors. They range from the ColorVision Spyder 2express to the more expensive Spyder 2PRO, which comes with additional adjustment options. Each version contains the same colorimeter but uses different software. The colorimeter plugs into a USB socket, which is where it also draws its power. The basic calibration functions are the same for both versions. The software generates test patterns on the screen and the colorimeter takes readings off them. The software then generates the ICC profile based on these measurements. Once this profile is assigned to the display card, the monitor is successfully calibrated.

Image: ColorVision

The Spyder 2 colorimeter can also be used with CRT monitors.

ColorVision provided me with a Spyder 2PRO for testing. The following section refers to the Spyder 2PRO for calibrating a CRT monitor.

The less expensive Spyder 2PRO model from ColorVision offers fewer adjustment options than the tested version.

You should first install the software before plugging the colorimeter into the USB port of your PC, and reset any of the changes you may have made to the display card driver to their default settings. Also, the monitor should be reset to its original factory setting via the on-screen display. To use the colorimeter on CRTs, you need to remove the LCD baffle (see image below). For LCD monitors you leave this baffle on.

For CRT monitors you need to remove the LCD baffle.

Image: ColorVision

Software installation is simple; just make sure the colorimeter is not plugged in when the software is installed. After restarting the computer, you can plug the colorimeter into the USB port and start the software.

Avoiding Software Conflicts

To avoid software conflicts, disable other manufacturers' software for calibrating monitors, such as Adobe Gamma. If you have installed Photoshop, you should disable it in the *Startup* tab of Windows *System Configuration Utility* (run msconfig).

The software offers detailed help for each adjustment. Once you select monitor type, you are prompted for the desired gamma and white point. The default calibration is set for a gamma of 2.2 and a white point with a color temperature of 6500 Kelvin. Spyder 2PRO also offers the possibility to set luminance values freely, although it is not necessary for adjusting the Visual Luminance.

Next, adjust the White Luminance of the monitor. This is done in hardware with the monitor's contrast control, which varies from model to model. In most cases, it is done with the on-screen display of the monitor (consult the monitor's user manual for that). Under no circumstances should you use the display driver to adjust White Luminance, even if there is a provision to do so. The contrast needs to be set so that the four patches of the test image can still be separated.

High-Bright, SuperBright, UltraBright, etc.

Some monitors offer several modes to optimize the display for best results with either text, video, or images. These modes affect the White Luminance. Pick one mode and stay with it when calibrating the monitor.

Next, adjust the Black Luminance with the monitor's brightness control. This is also done via the monitor OSD. The adjustment is perfect if you can barely distinguish between the four patches of the black test image. Now the actual measurements can begin. Place the colorimeter on the screen - the software generates a sequence of test patterns in different colors for the colorimeter to read. The measured values are compared with the nominal color values and an ICC monitor profile is generated. You can name this profile whatever you like. It will be saved as an ICM file under C:\WINDOWS\system32\spool\drivers\color\. You may have to modify that pathname if your installation path for Windows is different.

Selecting ColorVision Monitor Profiles under Windows

You can select the monitor profiles either with the ProfileChooser supplied by ColorVision or directly in Windows. For the latter, right-click on a blank area of the desktop and select Properties > Settings > Advanced > Color Management. It is not really necessary to install the ProfileChooser. In either case, the ICC profiles will be available to all Windows applications.

Limits of Monitor Calibration

Once the monitor is properly calibrated, you can assume that your images will be displayed correctly on the device. The same applies to any other monitors calibrated with the same gamma and color temperature. However, it does not mean that images optimized on your monitor will be printed with identical colors by your inkjet or your photo lab. Monitor calibration affects only the image display on your monitor and helps you produce correct colors and tones only during editing.

Generating ICC Scanner Profiles

To generate an ICC scanner profile, you need a scanner target and appropriate software. For film scanners, the target is a calibrated color slide – an IT8 target. The scanner turns the color chart into a normal scan file. The profiling software compares the scanned color values with the nominal values from a reference file and calculates the profile. Scanning software, which can use ICC profiles, can create scans with high color fidelity.

Scanner Calibration with SilverFast

The full version of SilverFast Ai from LaserSoft Imaging includes an IT8 calibration slide. Generating a profile is conveniently integrated into the software and only takes a few mouse clicks. First, insert the slide into the scanner and generate a preview. Next, draw a selection frame. This must be placed precisely or else the measurements will not be accurate.

Proper positioning of the mask is crucial for accurate IT8 profiling.

If the mask position is off, the program will display a warning. Even a small misalignment can match color patches with the wrong reference values and thereby corrupt the profile. If a measuring field overlaps with more than one color patch, a faulty profile will be generated. Small overlaps may not be noticed automatically by the program. After measurements are compared with reference data, a profile is generated and saved under \WINNT\system32\spool\drivers\color.

Nikon Scan uses built-in scanner profiles. As a result this image has a slight color-cast.

It is better to generate an individual profile with an IT8 target. With VueScan the same image shows no color-cast.

In both cases it still takes some editing for a satisfactory result. Calibration will not save you this step.

Scanning Methods

Scanning is done in several steps. First, a thumbnail index of the filmstrip is generated. From this index a preselection is made. In the next step, previews of the selected images are generated. Then, the preview must be edited to prepare the image for the scan.

This chapter describes these steps in detail. There are hardly any differences among Nikon Scan, VueScan, and SilverFast in the scanning procedure. For best results none of these steps should be skipped; but for high-volume processing, a step might skipped to save time.

Content

Thumbnail Index –
Filmstrip Offset and Presorting

The index scan is the quickest way to get an overview of the inserted filmstrip. The thumbnails on the index are low-resolution and can only give a rough idea of image quality, but they are good enough to presort and to correct any filmstrip offset.

For negatives with normal exposure, there is a pronounced contrast between image and frame gap. For these, automatic image positioning works reliably. However, it is a different story for night shots, where image background and frame gap have almost the same density. In those cases, the frames may have to be manually aligned. Many programs from scanner manufacturers do not provide for manual alignment, but VueScan, SilverFast, and Nikon Scan are all capable.

The most convenient place to rotate or mirror the images is in the thumbnail view, although it is still possible later in the preview or final scan. Rotating in the thumbnail view prevents the possibility of creating reversed images by mistake.

The thumbnail index is only available if there is more than one image in the scanner. This feature simplifies batch processing. VueScan cannot generate thumbnails but goes straight to the preview instead. However, it can save a thumbnail index in parallel with previews and scans. SilverFast can save thumbnails directly, but Nikon Scan cannot.

SilverFast Ai does not let you rotate the thumbnails in the Overview, but Nikon Scan will.

Preview – Corrections before the Scan

Preview (also called prescan in some applications) takes more time than the index scan. The preview for a single image can take longer than the index scan of a whole filmstrip, but you get a much larger preview image as a result. It lets you edit the image far enough to give you the best quality scan afterwards.

The preview is much more suitable for evaluating the image than the tiny thumbnail.

It makes sense to trim the image in the preview window. By default the scanner captures the entire image plus border and frame gap. If you restrict yourself to the actual image area, you will get more compact image files. In addition, in Nikon Scan the black borders interfere with auto exposure. SilverFast and VueScan have an elegant solution for excluding the borders for exposure metering.

Cropping the Image

For scanning, only frame edges should be trimmed. At this stage, the image should not be cropped but rather the entire image information of the original should be preserved.

Later during editing, the image can be cropped for aesthetic improvements. If the image is cropped, it may have to be rescanned later. Images should not be cropped, especially if they are being scanned for archival purposes. It is possible to turn on correction filters like ICE, FARE, ROC, or GEM when generating the prescan and view the effects in the preview window.

If possible you should trim the black borders before the scan.

Image Corrections before the Scan

Image corrections such as ICE, FARE, ROC, or GEM can be applied in the preview so that their effects can be assessed in the preview window. The extent of the corrections depends on the chosen operating mode. The following adjustments must be performed before the scan with all scanning programs, since these corrections cannot be made afterwards in the editor:

▸ Analog gain / exposure time
▸ Focusing (AF or manual)

If images are scanned in TIFF format, all the corrections will be permanently included in the image file. RAW files are more tolerant in that respect, but even there some adjustments are irreversible. For instance, in Nikon Scan the following corrections will be permanently included, even with NEF:

▸ Dust and scratch removal with Digital ICE
▸ Color restoration with ROC
▸ Highlight and shadow recovery with DEE
▸ Grain reduction with GEM

If any of these corrections turns out unsatisfactory, the image will have to be rescanned.

Sorting Your Slides with Loupe and Lightbox

It is much quicker to sort out unsharp slides before you insert them into the scanner. A high-quality 8x magnifier, such as the ones offered by Rodenstock, Schneider, or Pentax, is good for that. If possible, use a lightbox as well. Examine your slides carefully and you will not waste time with unnecessary scans.

Difference between Scanning Program and Image Editor

Certain adjustments are possible with the scanning software, but in most cases they are not useful. Unsharp masking is one example. This should be done only if the resolution of the final image is already fixed. Usually the image resolution is not identical with the scan resolution.

NEF files let you freely change the unsharp masking afterwards.

If you work with Nikon's RAW format NEF, you will not have to commit yourself immediately. Choices are only saved as additional information in the scan file and can be changed later as often as desired. Unlike with TIFF and JPEG files, the configurations are not permanently applied to the image data. Therefore, at RAW level, the risk of degrading the image data with poor adjustments is lower. Don't spend too much time with fine-tuning color and contrast in the scanning software; doing so just disrupts your work rhythm. Only apply essential corrections and use the image editor for optimizing the image.

Scan – Create the Image File

After preparations with index scan and preview are done, the actual scan is comparatively simple. All that is left is to pick a meaningful name for the image file and select the proper file format. I always try to make sure to name the files with numbers that correspond with the filmstrip numbers. This makes it easier to clearly match file and original. In addition to naming your files, you have to choose a file format, which should be either TIFF or RAW format.

At this point you have one last chance to change the color depth. Often, scanning programs are set to a default of 8 bits per color channel. However, you should take advantage of the maximum color depth supported by the scanner's A/D converter, which is usually 12, 14 or even 16 bits. Afterwards, you still can reduce it to a lower bit rate. The scanner software lets you define the final file name. Apart from progressive numbering, you can also define prefixes and suffixes for the file names. If you don't have a perfect numbering scheme, don't waste too much time - with freeware tools such as Lupas Rename, you can quickly and easily rename large numbers of files later.

Single and Batch Scan

Going through index scan, preview, and scan can take several minutes. The most time is spent not on setting up each scan, but on the scanning process itself. Depending on the model, this can be a real test of patience. It is better to prepare several images at once and have the scanner run in batch mode unattended. Only in batch mode can you manage to scan large numbers of slides or negatives.

Some scanners support batch scanning in their basic configuration. For other models, optional adapters are available; some models cannot do batch scanning at all. Typically, the supplied slide holders can batch four to six slides. Even more convenient is scanning directly from slide trays, like the Reflecta DigiDia 4000 (identical to Braun) does.

Nikon 35mm scanners are rather rudimentary in handling mounted slides; in their basic version, they can only scan one at a time – four to six slides cannot be scanned in one go. Only with the expensive slide feeder attachment SF-210 for the model Super Coolscan 5000 ED can you batch scan mounted slides. Competitors such as Minolta and Reflecta offer more user-friendly solutions. For Nikon the least expensive way to batch-scan slides is to leave them uncut in the strip, since the supplied filmstrip adapter SA-21 handles color positives as well.

Minolta DIMAGE 5400: on the left the insertion of a single slide, on the right the supplied slide holder SHM10 for up to four mounted slides, which makes for a rather small batch scan.

Multi-Sampling

To improve image quality, a slide can be scanned multiple times. The scanner software averages multiple readings. Multi-sampling is used to reduce image noise, to get more natural colors, and to achieve smoother color transitions.

Image: Peter Steinhoff, 1977

With a single scan the texture of the film is quite visible.

With multi-sample scanning (16x) the transitions become smoother, but the scanning time is several times longer that that of a single scan.

There is a difference between single-pass multi-sampling and multi-pass multi-sampling. The Super Coolscan 5000ED uses the single-pass method; each line is read multiple times before the scanner advances to the next step. In the multi-pass method, the entire image is first scanned completely and then repeated multiple times. With the multiple passes for a single image the scanning time increases accordingly. The Coolscan IV and V do not support multi-sampling under Nikon Scan. SilverFast and both VueScan models can do multi-sampling, but only in multi-pass mode.

Multi-sampling is used only for squeezing the last bit of quality from an original – it comes in handy, for example, for scanning old slides. It is not needed for working with good quality material. Film grain becomes softer, since multi-sampled scans are usually a bit less sharp than single scans. This effect is more pronounced when GEM is applied.

If the scanner is slightly out of registration in the multi-pass mode, it will cause banding, as shown in this image. The more you down-sample the image, the more obvious the effect will be.

Scanning Correction Filters in Detail

Modern scanners can read the tiniest bit of information on an image. Unfortunately, they also record details we could do without: specks of dust, scratches, film grain, and the color flaws of faded slides and negatives. The first time I saw my slides on a monitor, I was shocked to find how many scratches there were. No matter how carefully you handle it, every piece of film has some minor or major damage. Powerful scratch removal functions in hardware and filters for smoothing film grain and restoring faded colors are standard nowadays. However, there are big differences among the ways Nikon Scan, SilverFast, and VueScan handle these functions. In almost all other manufacturers' scanning programs, image correction filters are poorly implemented.

7

Content

Dust and Scratch Removal in Software

Dust and Scratch Removal in Hardware

Restoring Faded Colors

Grain Equalization

Highlight and Shadow Recovery

Dust and Scratch Removal in Software

After scanning, there is always an opportunity to touch up dust and scratches later in Photoshop. Most image editors can handle these functions, and for Photoshop there are also convenient plug-ins. However, software cannot easily distinguish dust and scratches from other image details. Therefore, the process cannot be automated. In some cases manual retouching makes sense; it gives full control over the extent of correction required to improve image quality. For large numbers of images, however, it is too time-consuming and therefore not practical. Scratch removal in software is used only when hardware-based methods fail.

Scanner Light Sources and Scratches

The scanner's light source plays a major role in highlighting scratches in black and white negatives. The comparatively harsh LED light of Nikon scanners tends to emphasize the scratches. This effect is less pronounced in scanners with soft, diffuse light sources. Using the right scanner model can reduce the need for scratch removal.

SilverFast SRD

The software program SilverFast Ai offers its own scratch removal with SRD. During the scan, it analyzes the entire image and automatically marks the scratches in red. This method is highly recommended for black and white film. For color film, SRD makes sense only for scanners without ICE, which are rarely recommended anyway. SRD is clearly inferior to ICE. The tedious process of manually marking scratches can largely be avoided with the automatic detection feature. The sliders *Detection*, *Defect Size,* and *Intensity* let you configure automatic detection. In the default setting, SRD will not detect the infamous horizontal "telephone wire" scratches on the film surface. For that problem there is an expert mode with settings that increase the detection rate of horizontal or vertical scratches quite a bit. In my tests, I generally got the best results with the correction set stronger. Some detail gets lost, but the annoying scratches are mostly gone. Overall, SRD simplifies scratch removal, but the detection rate could be improved. Even with automatic detection, there is still some need for manual retouching.

A long horizontal scratch and specs of dust spoil the b/w negative.

The horizontal scratch is detected only when options are set properly.

SilverFast iSRD

LaserSoft Imaging has a scratch removal method that uses infrared for detection but still allows for a large degree of manual intervention. Quato has implemented this method in its IntelliScan 5000 (the images printed here are from this scanner). While ICE and Infrared Clean from VueScan offer little control, iSRD can be configured more flexibly. The familiar SRD still exists in parallel and even has a menu in the same window, but the two methods cannot be used simultaneously. Once iSRD is selected, the options for SRD are grayed out, and vice versa. In actual use, this supposedly great masking method quickly shows its limitations. This is because it subdivides the preview image into many small segments. The program takes its time going from one segment to another and many seconds can elapse before the image is ready to be processed. For proper masking, each segment must be inspected; it is quite easy to spend ten minutes on checking just one image alone. Also, the sliders help improve the detection rate of iSRD a little bit, but in my test negative, there were still many scratches that even the highest setting in iSRD missed.

iSRD can be run in automatic mode as well as in the awkward manual mode described above. Using automatic mode helps avoid having to set a lot of troublesome configurations; but overall, this new correction scheme cannot compete with ICE and Infrared Clean. The idea is good, but the execution is poor.

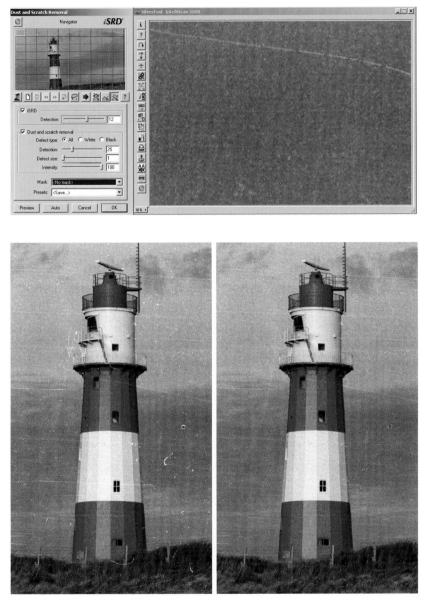

iSRD lets you fine-tune the correction filter with sliders.

The uncorrected image is littered with scratches. *The iSRD scratch removal is not as thorough as ICE.*

Dust and Scratch Removal in Hardware

Digital ICE

Software-based correction is not as powerful and user-friendly as systems built into the scanner hardware, whereby an infrared beam detects dust and scratches to be removed from the image data. Scanner hardware and software have to support the inherent correction method together. For that reason, there is no ICE plug-in for Photoshop. Digital ICE successfully removes dust and scratches in Nikon and Minolta scanners. The process works only with color negatives and color slides. For a Nikon scanner, one of the following must be selected before the scan:

▸ No ICE
▸ ICE normal
▸ ICE fine

ICE is CPU-intensive, so scanning times and processor load increase considerably. Despite that, ICE should always be enabled. One disadvantage of using ICE is some loss of sharpness and detail, especially in ICE fine-mode for removing even the finest scratches. ICE normal-mode is sufficient for most cases; almost all scratches will be eliminated without too much loss of sharpness. The softening of the image is justifiable and is fully recoverable with sharpening.

Not every product that is labeled with ICE also contains the full ICE. There are flatbed scanners from Microtech which offer ICE only for reflective media, but not for film.

Conventional black and white film contains silver crystals, which prevents dust detection via infrared. These films are explicitly not supported by ICE. This does not apply to chromogenic black and white films that can be developed with the C41 process for color negatives. Kodachrome slides are also special; they are based on a different technology (K14) than normal slide film. The standard versions of ICE should be turned off for Kodachrome slides since they degrade image quality. Currently, only Nikon's Super Coolscan 9000 ED comes with Digital ICE professional, which can handle Kodachrome. With a Scanhancer, even regular ICE works for Kodachrome.

The following image is an extreme case. The negative has many scratches, which are particularly deep. The occasional scratches and specks of dust that are present, even in carefully handled film, are completely removed with ICE.

By default, ICE should be set to normal for standard scans. Only in exceptional cases should it be turned off. ICE fine is only rarely useful. It does remove the finest scratches, but the image suffers noticeably. Alternatively, Photoshop may be used to remove any scratches that ICE normal misses. Below are detail views of the scanned image:

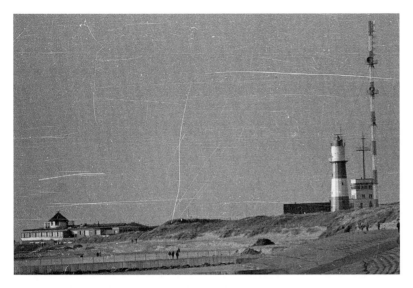

Without ICE: serious scratches ruin the image.

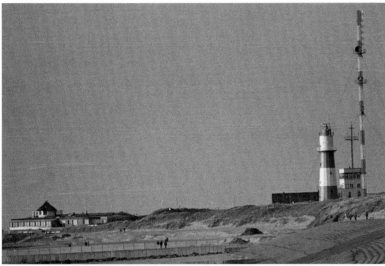

With ICE normal: most scratches are gone.
Unsharp masking can compensate for the slight loss of sharpness from the scratch removal.

ICE fine: Even the finest scratches have been removed, but the image looks soft. Therefore, this type of heavy correction is not recommended.

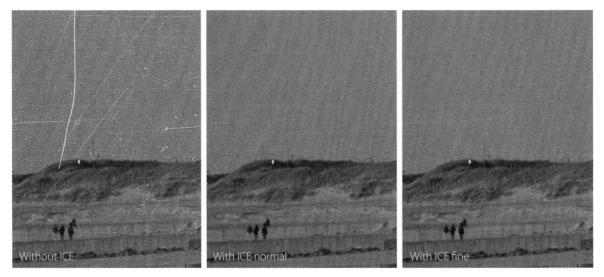

The enlarged detail view shows the increasing effect ICE has on image sharpness, although at normal magnifications it does not look so bad.

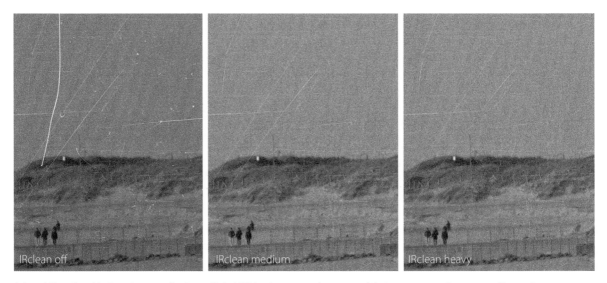

Infrared Clean from VueScan is not as effective as Digital ICE, but it preserves the texture of the image even at the strongest filter setting.

ICE and FARE for Kodachrome Slides

Kodachrome film, based on the K14 process, is a different technology than the conventional E6 slide film. The emulsion side of Kodachrome has a similar appearance as black and white film. As already noted, ICE does not work for black and white film, so it comes as no surprise that scanner manufacturers also advise against using ICE on Kodachrome.

So far, the only scanner that offers ICE specifically for Kodachrome is the Nikon Super Coolscan 9000 ED ($1,900). I have not tested it myself, but this multi-format scanner has generally received positive reviews.

For my tests on Kodachrome slides, I had to make do with a Nikon LS-40 and LS-5000 scanner. In the first attempts at scanning Kodachrome, ICE was accidentally turned on. In full-screen mode the result actually looked acceptable. Unlike with black and white negatives, with Kodachrome ICE and FARE actually removed dust and scratches. The subjective quality of the correction was not overwhelming, though. This type of correction works better with E6 and C41 film.

A further problem is that ICE can mistake fine image details for dust and remove them. This becomes visible only when you zoom in.

Tests reported by a German computer magazine showed that this effect varies with the scanner model: the ICE of the Minolta DIMAGE Scan Elite 5400 could keep up with the ICE professional of the Nikon Super Coolscan 9000 ED when correcting Kodachrome, even though the Nikon is optimized especially for Kodachrome. So, ICE and FARE should not be automatically dismissed for Kodachrome. The best recommendation is to simply run your own tests to see the effect of ICE. Also, if you are not planning on big enlargements, it makes sense to sacrifice some minor details for the sake of a generally clean image. (Note: With a Scanhancer, regular ICE works for Kodachrome without limitations.)

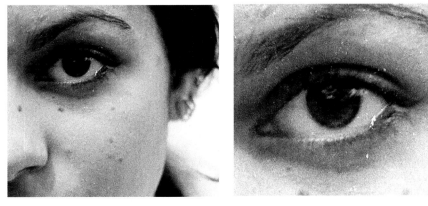

Without ICE: annoying dust on Kodak T-Max is apparent.

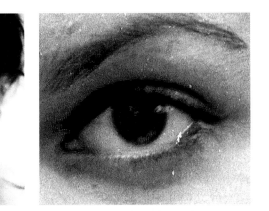

With ICE: dust is still there, but the texture of the iris is gone.

ICE and FARE for Black and White Negatives

For physical reasons, scratch and dust removal does not work with conventional black and white film. The silver crystals in the emulsion are identified incorrectly as dust particles, which leads to faulty correction.

The examples clearly demonstrate the effect of ICE on silver-based film. Neither dust nor scratches are removed, but instead the eyelashes and the iris of the model turn into black blotches. On the other hand, ICE works without problems with black and white film based on C41 chemistry. As the image of the beluga whale on Ilford XP2 film (C41 process) shows, scratches and dust are reliably detected and filtered out.

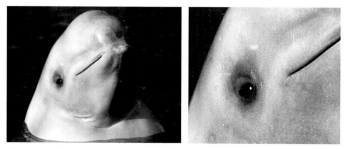

Without ICE: beluga whale on Ilford XP2 film with clearly visible dust and scratches.

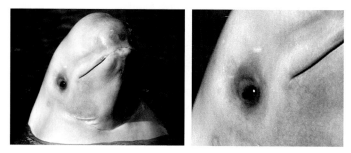

With ICE: scratches and dust have been accurately removed.

Infrared Clean – Scratch Removal in VueScan

In VueScan, scratch detection is handled with Infrared Clean. This requires a scanner with an infrared channel. Unlike ICE, Infrared Clean affects the texture of the image noticeably; however, scratch correction is less effective than ICE.

VueScan is clearly superior to its competitors Nikon Scan and SilverFast (which both use ICE) in the following respect: VueScan can scan images as true uncorrected RAW files. In this mode, even after the scan you can still decide whether to apply Infrared Clean, and at what correction level to apply it – Light, Medium or Heavy. There is no need for a rescan. In Nikon Scan and SilverFast, you must choose the desired ICE correction level before the scan, even with NEF files. In both Nikon Scan and SilverFast, the ICE correction level cannot be changed after the scan

Restoring Faded Colors

Nikon Scan: Digital ROC

Film will age, even when properly stored. Over time, the colors in the film fade noticeably. In the case of slides, however, since the different color layers don't age equally, slides take on a color-cast and become unsuitable for projection.

Applied Science Fiction has developed the ROC filter for color restoration. Even twenty-year old slides can look like new again. ROC removes the color-cast and refreshes faded colors. The degree of restoration is selectable; if it is set too high, colors will look unnatural. Water spots on the film surface (from developing) and other impurities can also become exaggerated.

To check for unwanted side effects beforehand, always generate a preview when using ROC. The ROC filter has a considerable impact on the colors and should be used with caution. The example shown on the following page demonstrates an extreme case. The slide is almost fifty years old and badly discolored. This example shows that even a seemingly hopeless slide can contain some interesting hidden information. ROC corrects typical signs of age very well and improves the image significantly.

Current Nikon scanners include ROC. ROC can also be executed after the scan - not with the Nikon scanner software, but with a Digital ROC plug-in for Photoshop at extra cost. The software allows experimenting with different settings without having to perform a time-consuming rescan each time. This is a definite advantage over the solution implemented in the scanner software. For scanning old film material, ROC is a great help.

VueScan: Restore Fading

With Restore Fading, VueScan has integrated a function similar to ROC. However, unlike ROC, the function cannot be controlled with sliders but uses check boxes instead.

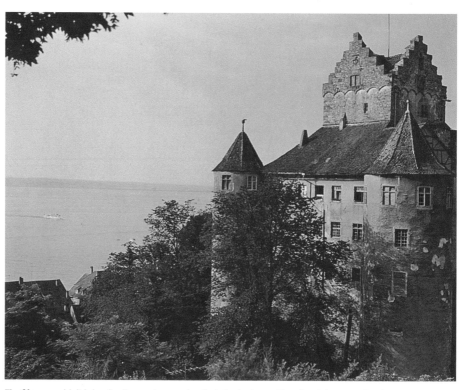

The fifty-year old slide has badly – and unevenly – faded color layers. Therefore, it has a stark color-cast.

Image: Siegfried Gromotka, around 1960

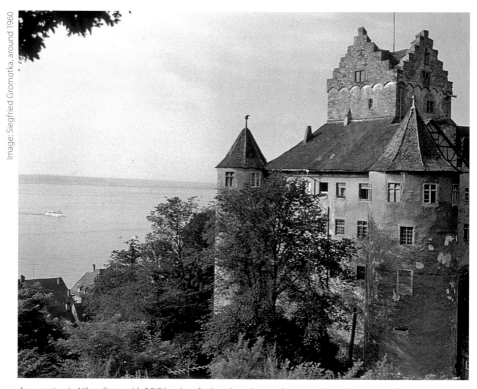

A correction in Nikon Scan with ROC level 7 refreshes the colors and removes the color-cast significantly.

Grain Equalization

Digital GEM

Film is grainy. Graininess can actually enhance the perceived sharpness of an image. Whether this looks good or bad, or to what degree grain looks ideal, is an ongoing discussion among photographers. Film grain was typically optimized to give good results with the wet chemical process of the photo lab; but for scanning, grain can look very unsightly. The visual effect depends on the film and the scanner model. The size of the film grain also depends on the exposure.

Grain in scanned images can look objectionable. Supposedly, smooth surfaces – especially skin – appear gritty and patchy. The effect is even more pronounced when a high-resolution scan is down-sampled. With the help of GEM, the grain can be made to look smoother. The degree of equalization can be set in different steps. It is a matter of personal taste as to how smooth to make the grain.

The images on the following page were done with Nikon Scan, which lets you set GEM from level 1 to 4. I deliberately turned off ICE for this example, since ICE also tends to reduce the grain slightly. In practical use, ICE and GEM are used together and their effects are cumulative. It is advisable to perform a test scan to find the best settings. For film with normal ISO speed, reasonable results are achieved with ICE set to normal and GEM set to level 2.

Since grain size depends on the film material and the exposure, it can happen that different settings for GEM are required for different images on the same roll. GEM is especially useful for high-quality scanners that can record even the finest grain.

Often you can do without GEM when the reproduction of grain is already dampened by virtue of a lower scan resolution. A way to do that is to scan at 4000 dpi but save at a lower resolution, such as 2000 dpi. Even without GEM, this method delivers a more pleasant grain and helps preserve the texture of the film better than with GEM. The obvious disadvantage is that saving at a lower resolution affords only half the output size of the scan.

VueScan Grain Reduction

The grain reduction filter in VueScan is comparable to GEM in Nikon Scan. It has three levels to choose from. VueScan has an advantage over Nikon Scan in that corrections can be performed or changed after the scan, provided the scan is saved in RAW format.

VueScan's filter for grain reduction.

Without grain reduction: clearly visible grain.

GEM at level 1: slightly smoother grain, but still some distracting grain particles.

GEM at level 2: the graininess is pretty much gone.

GEM at level 4: no more visible grain, but also unnaturally smooth, polished skin.

Scanned at 4000 dpi and down-sampled in Photoshop: clearly visible grain.

Scanned at 4000 dpi and saved at 2000 dpi in the scanner software: the grain is clearly smoother.

SilverFast GANE

SilverFast GANE has a preview window, which puts it above VueScan and Nikon Scan. GANE is implemented as an additional filter with three levels. Expert mode allows free choice of strength and threshold. In the RAW mode HDR, the filter can be applied after the scan, so it should be used only in certain cases and with the strength matching that of the subject.

GANE grain removal with preview window.

Highlight and Shadow Recovery

Digital DEE – Correction for Highlights and Shadows

Starting with version 4, the Digital Exposure Enhancer (DEE) is integrated into Nikon Scan. It offers automatic exposure corrections for two difficult areas: underexposure in shadow areas and overexposure in very bright areas. Digital DEE can correct the exposure to recover more detail in the highlight and the shadow regions. Different regions can be corrected separately. The resulting image can improve drastically. This feature was introduced with the current generation of scanners (Coolscan V / 5000 / 9000). The same effect can be achieved by manually changing the gradation curves.

Since DEE correction can now be performed in Nikon Capture with the D-Lighting feature after the scan, there is no reason to continue using DEE. Unlike DEE, D-Lighting is fully reversible and is not frozen in the NEF files. Starting with version CS, Photoshop has also integrated this functionality with the Shadow/Highlight adjustment.

Upgrade to ROC, GEM, and DEE Functionality with Photoshop Plug-ins

For ROC and GEM, trial versions of Photoshop plug-ins with the same names can be downloaded from www.asf.com. These also allow scan file corrections after scanning. The plug-in for correcting highlights and shadows is called "SHO", but its functions are identical to DEE. All three plug-ins are available in standard and pro versions with extended functions. The free trial versions are fully functional, but the images are saved with a watermark as a reminder to register the software. The advantage of the plug-in solution over the integrated scanner software is that the plug-ins do not require rescanning of the image if the results of the corrections are unsatisfactory.

SilverFast AACO – Auto Adaptive Contrast Optimization

SilverFast users can only enjoy the DEE-like function AACO if they have bought SilverFast Ai Studio. The basic version SilverFast Ai does not support this feature. The basic version offers fewer controls than DEE, D-Lighting, or Photoshop Shadow/Highlight.

Configuring the Scanning Software

There are a vast number of driver applications for scanners, each with its own user interface. Nikon Scan is a quasi-standard in this category, so it will be used here to introduce some important tools and options in scanning programs. In SilverFast and VueScan, the buttons look slightly different, but for the most part, the basic functionality is the same.

Some settings, such as scan resolution, must be configured before scanning. Others, such as color and contrast adjustments, can be adjusted either immediately in the scanning software or later in Photoshop or other editors.

Content

Image Orientation

Rotating and Mirroring the Image

An image can be rotated and/or mirrored directly in the scanning software or later during image processing. For scanning, it is important to have the emulsion side of the image facing the correct way. Otherwise, the image will have to be mirrored later. This is not a major concern for rotating an image. In most cases the image editor lets you perform a lossless rotation (90° cw and ccw, 180°) or mirroring. Exceptions are JPEG files, which undergo lossy compression in some viewers and editors.

In some cases, there are problems manipulating the scanned file after scanning: Nikon NEF files, for instance, can no longer be opened in Nikon Scan after they have been rotated and saved in Nikon View or Capture Editor. These problems can be avoided if the film is inserted correctly into the scanner and any rotations are performed directly in the scanner software. At that point, the original is still available for reference for the right orientation.

Nikon indicates a mirrored image with a red "R". This is not needed if the film is inserted correctly.

Cropping

Frame gap and frame borders should be trimmed in the preview window before the scan, because the black borders interfere with auto exposure. The question remains as to how to determine the size of the scanning frame.

In cropping, you don't want to clip important image information, but you also don't want to have to set the scanning frame individually for every image. Good scanning software lets you store frame sizes for your convenience, especially in batch mode.

The nominal size of the 35mm format is 24mm × 36mm. However, the actual size of the image on the film varies slightly from camera to camera. For cameras with interchangeable lenses, the size may depend on the lens used. For slides, the aperture of the mount is important. Most slide mounts crop the image to slightly less than 24mm × 36mm. One exception is the Pro Scan mount from Gepe. The Pro Scan opening is exactly 24mm × 36mm, since the device is intended not for projection, but for scanning.

Automatic frame detection does not always work with dark subjects.

A slight shift of the film in the mount can further reduce the usable image area. If the ideal scan frame is kept as a standard setting, it will only be necessary to move the position of the frame in the preview window. In Nikon Scan, the crop setting can be saved under a user-specified name. This is faster than manually drawing the crop frame each time. Nikon Scan detects the ideal position of the crop and positions it accordingly in the preview. In most dark images, however, the position has to be corrected manually.

Setting Your Own Focus Point

Every good film scanner has an autofocus that can also be set to manual. By default, the autofocus feature focuses on the center of the image, which is fine in most cases. For a flat film, the sharpness will extend across the entire image, provided the image itself is actually sharp.

On the other hand, warped film is not sharp across the entire image, because the scanner's depth of field is usually not sufficient to maintain that sharpness. In this case, it is best not to rely on autofocus, but rather to manually focus on important parts of the image instead, such as on the eyes in the case of portraits.

In my tests, it didn't matter whether there was a contrasty detail or a plain area at the focus point. Contrary to what I expected, the autofocus of Nikon scanners can focus correctly in both cases (unlike the autofocus of an SLR, which only works with contrasty details). I suspect that the film grain provides sufficient detail for the scanner to focus correctly in this mode.

In many shots, the important parts are not in the center.

Filmstrip Offset

The filmstrip offset has to be corrected manually every time a filmstrip is inserted or the automatic detection will not work properly. It is difficult for the automatic feature to separate the frame gap from the image, especially with dark and low-contrast images. This can be corrected by manual adjustment of the filmstrip offset, so that the entire image area can be scanned.

Correcting the filmstrip offset in the prescan window of SilverFast.

Image Properties

Setting Image Size, Position, and Resolution

In the *Crop* palette you can define exact dimensions for the area to be scanned. The part of the image outside the crop frame will not be captured. If the black borders lie within the crop, auto exposure may give a false result. VueScan and SilverFast perform best in this situation, since they let you set a margin to be ignored. The exact position of the crop is determined using the mouse.

For best image quality, images should be scanned at the optical resolution of the scanner. As a rule, that is always the case for high-quality slides and negatives, with one exception: when negatives from a single-use camera are scanned, it is not necessary to scan at 4000 dpi or even 5400 dpi; 2000 dpi will suffice.

It makes no sense to scan at a resolution higher than the scanner's optical resolution, even if the scanning software offers it. The corresponding interpolation creates unnecessarily large file sizes without any increase in image quality. If you need a higher resolution later (for example, for printing a

poster), you can achieve the resolution you need with better control by up-sampling in an editor.

Color Depth

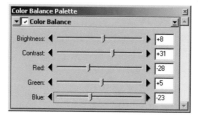

Current film scanners support at least 8-bit color depth and in some cases up to 16-bit color depth. For post-processing images, scan at the highest supported color depth. This provides more reserves for processing later. The editor must support 16-bit throughout, though, as is the case with Photoshop CS and CS2. If post-processing is not required, 8-bit color depth will be fine. At any time, a 16-bit file can be converted to an 8-bit file, but not the other way around.

Color Balance

The Color Balance palette in Nikon Scan

In the palette *Color Balance*, there are sliders to control *Brightness* and *Contrast* separately as well as the color channels *Red, Green,* and *Blue*. These are global settings. To tweak a specific tonal range, use *Curves*; adjustments to tonal range cannot be done with *Color Balance*. Brightness and contrast apply to all color channels of the image. With the RGB sliders, they can be changed individually.

Optimizing the image with *Color Balance* is quick and easy, but it only allows for relatively rough corrections. For that reason, experienced users prefer the more complicated tuning with *Curves*. This feature allows much finer color balance and contrast correction.

Brightness

Brightness changes the brightness of the entire image. For example, if many details are overexposed, the overall brightness can be reduced. It is not possible to make a specific tonal range darker or brighter. DEE and comparable functions are available for that purpose.

Contrast

Contrast describes the brightness difference between bright and dark portions of the image. If the contrast is too low, the image looks flat. If the contrast is too high, details get lost and the color distribution in general looks hard and unnatural. Below, the example with the maple leaf is a collage of three partial images. In the middle the contrast is ideal, on the left it is too low, and on the right it is too high.

When the contrast is too low, the image looks flat. When it is too high, it looks unnatural.

Color Channels

The color channels allow the red, green, and blue portions of the image to be adjusted. If, for instance, the image has a red cast, the red channel needs to be reduced. The slide below has a minor green cast that has been corrected in the left half.

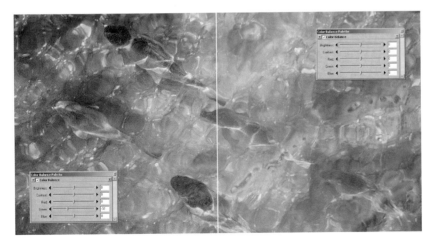

On the left, the color-cast has been removed by correcting the green channel.

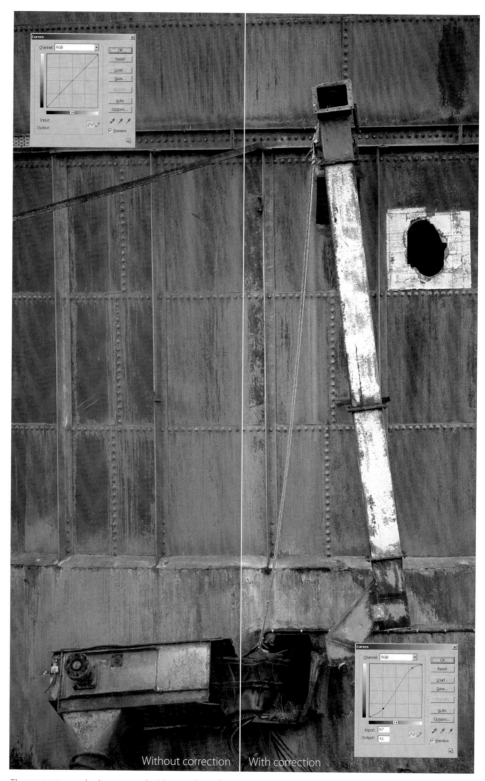

Without correction | With correction

The contrast can also be corrected with an s-shaped tonal response under **Curves**. *The flat original (left half) becomes much more contrasty (right half).*

Unsharp Masking

Digital images, including files from a film scanner, always appear soft in their unprocessed state. Correction filters, such as GEM and ICE, further enhance this effect. Unsharp Masking is the best function to sharpen images.

The sharpening occurs by increasing the contrast along edges inside the image. The control parameters for sharpening are *Amount, Radius,* and *Threshold.* The goal is to improve perceived sharpness without losing important details and without creating unwanted artifacts, such as halos.

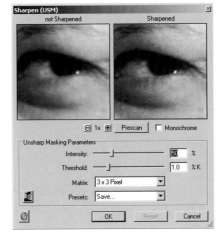

USM in SilverFast with its own preview window

An important factor in sharpening is the resolution of the image. It is rarely useful to sharpen directly during scanning. For example, if the scan goes straight to the printer (i.e., if the digitized image is outputted in a different resolution from the scan resolution), it is not meaningful to set the "ideal" sharpening parameters during scanning.

In my opinion, *Unsharp Masking* belongs in post-processing. Even during image processing, *Unsharp Masking* belongs at the end of the workflow. It is possible with *Unsharp Masking* to sharpen all color channels together or each color channel individually. Also, simple viewers such as IrfanView provide basic sharpening functions. IrfanView offers only one option for *Sharpen,* without any adjustable parameters. It is easy to use, but the result is inferior to a sharpening function, which can be configured in more detail with *Amount, Radius,* and *Threshold.* The USM function in SilverFast is particularly nice: unlike the case with Nikon Scan, the SilverFast USM function uses a preview window for judging the effect of the correction.

Amount

The slider *Amount* defines how much the edge contrast will be increased. Ultimately this increase in contrast creates the impression of greater sharpness.

Radius

The slider *Radius* determines how many adjacent pixels will be involved in edge sharpening process. The bigger the radius, the greater the chance unwanted halos will occur.

Threshold

Threshold defines the minimum level difference between adjacent pixels at which a pixel is considered part of an edge and sharpening kicks in. Setting a high threshold can exclude areas with low contrast. A good example is sharpening eyelashes without affecting the texture of the skin around the eyes.

Sharpening in Two Steps

An alternative to sharpening at the end of image processing is using a two-step approach: first sharpen mildly after the scan, and then perform final sharpening at the end of image processing. With TIFF files, never sharpen on the scan file - use a backup copy instead. Because sharpening is no trivial matter, countless Photoshop plug-ins, such as Nikon Sharpener Pro, have been made available to make the job easier.

Curves

Nikon's palette *Curves* is somewhat similar to the *Color Balance* palette in allowing contrast, tonal distribution, and color balance correction. It differs from *Color Balance* because *Color Balance* allows only global color changes – all levels and color ranges are treated equally. The *Curves* function is more powerful since it allows finer corrections, but its use is more demanding. The histogram integrated with the tool helps in evaluating the corrections. Also, *Curves* allows selective range corrections without unwanted effects on other tones, such as often occur in the case with *Color Balance*. The color channels can be corrected individually or combined in the RGB channel.

The horizontal axis of the diagram represents the input values; the vertical axis, the output values. The "0" on the left is the blackest part of the image, and "255" on the right is the maximum possible brightness. In the histogram, the vertical axis displays the frequency with which a given level occurs in the image. If a level occurs frequently, then the bar for that level is high; if the level is rare, the bar stays low. The vertical scale for the histogram is not fixed, but is adjusted flexibly to have the tallest bar always fit within the graph of the curves. The numerical values on the vertical axis define the black point and white point on the output side.

Initially, the curve is a straight line, which means that input and output values are identical. Pushing the curve increases the brightness level of specific tonal ranges. Moving the mouse over the image displays a point running along the curve to indicate the level value of the pixel currently under the cursor.

Difference from Curves in Photoshop

Nikon integrates the histogram with the *Curves* tool. In Photoshop, Levels and Curves are two separate tools, with no histogram display in the background of the Curves graph. A similar function is available with the live histogram of the *Histogram* palette; with the Curves window placed next to the histogram, the histogram levels change as the curve is pulled.

Working with Histograms

The histogram helps assess the effect curve correction has on the distribution of tones in the overall image. The histogram can show the distribution of levels not only of the full image, but also of a selected crop. The histogram displays the frequency (y-axis) of pixels for each level (x-axis) within the image. This type of display provides a very helpful tool for image processing. For example, a distribution spread evenly across the whole scale from 0 to 255 indicates a correct exposure with balanced levels.

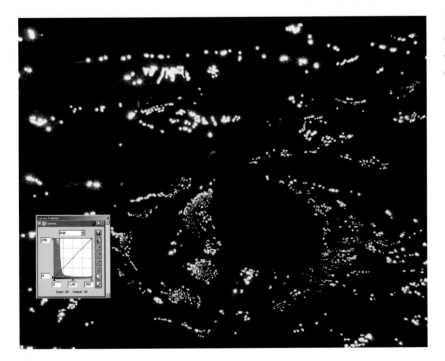

The histogram of an underexposed image shows – as expected – a disproportionate concentration of the dark levels on the left.

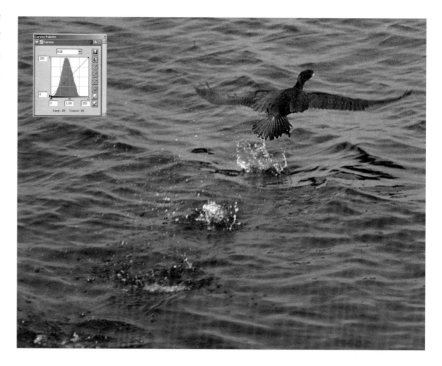

When adjustments are made in *Curves*, the histogram does not update in real time, even though the changes affect the histogram. The *Histogram* button in Nikon Scan is used to display changes. It also functions as a toggle to show "before-and-after" values in the histogram. In Nikon Capture, this button offers a live visual update of the histogram. Unlike Photoshop, Nikon Capture does not offer superimposed histograms for a before-and-after comparison. There are no fixed rules for how a good histogram should look; the subjects and their level distributions differ too greatly. Gaps in the histogram after corrections are always a concern. They point to a loss of detail due to shifted levels.

Before/After Histogram Button and Auto Contrast

Using the *Before/After Histogram* button displays the effects of the correction. With one mouse-click, the function provides a comparison of the updated graph with the original one. Unfortunately, in Capture Editor it is hard to tell whether the "before" or "after" histogram is being displayed. The Nikon Scan interface is clearer and it is easier to determine the proper settings. Using the *Auto Contrast* button lets the program make an automatic adjustment of the contrast.

In my tests, the results of performing contrast corrections were in many cases unsatisfactory. Manual corrections seem to be better. There is no way to undo Auto Contrast except by completely resetting all curves. This can be irritating if the curves have been changed extensively; those changes will all be gone as well.

Black Point and White Point

The *Black Point* is the darkest pixel in the image, indicated by the value at the left end of the histogram. The *White Point* is the brightest pixel in the image, indicated by the value at the right end of the histogram. Usually, the *Black Point* is at 0 and the *White Point* is at 255. However, in many images the darkest point is not deep black and the brightest point is not pure white. This means that a part of the dynamic range is not being used. Manually moving the two sliders to the respective ends of the histogram will use the entire dynamic range.

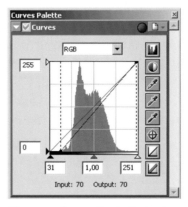

Uncorrected histogram: the entire level range is not used and the image is flat.

After manually correcting the black point and white point, the levels are optimized.

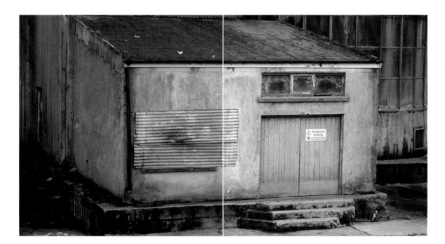

On the left is the original, and on the right is the same image after stretching the levels: the result is more brilliant colors.

The fastest way to adjust levels is to use the RGB channel, although it is not the best way. It is more effective to make the effort to adjust the levels for each color channel separately. This not only makes best use of the tonal palette, but also compensates for most color-casts (with the exception of high/low-key shots).

Another way to adjust levels is to use the eyedropper tools *Set White Point* and *Set Black Point*. First click on the eyedropper to activate it, and then click on the desired part of the image. For example, to set the white point, click on the pixel that is considered the brightest. Areas with even brighter pixels will be washed out.

The sliders for black point and white point can be set separately for each color channel. If the eyedroppers in the RGB channel are used, then automatically each color channel will be adjusted individually. This is also a good way to fix color-casts, provided suitable black or white points can be found in the image, which is not easy for every subject.

Setting the Gray Point

The Gray Point lies between the black point and the white point. By default, it is right in the middle. Sliding to the left of the *Gray Point* makes the image brighter. Sliding to the right makes the image darker. Unlike the global brightness adjustment in *Color Balance,* this correction does not affect the endpoints of the curve. Black point and white point remain unchanged; only the midrange is affected.

With the gray value, the gamma changes. One can slide the gray triangle or type a number in the field below it. Alternatively, the gray eyedropper may be used to assign a certain image area the value "neutral gray"; each color channel is then corrected separately. This is a very good method for removing any color-cast, but only if there is a suitable neutral gray area in the image.

The gray point slider before (left image) and after (right image) the correction.

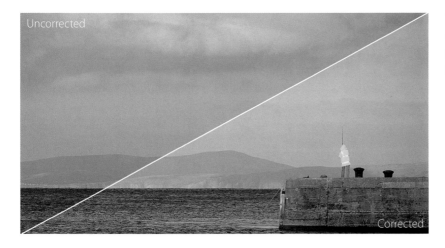

The original image (on top) is a bit too dark. Correcting the gamma with the gray point slider makes the mid-tones brighter (lower half).

LCH Editor

The *LCH Editor* performs image corrections according to the concept of the LCH color model. Here you can adjust colors through their components Lightness (Luminance), color saturation (Chroma), and color tone (Hue) separately.

The *LCH Editor* gives the photographer a powerful tool for optimizing images. In Nikon Scan, the *LCH Editor* is functional only if Nikon color management has been enabled. Otherwise, the *LCH Editor* options are grayed out and cannot be used.

Adjusting brightness with the LCH Editor in Nikon Scan.

Lightness

This option allows adjustments to the brightness of the entire image. Colors are affected only indirectly; a very bright image automatically looks paler.

Chroma

The *Chroma Editor* allows changes to the color saturation of the image. In the example on the following page, using the *Chroma Editor* makes the colors in the parrot's plumage more vibrant. Unfortunately, scanning degraded the colorful image somewhat, but with the *LCH Editor* the quality of the color could be recovered to a degree. The color saturation is controlled by the gray point slider in the middle. Moving the slider to the right makes the image become less saturated; sliding it to the left makes the colors more saturated.

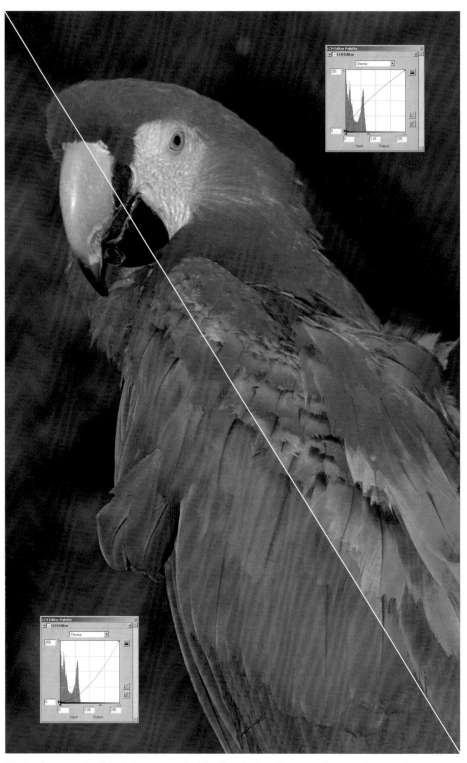

*Moving the gray point slider for **Chroma** to the left will make the colors more vibrant and saturated.*
Sliding it in the other direction makes the image less colorful.

Chroma in Capture

In Nikon Capture, the Chroma feature looks different; it is not shown as a diagram with a curve. Instead, it is shown as a spectral diagram with a horizontal line. Color saturation is changed by grabbing the arrow and pulling the line up or down. The effect is the same as in Nikon Scan.

In Capture, color saturation is increased by pulling the line upwards.

Hue

The *Hue Editor* also works with a spectral diagram instead of the more common curves diagrams. The background shows all the colors from the color wheel along the horizontal axis, which means the full 360°. The vertical axis toggles between the colors of 60°, 120°, or 180° of the color wheel. With 60° there is less of a shift, but a higher resolution. At the outset, the input hues are identical with the output hues. The numerical values for input and output are shown at the bottom. Grab the straight line at any point and drag it upward or downward to assign different values to the input value for the selected range of hues. The width of the change is adjusted with a slider on the bottom left to allow some fine control. This way, it is possible to choose whether only one particular color or also its neighboring colors are affected by the change.

Example: Change the Color of the Parrot's Head with the Hue Editor

Activate the *Hue Editor* by clicking on the diagram. First, the hue of the original color must be found – here the red color of the head. Moving the mouse cursor over the head shows the hue as a little point on the horizontal axis and also as a numerical value in the status line at the bottom. Clicking on this location on the axis sets a marker.

Using the mouse or the arrow keys pulls this marker into a different color region, until the color of the head turns the desired turquoise. Usually this change will also affect neighboring color regions, but this effect can be fine-tuned with the *Width Slider*. The width must be set narrow enough so that only the desired color range changes.

On the hue curve, the input value for red is pulled upwards into the turquoise region.
The formerly red head of the parrot has changed color dramatically.

Analog Gain

Analog Gain ("Lamp Brightness" in SilverFast) is usually taken care of automatically by the scanning program as part of exposure control. It is a matter of exposure time and not the brightness of the light source, as the name would seem to indicate. For film with normal exposure, this function is not really necessary and the exposure may be left at its default setting.

For underexposed or overexposed pictures, manipulating the *Analog Gain* produces better image results.

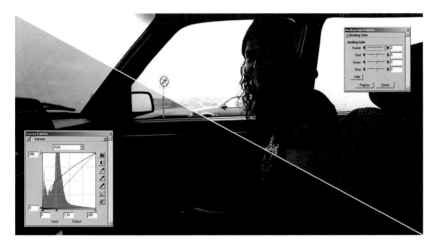

When Brightness or Curves can no longer extract more details from an underexposed image, only Analog Gain can help.

Analog Gain directly controls the scanner hardware. It governs exposure time – how long the scanner lamp shines through the film. The same effect cannot be produced later in image processing; more light must be physically projected through the film.

Nikon Scan simulates the effect in the preview window to give a point of reference. However, only performing the proper scan would show the exact result of adjusting exposure. Increasing the *Analog Gain* makes sense only if the monitor is calibrated. Often, a scanned image looks too dark simply because the monitor is not adjusted properly. If one tries to compensate for poor monitor adjustment with *Analog Gain*, the scanned files will not be usable on a calibrated monitor.

The effects of *Analog Gain* are fixed in the image file. Since *Analog Gain* represents change at the hardware level, a poor setting cannot be fixed later in Photoshop. One negative side effect of using *Analog Gain* is an increase in image noise.

The simplest way to work with *Analog Gain* is with the *Master* slider (all three color channels together). In most cases this works fine. It is also possible to tune each color channel separately. However, finding the ideal settings for tuning can be tedious.

For overexposed images, reduce the *Analog Gain* to lessen the exposure time. This may salvage image portions that would be blown out by the scanner light on the standard setting. *Analog Gain* does not work miracles; it merely helps to recover some detail in poorly exposed images. The results of using *Analog Gain* will never match a properly exposed shot.

In the overexposed slide, many details are blown out. With a reduced Analog Gain, the sky shows more detail. The drawback is a strong color-cast.

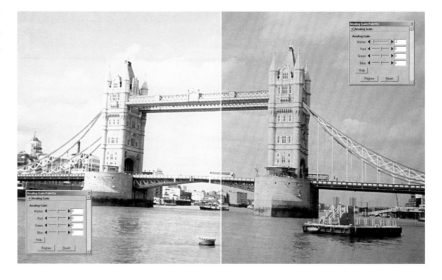

Nikon Scan

Nikon scanners include Nikon Scan software. This software will be described here as a member of the TWAIN family of drivers, which are typically included in a scanner purchase. The tight integration of Nikon Scan with the RAW editor Nikon Capture makes it especially interesting to photographers. Currently, no other program offers ease of use comparable to Nikon Scan at this level.

Content

Installation
Look and Feel
Saving Configurations
Preferences
Color Management
Documentation
Conclusion

Installation

Nikon Scan and program updates can be downloaded from the Nikon support website free of charge. The software supports only Nikon scanners. It should be noted that the current versions no longer support all old Nikon scanners. Nikon Scan 4 is compatible with:

▸ Coolscan IV + V ED
▸ Super Coolscan 4000 + 5000 ED
▸ Super Coolscan 8000 + 9000 ED

Nikon Scan can be used either as a fully functioning standalone application or as a plug-in for image editors such as Photoshop. The plug-in solution is convenient for situations in which the scanned file is processed immediately with an external image editor. However, during scanning in the plug-in mode, the editor is locked. It is better to save the image files directly to disk and edit afterwards. When Nikon Scan is run in stand-alone mode, images can be edited in parallel with Photoshop or Capture – provided there is sufficient computing power to do so.

Plug-in Mode: Limitation of the TWAIN Interface

Nikon Scan can transfer color space information to the image file only in standalone mode. The TWAIN interface used in plug-in mode cannot communicate the color space in the same fashion.

Almost all fine-adjustments can be configured in Tool Palette 1

Look and Feel

The layout of Nikon Scan is visually simple, but highly functional. It takes some getting used to, but after brief familiarization, it is easy to use. When the application starts, the icon Open Twain Source opens the actual scan window. This only works if a scanner is connected and recognized by the system. If not, an error message indicates that no active device has been found and the scan window cannot be opened. In this case, there is no need to restart the program; just switch on the scanner, wait for one minute, and then open the window.

Layout of the Scan Window

Control Area

In the control area, there are three drop-down menus: The menu Settings lets you save and recall configurations for the current scan. The Film Type menu lets you select among settings for color negative, black and white negative, Kodachrome slide, and regular reversal film. No further film profiles can be attached, you have to take care of color correction for the different films yourself. In the Color Model menu you can choose between Grayscale and Calibrated RGB. (Note: NEF files should not be scanned in grayscale mode – neither Nikon Capture nor Nikon Viewer support it).

In grayscale mode, you will face compatibility problems later.

Information Panel

The information panel in the scan window clearly shows the most important settings, readouts, and status for the currently selected image. A yellow warning sign indicates that such image corrections as ICS, ROC, GEM, Analog Gain, Scan image Enhancer, and DEE are not yet taken into account in the preview. Only a refresh allows a realistic evaluation of the image corrections.

The most important settings at a glance.

Preview Area

In the preview area, the image can be viewed with the two tabs Natural and Processed. You can toggle between them either by clicking with the mouse or by using the keyboard shortcut ctrl + F5. Whereas the Natural option shows a preview without any image corrections, the Processed option shows a preview that includes image corrections, which allows a direct before/after comparison. Whether the preview matches the actual scan, and to what extent, can be configured under Preferences with Preview Settings. If Digital ICE is activated, the projected effects of scratch removal can be checked in the preview as well.

Shown as a collage: on the left the manually optimized image, on the right the original image.

Title Bar ▸ The title bar displays information about the connected scanner and which version of firmware it is running.

Thumbnail Drawer Tab ▸ The thumbnail drawer tab is somewhat hidden to the right of the control area in the scan window. Open the drawer either by clicking on the tab or using a keyboard shortcut: the function key F4 opens it and F9 closes it again. (Note: shortcuts work faster than the mouse.)

The thumbnail drawer automatically closes after double-clicking on a thumbnail to start the preview.

The small size of the thumbnails and their distorted representation do not allow a realistic evaluation of the image. However, the representation is good enough to sort out obvious exposure errors and to correct the filmstrip offset. Nikon Scan does not allow thumbnails to be saved to disk, although it is possible to do so with VueScan and SilverFast.

Thumbnails à la Nikon: the faces are slightly garbled and the person looks different in each picture.

Tool Palette 1

The Tools button lets you open the Tool Palette 1 in a floating window that provides all tools for image processing. With this palette, you can build your own tool chest. In general, you do not need all the functions available in the Tool Palette 1. You can often work faster with a palette window tailored to your own needs.

Trimmed down Tool Palette 1: not all functions are needed for scanning.

The best spot for the tool chest is next to the scan window, not in front of it.

You can move a tool title bar (such as Crop) by clicking on it and dragging it by holding down the mouse button. This way you can rearrange the sequence of the Tool Palette 1 or even create a new palette by dragging the tool outside the existing palette. Palettes with a single tool receive a palette title with the tool name – in this case, Crop. For multiple tools in the palette, tools are numbered sequentially.

Unfortunately, it is not possible to name the palettes – Nikon Scan gives them names automatically. Also, Nikon Scan does not let you set the palettes to always stay in the foreground. This can get messy when scan window and palettes overlap, which is often the case with a regular size monitor. When you click on the image, the palettes disappear behind the scan window and need to be restored by clicking the Tools button.

Capture has shortcuts such as Alt + 1 (where the number stands for the palette number; in this case, Tool palette 1), but these shortcuts do not work for Nikon Scan. If you have a large monitor, it is best to place the palettes next to the scan window.

Scan Progress

The Log keeps track of what the scanner is doing right now.

The Tools button is also used to bring up the Scan progress window. This is another floating window with tabs for Queue and Log. The Queue tab lists remaining scan jobs, which can be useful for batch scanning. The Log tab lists completed jobs, which helps keep track of a sequence of steps. Unlike VueScan and SilverFast, Nikon Scan does not have an acoustic notification for the completion of a scan.

Preview Area

The larger the preview, the more effectively you can work with it. Therefore, it is best to first enlarge the window, so that Nikon Scan will generate a correspondingly large preview.

If the window is enlarged afterwards, the preview becomes pixilated, which can only be fixed with a new preview. Pixilation can sometimes occur when an image is rotated (for example, from landscape to portrait). If you are satisfied with small thumbnails, you would expect faster previews – higher resolution takes longer to scan. This is not quite the case; in actual tests with a Coolscan IV, it did not matter whether the preview was filling the screen or was as small as a slide mount - the scanning time was the same in both cases. Thus, it is best to keep the preview window at maximum size; it can be reduced any time.

Nikon Scan does not allow thumbnails to be saved – only the actual scan. The same is true for SilverFast - only VueScan has no problem saving thumbnails.

Enlarging the preview area afterwards causes heavy pixilation.
Therefore, the final size should be set before the preview.

Saving Configurations

Coming up with optimized combinations of various configuration options for different purposes can be extremely time-consuming. Therefore, it is very useful to be able to save settings at different levels so that you do not have to repeat those settings before each scan. If you know the different ways of saving settings and apply them appropriately, you can save time and avoid tedious, repetitive tasks in the future.

The "Settings" Menu

The Settings menu allows you to save and delete configurations. Some of the settings are:

▸ Scanner model
▸ Media type: color negative, B&W negative, slide
▸ Crop
▸ All options in the tool chest

Unfortunately, Settings does not allow the selection of individual sub settings – all settings are saved collectively. If you get lost in the various configurations, you can always go back to square one with Restore Factory Defaults.

Store and Delete Settings

The Save Settings option under Settings lets you add newly created settings to the bottom of the menu as a menu option with a name of your choosing. If you save many different settings, the menu can become unwieldy. You can remove obsolete settings from the list with Delete Settings.

Set User Settings

Set User Settings lets you define the current settings as user settings. This allows you to make a set of customized settings for your personal needs. All settings can be reset to these values with Settings ▸ Reset User Settings. Additionally, there is a Reset to User Settings under each tool of Tool Palette 1. This is very useful should you get lost in a "jungle" of options.

Customization:
defining user settings.

Import and Export Settings

In order to keep the drop-down menu of Settings from becoming too long, configurations can be exported to a .set file and imported again when needed. Only current configurations can be exported. To export a configuration (using the option listed in the drop-down menu under Settings), you first have to select the configuration and make it current.

Saving Configuration in Tool Palette 1

The Settings menu only lets you save all settings together. This includes settings for the tool palette as well. Individual settings can only be set directly in tool palettes such as Tool Palette 1. Functions in these palettes follow the same logic as functions under the Settings menu.

Exporting the ICE configuration.

Configurations can be stored, set for display on the drop-down menu of the tool, or imported and exported. However, not all tools in the palettes are supported. At the tool level, the triangle at the right end of the title bar gives access to the Settings. Tools that are not marked with a triangle do not support saving, importing, or exporting of tool parameters.

Copy Settings to Clipboard is another handy function available with a few tools. Once on the clipboard, the settings can be applied to an image through the menu option Paste under Edit.

Crop ▸ The settings for image size, resolution, and position of the cropping frame can be exported to an .ncc file.

Layout Tools ▸ Layout tools do not support the export of any settings at the tool level. Any configurations generated in layout can be saved only through the drop-down menu under Settings in the scan window.

Curves ▸ The settings for curves can be saved to an .ncv curve file and retrieved later.

Information ▸ This tool displays various image information – saving or exporting settings are not possible.

Color Balance ▸ Color balance files can be saved in the .nca format.

Unsharp Mask ▸ Settings for the tool Unsharp Mask have their own file format, .num.

LCH Editor ▸ The LCH curve data can be saved to .nlv files.

Digital ICE Advanced ▸ Settings for Digital ICE Advanced have their own file format, .nla.

Analog Gain and Scanner Extras ▸ Neither Analog Gain nor Scanner Extras allows saving or exporting settings at the tool level.

Preferences

The basic setup is done in Preferences.

The Preferences option may be opened either with the Preferences button or with the shortcut ctrl + K . Preferences contains configurations to be applied to all scans globally.

File Locations ▸ File Locations shows the path to temporary files. These files should be located on a separate partition with plenty of free space and without too much fragmentation. If the partition is badly fragmented, scanning slows down. If possible, the temporary files and the scan files should reside on a different partition from the operating system, prefereably on a different hard disk.

Save to disk is very helpful for batch scanning.

Single Scan ▸ The menu Single Scan contains the settings Autofocus, Auto Exposure for Positive Film, and Auto Exposure for Negative Film. For manual focusing, Autofocus should be deactivated. Alternatively, you can set the focus point with the focus tool to define the point in the image to be focused on. To do that, leave Autofocus active.

The most important setting in the menu Single Scan is Save to Disk. The image file will be saved directly to disk only if this box is checked. If not, a window with the image will open and you will have to save it manually.

Batch Scan ▸ The settings under Batch Scan for the most part match the ones under Single Scan. There are three additional options.

The option Prompt for This Information shows a selection menu before the batch scan. When prompted, you can double-check the set options before launching the batch scan. This helps getting used to the program in general. Once you have developed a routine, the function becomes superfluous and you can turn it off to speed up your work.

The option Create Scan Log generates a log. This can be useful if problems occur during the batch scan and you want to find out how much time is being spent on a single scan. (Note: this option can be deactivated for daily use – the scanner runs fine without the log.)

The option Stop on Errors stops the batch scan in case of a malfunction and allows you to fix the scan right away.

> ### No Notification after Completion, but Ejection
>
> Nikon Scan offers the option to automatically eject the film after batch scanning to indicate the end of the job. This function can be set with Settings ▸ Batch Scan ▸ Close Window and Eject Film. When the job ends, the scan window closes as well and must be reopened for the next scan.

File Saving

The menu item File Saving lets you define a default file format for saving. This is simply a default that can be changed during the scan.

The option Last Used is even more practical. If you work with different formats, once you choose a specific format, that one remains the default until you change it again.

All the file formats supported by Nikon Scan.

Automatic Actions ▸With the function Automatic Actions, you can automatically generate a preview and thumbnails when a film is inserted. This saves a few mouse clicks. Thumbnails are needed for filmstrip to identify and correct filmstrip offset. Activating one of the options under Thumbnail When Film Is Inserted will start the function automatically.

Automatic thumbnails are always useful, but automatic previews are not.

However, simply inserting the film will not "wake up" the scanner; the scan window must be open, as well.

Whether the option Perform Autofocus When Focus Point Is Used is helpful is a matter of taste. To engage it, you first have to set the focus point in the Tool Palette 1. It is actually faster to initiate a manual focus with the Autofocus

icon in the option area of the scan window. To do that, hold down ⌃ctrl⌄, click on the Autofocus icon, and then click on the desired location in the image. The system will focus immediately without going through Tool Palette 1 first. It is worthwhile checking Multiple Image Adaptor, only if all of your images are of excellent quality. Often the thumbnails can be pre-sorted to avoid the time-consuming task of generating previews for poor images.

Advanced Color ▸The functions under Advanced Color for RGB and Grayscale let you define the White Point, Gray Point, Black Point, and the default for the Auto Contrast Calculations. These functions should be considered for fine-tuning only; the standard settings are quite usable.

Preview Settings ▸Functions under Preview Settings allow for AutoFocus and Auto Exposure for Positive/Negative Film.

If you prefer the highest quality even for the preview, you can activate Multi Sampling and Digital ICE as well. Both prolong scanning time considerably and are not really needed unless you want to tweak the preview for maximum quality. All these settings are irrelevant to the result of the final scan; they only affect the preview. Nikon Scan supports Multi Sampling only for the models 4000 ED, 5000 ED, 8000 ED, and 9000 ED. Not only is it not needed for the preview, but you will not be able to see any quality gain from Multi Sampling in the relatively small preview frame. For Digital ICE it is different. If you use Digital ICE and still see some foreign matter such as dust on the image, you should clean the original one more time before scanning.

The fewer boxes checked, the faster the preview will be generated.

Grid Settings > You can put grid lines over the preview with Tool Palette 1 ▸ Layout Tools ▸ Display Grid. To configure the grid, select Settings ▸ Grid Settings. With this you can use your imagination to freely set grid spacing and line color.

It can be handy to define the grid spacing in pixels. In the sample image below, grid spacing is set to 1535, which corresponds to a 6" wide print at 300 dpi. An enlarged crop for a 4" × 6" print in itself covers over a quarter of the image area.

The grid helps image flaws become more noticeable, such as a tilted horizon; but a correction is possible only later in Capture or Photoshop. Nikon Scan has no tools for straightening.

To make these settings the default, select the option Show Grid for New Windows. With this option, every new review will show a grid. If the grid is bothersome, it can always be turned off in the current window with Layout Tools.

A grid with a particular spacing can help to judge the potential for enlarging crops.

Color Management

The Nikon color management system is supposed to guarantee a consistent color reproduction from scanner through screen display all the way to printed output. If you want to take control yourself, you can deactivate the color management function. When color management is deactivated, the color space is not applied to the image. You get unprocessed RAW data from the scanner. If color management is activated, then a color space transformation will be performed, even when NEF files are used.

Input Profiles / Scanner Profiles

The input profile used by Nikon Scan depends on the scanner model and the film type. It is automatically selected by Nikon Scan and cannot be overridden. Operator error is thereby eliminated. Apart from selecting a scanner and a film type, there are no other ways to configure input profiles. It is not possible to generate your own ICC profiles and apply them to your own scanner. Nonetheless, Nikon Scan comes with working scanner profiles for all supported scanners. SilverFast and VueScan do not include ready-to-use scanner profiles, but unlike Nikon Scan, they let you use your own ICC profiles. With

the Nikon solution, you cannot use ICC profiles to correct changes in the color characteristic of the scanner, which could be caused by an aging light source or by manufacturing tolerances. This is a shortcoming of the Nikon scanner software.

Monitor Profiles

In Nikon Scan, the suitable ICC monitor profile is set with Settings ▸ Color Management > Monitor, but only if color management is activated; otherwise, the tab is grayed out. The ICC profiles chosen here affect the display of the image in preview and during image editing in Nikon Scan. Using the proper monitor profile will ensure that you are correcting the color-cast of the image, not the color-cast of the monitor. The profile affects only the color representation in the image window and scan window of Nikon Scan; other programs remain unaffected. Nikon Scan already includes a number of standard profiles, but using an ICC profile specifically made for the monitor is always preferable.

Selecting the option Use Factory Default Monitor Profile adopts the Windows default configuration, thereby making a custom configuration in the scanning software unnecessary - provided that Windows already utilizes a suitable profile.

Setting Monitor Profile as Windows Standard

By right-clicking on the desktop and selecting from the menu Properties ▸ Settings ▸ Advanced ▸ Color Management, Windows lets you define a monitor profile as the default. In Nikon Scan, if the option Use User Defined Monitor Profile is active, you can choose a different profile.

Color Space Profiles

Nikon Scan supports a number of color spaces that can be set under Preferences ▸ Color Management under the tab RGB. For most applications, Windows users will choose either sRGB or the wider color space Adobe RGB.

In the current version of Nikon Scan (version 4.02), the RGB tab is labeled incorrectly. The color spaces from sRGB through Scanner RGB have a gamma of 2.2. The color spaces with a gamma of 1.8 are Apple RGB, Color Match RGB, and Apple RGB (compensated).

Nikon scanners can read more color information than even that represented by the color space Wide Gamut RGB (compensated). That's why Nikon offers another item on the list with the color space Scanner RGB. This option eliminates conversion to the selected color space, along with its associated color losses. It deals with the entire color range of the scanner's RAW data. Unlike the case in which color management is completely disabled, using

the profile Scanner RGB offers the possibility to work with the LCH Editor and use the Unsharp Mask function. These functions would otherwise be unavailable when color management is deactivated in Nikon Scan.

Color spaces are configured under Preferences.

There are two preconditions that must be met before a selected color space can be embedded in the image file. First, the chosen file format has to support color profiles, which is the case for TIFF and NEF. Second, Nikon Scan has to run in stand-alone mode. In plug-in mode the TWAIN interface does not allow the transfer of color spaces.

Besides RGB, the color model CMYK is also available. Internally, the Nikon scanners work in RGB mode, but they can convert with CMYK profiles. This function is of little interest for home users, but of great interest for prepress.

The topic of color management in Nikon Scan is discussed in great detail in the guide to Nikon Scan 4 color management. This document is available in PDF format for download from the Nikon website. The guide can also be found in the user manual.

Special case Photoshop: Nikon color management is ignored

When scanning from inside Photoshop, the Photoshop settings determine the color space assigned to the image file, not the settings in Nikon Scan. The same applies to other image editors that can use Nikon Scan in plug-in mode. It is the setting of the image editor that is important.

Film Profiles

Nikon Scan includes the film profiles Positive, Negative (color), Negative (mono), and Kodachrome. It is not possible to choose profiles for more specific film types or to generate and apply your own profiles.

VueScan offers many film profiles; Nikon Scan, only four.

Since every film has its own color characteristic, there is no setting which suits all films equally. VueScan and SilverFast use film profiles to convert negatives to a positive image file as true-to-color as possible. These profiles contain color corrections for the individual film types. On the other hand, Nikon relies on a hardware-based conversion; it is supposed to do away with special film profiles.

Still, individual color adjustments can be carried out and saved in Tool Palette 1. To do that, the ideal correction for a film is determined from a test image and then applied either directly during the scan or afterwards to the file. This method is more efficient than correcting the colors for each single image.

Compared to the Nikon method, the film profiles of SilverFast and VueScan are more convenient. Usually it is enough to select the right profile before scanning. The Nikon solution is workable if you prefer to perform your own color corrections instead of relying on standard settings.

Documentation

The Nikon Scan documentation is very good. The online help, which can be started with Help, is rather basic, but there is an extensive reference manual available in PDF format.

The Nikon reference manual is clear, vivid, and informative.

The latest versions of the manual can be found on the Nikon support website. Every function is described in the approximately 140-page manual in great detail. The manual also takes advantage of the features of the PDF format: Hyperlinks allow convenient navigation between scan functions. Even without using Nikon Scan, the manual is quite interesting to read to get a general overview of scanning techniques.

Conclusion

The proprietary NEF file format and its integration into Capture and the viewer is an exclusive feature of Nikon Scan. The disadvantage of the otherwise excellent Nikon Scan support for RAW data is that the ROC, DEE, GEM, and ICE filters are firmly applied to the image. In this regard, VueScan has a more consequent approach. But when the entire workflow is considered, Nikon Scan offers the most convenient way to work with RAW files. No other solution lets you generate RAW data and then view, edit, and save it in different versions. Multiple copies are not even necessary; a single file can do it all.

On the other hand, Nikon implemented color management only half-heartedly. A big disadvantage of Nikon color management is that you cannot apply your own ICC profiles to the scanner. The software includes profiles for each supported scanner, which themselves cannot be modified. The competition is doing better in this regard: SilverFast and VueScan both support color management throughout.

Also, in Nikon Scan, film profiles are missing. This is because Nikon scanners use hardware-implemented functions to control conversion of the negative. All in all, particularly because it is free of charge, Nikon Scan is a serious alternative to SilverFast and VueScan.

VueScan

10

With VueScan, Ed Hamrick has written a lean, but nonetheless powerful scanning tool for the Windows, Mac OS, and Linux operating systems. Neither SilverFast nor Nikon Scan support Linux, so VueScan is the only option for this operating system. Unlike its two competitors, VueScan is purely a scanning program with only some rudimentary editing functions. This is not a disadvantage if you use a good image editor for post-processing. The program offers powerful features with full and impressive RAW support. Also, for editing RAW data, extra, expensive programs are not needed – unlike with Nikon Scan and SilverFast.

Content

Purchase and Installation

There are two versions of VueScan: the standard version, which sells for $50 and the Professional Edition, which sells for $90. The software is available only through download from Ed Hamrick's website, www.hamrick.com. It is advisable to backup the installation files of the version for the purchased serial number, because the website has only the newest versions available for download, which may require a different serial number. The purchase price of the Professional Edition includes updates; otherwise, for updates, you have to request a new serial number. VueScan only comes with an English user interface.

Unlike the professional version, the standard version can neither generate RAW data nor does it support ICC profiles and IT8 calibration. Therefore, for archiving film material, the professional version is the better choice. Currently VueScan supports around 500 scanner models. The license covers any number of scanners you own. (SilverFast is less generous: you need a separate license for each scanner, because there is a program version for each scanner type.)

With a size of less than 3 MB, VueScan installs in a snap. The installer creates the directory \VueScan on the local hard drive, and a shortcut on the desktop for convenient launching, but does not generate any entries in the start menu. To uninstall, simply delete the folder and the shortcut.

VueScan is a standalone program, but it can automatically open the scan file in an image editor for further processing.

Unlike the common plug-in solutions through the TWAIN interface, VueScan does not tie up the photo editor during scanning. You can scan and edit in parallel, which is ideal for batch scanning. The software itself is lean, but the way it works as a RAW editor requires a large amount of memory.

One Scan Is Enough: New Variations Without Rescan

VueScan is designed to scan an image only once. The RAW data of a scan remain in memory until the scan for the next image has begun. It is possible to save the raw data and to make the scan permanently available. Any image manipulation that is possible before the scan, can still be performed later on the RAW files – even hardware-based scratch removal. This is because VueScan saves the infrared channel separately and does not apply it to the image. Neither Nikon nor SilverFast can do that.

Look and Feel

In comparison to the colorful interface of SilverFast, VueScan appears some-
what sparse. Yet, it is structured very logically and is easy to navigate.

The main functions are accessible through the tabs Input, Crop, Filter,
Color, Output, and Prefs. VueScan maintains ease of use despite an abun-
dance of features. Through Options, each tab can be switched between Basic,
Standard, and Advanced to show only the most basic, the most common, or
all options, respectively.

This control of options displayed allows the beginner to slowly get used to
the program's extensive functions. Though the number of options in Advanced
mode can seem overwhelming, there is comprehensive online help available
that describes each function in detail.

The interface of VueScan is simple,
yet functional.

This chapter refers to VueScan version 8.2.30. Since new versions quite often
introduce small changes, the screen shots shown in this chapter may differ
slightly from your version. The display of functions varies according to the
chosen options. Unnecessary switches are hidden. Initially, this can be confus-
ing when looking for a particular function and not finding it. The display also
depends on the scanner model; VueScan only shows options supported by the
particular scanner.

Saving Settings in *.ini Files

The file VueScan.ini stores all configuration changes in VueScan. You can store configurations in this and any other discretely named *.ini file. It makes sense to make separate files for different scanning processes, such as slide, negative, or scan from disk. Stored configurations can be loaded on demand with File ▸ Load Options. To restore the factory settings, simply delete VueScan.ini and restart the program.

Input

Under the Input tab, input options can be found. VueScan not only supports many scanners as input devices, but can also open RAW data from digital cameras and scanners. With the right options, it makes no difference for the program whether the data come from a scanner or from a file. (Note: my attempts to import NEF files from an LS-5000 scanner failed – apparently, VueScan's NEF support refers only to Nikon digital cameras.)

Scans with multiple passes are possible even for scanners without a multi-sampling feature.

The 64-bit RGBI option under Bits per Pixel is especially interesting. With this option, the infrared channel data are saved in addition to the three color channels. The penalty is a 25 percent larger file size compared to a standard RGB scan, but the option allows scratch removal with Infrared Clean afterwards.

Under Scan Resolution, the exact optical resolution of the scanner needs to be set to avoid degrading image quality.

With the Batch Scan option, you can have VueScan generate previews from a folder with RAW files in one go. Depending on the number of images, generating previews can take a while; but later during editing, the function

allows you to quickly scroll through your collection. Unfortunately, there is no thumbnail view like that in SilverFast or Nikon Scan. To switch between images in a batch scan, you have to move the slide Frame Number or type the frame number directly.

The option Number of Samples is available only if the scanner supports multi-sampling (for example, the Nikon Super Coolscan 5000 ED). The screenshot on the previous page was taken with a Coolscan IV, which does not support multi-sampling. In this case, VueScan provides the alternative option Number of Passes. VueScan scans the image multiple times and assembles it to a single file. This is a genuine feature extension compared to Nikon Scan, and by now SilverFast can do it, too.

Automatically Generating and Saving Preview Images

The switch Preview under the option Auto Scan is handy for automatically generating a preview when the original is inserted. VueScan can save not only the actual scan, but also the preview image. The switch Preview under Auto Save will take care of that automatically. This is handy when scanning a lot of material for a quick preselection. Usually, only a few selected images are worth a full scan.

Crop

Sometimes, cropping the scanned image can be a little tricky. Especially in batch mode, cropping can lead to black borders. VueScan has a wide range of options to fine-tune each cropping parameter.

The switch Auto under Crop Size is particularly useful. The software automatically adjusts the size of the crop. It works well for images with normal exposure, but does not always work with dark images, such as night shots.

When cropping the image after the scan, you will always get black borders from the edge of the negative. Although the black edges can be trimmed, they have already caused the exposure to be altered, because automatic exposure treats them as black parts of the image.

The options Buffer and Border are intended to deal with these cropping issues. When enlarging the crop and deliberately scanning with the black border included, the slider Buffer can be used to control the percentage of the image inside the scan frame to be ignored for metering.

Alternatively, you can leave the crop size on Automatic and add a safety margin with the Border function. Now, the automatically selected crop will be scanned with a "safety margin," but only the area inside the crop will be used for metering. Unfortunately, in the preview there is no indication of a margin that VueScan may have added (for example, something like a second frame). You can only guess as to what the affected image area is.

The combination of Auto Crop and Border is particularly useful in batch mode. If the automatic cropping function has cropped the images too much, you will notice the shifted border.

Shifting the Crop Box with the Mouse

By holding down the Shift key, you can use the mouse to move the crop border within the image.

Filter

Under the Filter tab, VueScan's restoration and correction filters are found. Unfortunately, these filters are rather meager compared to Nikon Scan and SilverFast. Restore Colors and Restore Fading are not adjustable; they can only be switched on or off. The same applies to the option Sharpen, but this is less of a problem, since sharpening functions should be turned off for scanning film material anyway.

The red pixels are scratches identified by VueScan.

It turns out to be an advantage that VueScan does not apply any of these filters to the RAW data of the image. Unlike Nikon, VueScan generates true RAW data. No corrections are taken into account with RAW data; corrections are typically applied later in processing.

The Infrared Clean scratch removal does a fairly good job, but it is not as powerful as Digital ICE. The following example again shows that software has a major impact on the result of the scan. The sample image of the lighthouse shows how scratches found in VueScan are marked in red. This is useful for finding the best correction level for the image (Light, Medium, or Heavy).

With VueScan, the infrared channel can be saved separately as an image file.

Color Settings

VueScan's lavish set of tools for color management can be found under the Color tab. ICC profiles for printers, scanners, monitors, and even custom ICC profiles for films can be employed. VueScan also ships with an extensive selection of profiles for common negative films, as well as profiles for Kodachrome and regular slide film.

Though the color management is lavish, VueScan image editing functions are rather poor. There are sliders for RGB brightness and for each of the three channels. Black and white points are best set in Preview History. This function is somewhat sparse compared to Nikon Scan and SilverFast, but VueScan uses a completely different approach from the other two.

VueScan is purely a scanning program; the scanned image is intended to be processed in an image editor after the scan. The image is processed just enough to provide the full image information of the original for later use.

For post-processing, VueScan offers some assistance with Pixel Color. If this option is activated, VueScan color-codes those image areas that still need some work. The scanned image no longer contains these markings.

The function Clipped Black Color marks lost shadow details (on following image in blue). The function Clipped White Color marks lost highlights (on following

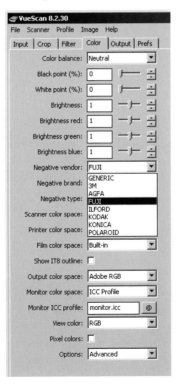

Film profiles included with VueScan.

image in green). Presence of both green and blue pixel markings usually indicates that the settings for Black Point and White Point are off and should be corrected either with the sliders or directly in the histogram.

Lost shadows are blue, lost highlights are green: black and white points need correcting.

Both white and black points should be pulled outwards. The uncorrected curve is clipped, which leads to lost levels.

VueScan does not utilize a gray point for adjusting mid-tones.

With Infrared Defect Color, the program marks identified dust and scratches in color (default is red). The display varies depending on how the Infrared Filter is set up. If the filter is set to Heavy, the program will recognize more pixels as defects than if the filter is set to Light.

Output Parameters

VueScan offers a diverse set of output options. The program can output several image files simultaneously. It is possible to save a scan together with its RAW File and Index File. The index print works just like the corresponding function in conventional photography. VueScan generates a thumbnail from each image and adds it to the central index bitmap. When scanning several films, you should assign different index files to give each film its own index.

The default for RAW files is rawooo1+.tif. The plus sign ensures that VueScan will pick up the count from existing files. Make sure to pick a naming convention that clearly identifies RAW files from regular TIFF files.

The file extensions are the same for these different files, which can be confusing.

In parallel with the actual scan, VueScan can also output thumbnails.

Prefs

The basic configuration of VueScan takes place under the Prefs tab. Configurations are saved in the current *.ini file, where configurations for special scans are also stored. A clean separation of special configurations from global settings would be better. Nikon has solved this problem with its Preferences.

 There are various ways to customize the VueScan interface. For instance, with Single Tab Panel, each tab can be displayed in full-screen mode. This way, you also get a full-screen preview. With External Editor, scanned images can be opened in a photo editor of your choice right after scanning. This is convenient for scanning single images. In unattended batch mode it should be deactivated, however, because it can use up too much memory. The same is true for the switch for Release Memory: this switch controls whether or not RAW data should remain in memory. For single scans, it makes sense to keep RAW data in memory. If you change a setting for the image, you do not have to rescan with the Scan button. It actually suffices to do one more Save, which is much faster. However, in batch mode, this option will dramatically increase the memory requirements.

 The switch Beep When Done is simple, yet ingenious. It indicates the end of a job with a beep tone, which is very handy for batch scans.

VueScan's configurations under the "Prefs" tab.

Keeping Basic Configurations for Different *.ini Files

All configurations of VueScan are stored in *.ini files. To avoid repeating the same configuration steps when using several *.ini files, it is recommended to proceed in two stages: first, create and save a basic configuration with all the settings that are common to all subsequent *.ini files. This includes items such as the ICC profiles of the scanner and the monitor. This configuration can be saved as VueScan.ini, thereby making it the new basic configuration. Next, build additional *.ini files for special purposes – such as slide or RAW data scan – which are then loaded as needed.

RAW Data

VueScan's RAW data processing is a powerful feature. VueScan uses a different approach from Nikon Scan for RAW data processing. VueScan is content with simply writing the RAW data to disk. Unlike with Nikon Scan, it is not possible to edit the RAW data directly. Therefore, VueScan requires a two-step process for editing:

1. Create and save RAW data
2. Generate a regular TIFF from the RAW file that has all corrections firmly embedded. This TIFF image can then be further processed with an image editor.

As far as storage is concerned, this method is more costly than the Nikon solution. At least two files exist for each image. Although VueScan RAW files can be opened with a normal photo editor, the results will be unsatisfactory because gamma correction is missing. Only in the preview can the image be evaluated. This does not make it very easy to sort through RAW files. VueScan does not offer a browser view comparable to those provided in Nikon Capture or SilverFast HDR.

As an uncorrected RAW file, this image is more suitable for a house of horrors than for the viewer.

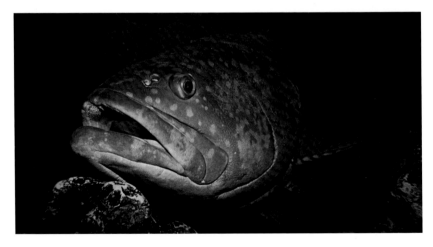

Without a doubt, the Nikon solution is more convenient than VueScan. With the scanning software, the viewer, and the Capture editor you get three well-matched components for a smooth workflow.

The killer feature of the VueScan RAW files – the ability to apply filters later – has only limited appeal. The quality of the filters could be better.

Overall, VueScan has an interesting approach for RAW data processing. But, in my opinion, the VueScan solution is too cumbersome for an amateur who wants to archive a slide collection without complications.

Documentation

The VueScan documentation leaves a mixed impression. The program does have extensive online help that describes all functions, but there is no search function for its content. Still, you can search each chapter with the browser. The documentation is accurate, but it is obvious that it was written by technicians. There are no illustrations, only abstract descriptions of the functions. This does not make for very lively reading.

Only the mathematically minded will appreciate the austere beauty of the help files.

Conclusion

VueScan offers genuine RAW data support and sophisticated color management at a comparatively low price. Despite its logical layout, the interface is rather plain and takes some getting used to. Image editing functions are very basic. Unlike Nikon Scan and SilverFast, VueScan is a program intended purely for scanning. In connection with a good photo editor such as Photoshop, it provides an exceptionally rich set of functions. For the technically inclined, VueScan offers a number of capabilities that are not available with Nikon Scan or SilverFast. Among the three products, VueScan provides the most inexpensive way to use the same interface for flatbed and film scanner.

SilverFast

LaserSoft Imaging offers the SilverFast family of programs for scanning and image processing. The basic advantage of the SilverFast family is the consistent user interface used throughout the products. Once you are familiar with the scanning programs SilverFast Ai or SilverFast SE, you will feel right at home with the RAW editor HDR. The extensive image processing functions of SilverFast Ai reach beyond what Nikon Scan and VueScan provide.

11

Content

SilverFast SE, Ai, Ai Studio, and HDR

Look and Feel

Set Basic Configuration with Options

Image Processing

RAW Processing with SilverFast HDR

Documentation

Conclusion

SilverFast SE, Ai, Ai Studio, and HDR

Several versions of SilverFast are available. The basic version, SilverFast SE, is available for download from www.silverfast.com for $49. Many scanners are packaged with a free copy of this version. The advanced version, SilverFast Ai, has an enhanced set of functions and is more suitable for demanding scans than SilverFast SE. Consequently, I will refer mainly to SilverFast Ai in this chapter.

SilverFast supports more than 200 scanner models. Each version is compatible with only one specific scanner model. For compatibility with other scanner models, additional licenses would need to be purchased. The prices for the various Ai versions depend on the scanner model. For example, the price for a Coolscan V is $218; for a Coolscan 9000 the price is $418. SilverFast is the most expensive scanning software on the market.

For SilverFast SE and Ai, extended versions are available which are the SE Plus and Ai Studio, respectively. The main additional features of these extended versions are AACO and Multisampling. Ai Studio offers further improved functions, such as a 16-bit cloning tool. With the Ai versions, you can scan images to the proprietary RAW format TIFF-HDR and save these to disk. These files can later be edited with SilverFast HDR.

The SilverFast HDR user interface is very similar to the SilverFast Ai interface; there is little difference between the two in usage, whether you access a scanner in Ai or open a RAW file from your hard disk with HDR.

Installing the Scanning Programs

You can install SilverFast SE or Ai, either as a standalone program or as a Photoshop plug-in. In the standalone form, you must go through the SilverFast Launcher to start the program.

Error Message with Filmstrip Adapters

Before starting SilverFast with Nikon scanners, film must already be inserted in the filmstrip adapter. If the adapter is empty, the program will display an error message and will not start.

Look and Feel

The SilverFast interface consists of several windows that can be freely arranged on the screen, but the size of the windows can be changed only to a certain extent. The layout is most suitable for large monitors common in image processing. SilverFast is rather slow running on a 2.4 GHz Pentium; its many functions seem to hog computer resources.

The user interface is divided into several individual windows.

SilverFast Main Window

In the main window, you can set all important scan parameters, such as resolution, color depth, and image type. For scanning, you need to specify whether you want to scan in normal mode or in batch mode. One special feature of SilverFast, not found on Nikon Scan or VueScan, is a setting for *Image Type*. With that setting, you can select preconfigured filter settings for various types of subjects and lighting conditions. This is handy when you first start using the program, since you can quickly explore several variations without needing a lot of background knowledge as to how those settings work.

In the main window, you can set scan resolution, color depth, filters, and image type.

The icons in the ScanPilot

Prescan

The prescan window shows a preview and a row of buttons for activating or deactivating various scanning options. The prescan window allows you to preview configuration changes. Unfortunately, it does not offer the Natural/ Processed tabs that Nikon Scan does for quick comparison, which makes it difficult to keep track of elaborate changes. All changes are updated instantly in the prescan window. Unlike Nikon Scan and VueScan, SilverFast does not have the option to generate prescans for an entire filmstrip in one go, and then switch freely between images. This can be annoying when working with a scanner with a filmstrip adapter: every time you switch to a new image, you will need a new, time-consuming prescan. The only way to avoid this problem is by scanning and saving images one-by-one with the JobManager.

The SilverFast prescan window

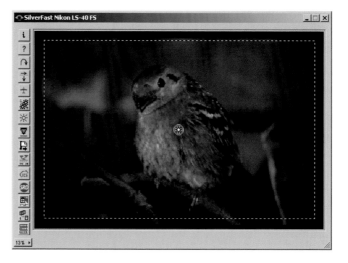

Overview

With Overview, you get a quick idea of what is on the filmstrip. Double-clicking on a thumbnail starts the prescan. Unlike the function in Nikon Scan, the index view in SilverFast can be printed. The print function for thumbnails in VueScan is actually superior, since several filmstrips can be grouped together in one file for printing. SilverFast's Overview does not allow you to rotate images or to correct the filmstrip offset.

Image preselection
in the Overview window

NegaFix

As with VueScan, SilverFast comes with a long list of film profiles for the color correction of negative films. When selecting the option Negative under the General tab in the main window, the NegaFix window pops up. SilverFast also allows you to generate and import your own film profiles. You

NegaFix has individual profiles for all common types of negative film

can also fine-tune the profiles using a slider. The option Neg.Direct is available specifically for Nikon scanners only; instead of the NegaFix profiles, this option uses the hardware-based negative conversion of the Nikon scanners. This option is useful if NegaFix does not have a profile for your particular film type, or if a profile is available, but you are not satisfied with the resulting image quality. SilverFast in Neg.Direct mode, as well as Nikon Scan, both resort to the Nikon Maid libraries for analyzing the film.

Densitometer

The Densitometer displays output values relative to the input value for a small area under the cursor. This is useful for editing colors. If you scan mostly for archiving and do not do much editing, you can just click to close this window. Once this window is closed, the Densitometer can be found under the third tab of the SilverFast main window.

Densitometer display

Picture Settings

Under Picture Settings, brightness can be adjusted with Exposure, and colors can be made warmer or cooler with White Balance. Mid-tones can be adjusted with Brightness (mid-tones); the gray eyedropper performs the same function. Contrast and Saturation complete the menu. In Nikon Scan, color saturation can be adjusted with the LCH Editor. SilverFast's solution with Picture Settings is less powerful, but more user-

Real-time histogram for output values

friendly: histograms are shown in real-time, which sets them apart from the other histograms used for corrections in the program.

Real-time histograms give a good view of the level distribution of the scanned image even before the scan is made.

JobManager for Batch Scans

JobManager allows the user to define tasks that the program must execute unattended. Typically, this is used for processing film-strips. In the SilverFast scanning programs, the job settings are defined for images in the scan queue. In the editor, HDR can handle any image files. For flatbed scanners, it is even possible to create a scan queue with a mix of black and white negatives, color negatives, and color slides in any order. For Nikon scanners, JobManager cannot jump between the modes Negative and Neg. Direct. The user must select one or the other. Once the batch is done, the program sounds a beep, just like VueScan.

I worked with version v6.4.2r2b of SilverFast Ai and found file naming very weak and cumbersome for multiple consecutive batch scans. SilverFast is aware of this shortcoming and intends to improve the situation in later versions.

Set Basic Configuration with Options

"General" Tab

The General tab in *Options* allows the user to overwrite SilverFast's default setting. This only works, however, if a custom setting has already been defined under Frames ▶ Settings ▶ Save. This is particularly useful if the majority of scans use the same basic setting.

"Auto" Tab

In order to scan filmstrips at full format, there is an option in SilverFast for Frame Inset. With that option, the exposure metering ignores a certain percentage of the edge of the selected scan area. Unfortunately, there is no preview for this function, and one can only guess the size of the actual area that is used for metering. With Frame Inset, the black borders included in the scan will not affect the exposure. VueScan offers a similar feature. In Nikon Scan, where this function would also be very helpful, there is no comparable feature.

"CMS" Tab

The full version of SilverFast Ai includes an IT8 calibration target. SilverFast makes it very easy to calibrate the scanner properly. In the prescan window, there is an icon for IT8 Calibration, which lets the user generate a scanner profile with a few mouse clicks and apply the profile under Options. The result can then be checked in the prescan window. The IT8 Calibration icon is active only if a scanner profile has been assigned.

Settings for the color management

"Special" Tab

In SilverFast, the analog gain is hidden in Options under the tab Special, and is accessed under the term Lamp Brightness. In Nikon Scan and VueScan, the best setting must be found by trial and error. This can be tedious, since each new setting requires a new preview scan. SilverFast has a better solution in the form of a real-time histogram for the estimated effect on the image. For some unknown reason, this Lamp Brightness feature is placed under Options, where it globally affects all scans. A classic use for the analog gain control is for correcting the occasional underexposed or overexposed image; it would make more sense to place this control at the frame level.

Analog gain in SilverFast with real-time preview

Speeding up Scans

If you use the preview image mainly for setting the crop and the black/white points, then you do not need a high-resolution color preview. Instead, you can use the switches Prescan Draft and Prescan Monochrome, and reduce the time for scanning the preview image. Avoid activating Scan Draft, as this feature severely reduces the quality of the full scan.

Image Processing

Image processing in SilverFast is extensive and greatly exceeds the abilities of VueScan and Nikon Scan, let alone the common TWAIN drivers. SilverFast offers many functions of a full-scale image editor. Therefore, the program is well suited for image processing during scanning.

A selective color boost makes the blue sky, as well as the green and red tones, more vibrant.

Selective Color Correction (SCC) and the Clone Tool are two good examples of advanced image processing functions. SilverFast does not reach the depth of Photoshop, of course. Whether or not the enhanced functionality of SilverFast is needed, depends on which workflow is chosen. If you post-process in Photoshop anyway, then VueScan and Nikon Scan will be sufficient.

For space reasons, I will elaborate only on color correction here. A complete overview of all options and functions can be found in the excellent SilverFast PDF manual. SCC is similar to the Nikon LCH Editor, but it is easier to use. Furthermore, in SilverFast, corrections can be restricted to certain image areas with the use of masks, which is not possible in Nikon Scan.

In the first step, take the eyedropper and pick the color to be changed. In the example on the previous page, it is the green of the excavator. To boost the green, draw a line from the center of the disk toward the green point on the outer circle. Next, select the color of the blue sky and boost it the same way. With SCC you can boost selected colors, change their characteristics, or even replace them completely. The easiest way to change color characteristics is to assign different output values to the colors in the table. The densitometer comes in handy here; it displays all color changes in real-time.

RAW Processing with SilverFast HDR

SilverFast HDR supports not only RAW files created with SilverFast Ai, but also various RAW files from digital cameras.

Creating RAW Files

With Ai you can save RAW files in the formats 48-bit HDR Color and 16-bit Grayscale. The latter format saves storage space for black and white images, but using it can cause problems later, since not all image editors fully support grayscale mode. Unlike VueScan, SilverFast does not save the infrared channel separately in HDR. Doing an ICE correction later is not possible. Still, all other SilverFast filters can be applied to the RAW data afterwards, such as GANE for grain reduction.

As with VueScan, SilverFast does not save changes directly in the RAW data. Both programs write a second file and leave the RAW file to serve as a *digital negative*. Nikon's NEF concept is more user-friendly, since everything is contained in one file.

RAW files are saved in the HDR TIFF format

Preselection on the Virtual Light Table (VLT)

The virtual light table helps sort and organize RAW files for processing in HDR. In addition to a number of RAW formats from cameras, HDR can also handle the SilverFast Ai TIFF-HDR format. It does not recognize scanner NEF files, but supposedly does recognize NEF files from cameras. The program supports the following camera formats: CRW (Canon), CS (Sinar), DCS (Kodak), MRW (Minolta), ORF (Olympus), RAF (Fuji), RAW (Leica, Panasonic), SRF (Sony), and X3F (Sigma). TIFF RAW files from VueScan cannot be processed, since they have no gamma correction.

Sorting and selecting your negatives on the virtual light table

SilverFast VLT is the file browser and image management software from LaserSoft Imaging. With SilverFast VLT, files to be opened in HDR can be selected by double-clicking the files on the light table. As soon as HDR opens a file, VLT closes, which initially can be confusing. The light bulb in the JobManager or in the prescan window allows the user to switch between HDR and VLT.

The link between HDR and VLT is the JobManager. JobManager is always required for batch processing. Files are processed by selecting them with the mouse and dragging them into the JobManager window.

When adding a file, the Options window opens and prompts for Settings and Picture Type. Only then will the image be added. Clicking on the Processing icon opens the image in HDR. Only one image may be open at a time. Overall, the way VLT is handled in connection with scanner RAW files is not very intuitive. Only VLT or HDR, but not both, can be open at one time, which is a problem since it is often necessary to jump between them during image processing. Especially with larger monitors, it would helpful to keep the VLT open next to HDR.

Scans from Disk with HDR

The user interface of HDR is in many parts identical with SilverFast Ai

Working with HDR differs only slightly from working with SilverFast Ai. One obvious difference is the absence of ICE, because in the SilverFast RAW format the infrared channel is not stored separately. ICE must be invoked during the scan. However, batch processing

The EXIF data also contain information about the scanner and the scan

of filmstrips is much more convenient in HDR than in Ai. With the JobManager, you can easily click your way through a long list of files. Previews will update to the selected image within seconds.

Using HDR makes sense if you split the scanning process into two steps: first, scan RAW files with only minimal adjustments. Then, add them to the JobManager with VLT. In JobManager, set the parameters for each image and save them. After all images have been prepared in this fashion, click on Start to begin the batch processing. Without any further user interaction, all images will then be written to the predetermined file location.

RAW Conversion of an HDR Negative: Also Possible in Photoshop

Unlike the gamma-uncorrected VueScan RAW files, HDR files can be easily converted in Photoshop. First, reverse the colors with Image > Adjustments ▶ Invert. This provides a positive, but it still requires some serious color correction. The easiest way to correct color is with Image ▶ Adjustments ▶ Auto Levels.

It is helpful to scan a bit larger and include the frame border. This portion of the negative is a perfect reference for the color black (for example, to be selected using the black eyedropper).

SilverFast conveniently displays the white point to help with the white balance. In Nikon Scan, you have to find the white point yourself.

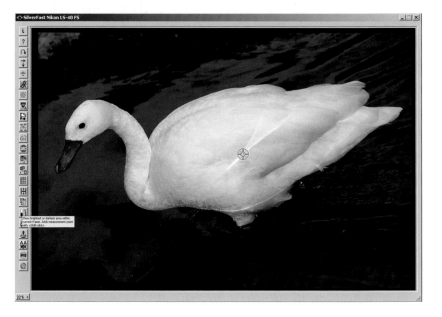

Documentation

None of the competitors has documentation as detailed and extensive as SilverFast. PDF files and video clips lead you through all the sophisticated software features.

The main SilverFast document is a 450-page manual in PDF format. The extent and quality of the PDFs, which can be downloaded free of charge, are actually better than the official SilverFast guidebook, which costs $23. For many functions, there are clear examples with images. In the program itself, most buttons display context-sensitive help when the curser hovers over them.

The 450-page SilverFast manual in PDF format has almost 32 MB.

Conclusion

Just like VueScan, SilverFast is a program that supports many scanners and often gets more out of slides or negatives than do the TWAIN drivers included with most scanners. LaserSoft's restrictive licensing policy can be quite costly, especially if you own several different scanners. Also, it is not quite clear why the Ai version for the Coolscan 5000 is priced so much higher than the same version for the Coolscan V.

The main feature differentiating SilverFast Ai from Nikon Scan and VueScan is the extended set of image editing functions in SilverFast Ai. The high cost of SilverFast can be justified only if you actually do all image processing during scanning, and not in Photoshop afterwards. However, doing most of the image processing in Photoshop, or any other good editor, is actually a far better approach.

One nice thing about SilverFast is that the scanning program, image editor, and image management functions are all very well integrated. However, the user interface, with all its scattered windows, is a real weak point of SilverFast. Working with SilverFast is quite clumsy without a large monitor. The workflow for batch scanning with the filmstrip adapter also shows clear weaknesses – in particular, there is no cache for prescans. On the other hand, the many automatic functions in the program are helpful for the beginner. Even advanced users will find the excellent product documentation very useful to help them exploit the full spectrum of SilverFast's functions.

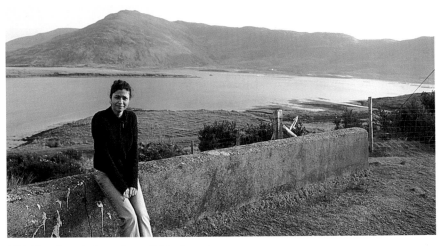

With Nikon Scan the image has a slight color-cast

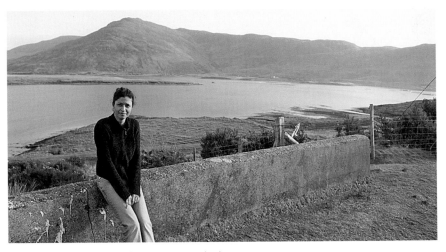

The IT8-calibrated SilverFast shows more neutral colors

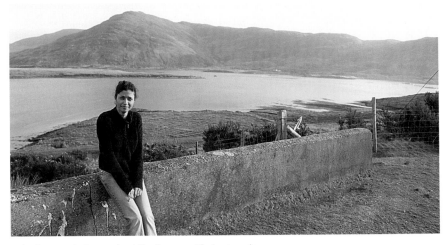

In both cases, the image should be fine-tuned for best results

Scan Workflows

The workflows introduced here have been proven in actual use with several thousand slides and negatives. To speed up processing, the editing functions of the scanning software are rarely used during scanning. The first priority is to capture the originals in full quality in a reasonable amount of time and get them onto the hard disk in the form of RAW data. This is always the primary goal when trying to efficiently process a large quantity of material. There are many opportunities for creative processing with an image editor after the scan has been completed - and they do not require spending time waiting for the scanner, either.

12

Content

Vital Corrections before Scanning

For technical reasons, the following settings must always be set prior to scanning. Any options not mentioned here can be taken care of later, either in the scan software or during image editing with Photoshop.

1. Set Scan Resolution

To archive originals in good quality, it is recommended that they be scanned at the optical resolution of the scanner. It is no problem to down-sample the scan later. It does not work the other way around, though, since up-sampling only increases file size without gaining image information.

2. Select Sufficiently Large Crop

Anything that has been cropped too tightly cannot be magically restored later. However, cropping too generously affects the exposure with Nikon Scan, because the black film border will be taken into account to determine exposure. It is different for VueScan and SilverFast. With these, the border can be configured freely, yet can be ignored for exposure metering. At any rate, it is always important to capture the entire image.

3. Set Focus

Only a correctly focused original can generate a sharply scanned image. For a flat film material, autofocus works quite reliably in most cases. Warped originals require a manual focusing point. It is best to flatten warped originals in a stretching frame prior to scanning. Only then can the scanner capture the entire area sharply.

4. Adjust Analog Gain

Adjusting the scanner's light source can compensate (within limits) for underexposure and overexposure in the original. This physical effect cannot be reproduced by subsequent correction in an image editor.

5. Perform Scratch Removal with ICE or FARE

Neither Nikon Scan nor SilverFast can perform an ICE correction after scanning. VueScan, on the other hand, can store the infrared channel in the RAW data and can later perform the function Infrared Clean.

6. Set Level Adjustments: Shifting Black and White Points

Spreading out the level spectrum before the scan optimizes the level distribution in the image. The correction can also be performed after the scan, but with a somewhat inferior result. The next section compares the effectiveness of level adjustments before and after scanning.

Level Adjustment: Before or after the Scan?

In many cases the original does not fully utilize the entire tonal range from 1 to 255. By setting the black and white points, or by manually adjusting the curves, the level spectrum can be spread out either before or after scanning. Applying a correction before the scan is always best. In that case, the scanner does not waste data on levels that do not even exist in the image. Correcting before the scan distributes the levels evenly.

8-bit scan: on the left, the original condition; in the middle, corrected after the scan; and on the right, corrected before the scan.

As can be seen from the example, stretching the levels after the scan deteriorates the image. The subsequent correction caused massive drop-outs in the levels. The correction before the scan is significantly better, but even here there are undesirable spikes in the 8-bit file. The second example was scanned with a 12-bit color depth. The subsequent correction generates fewer drop-outs in the levels, which demonstrates the effect of the 12-bit format having bigger reserves. But, even with 12-bit format being used, the result of the correction before the scan is a little better than the correction afterwards. The greater the color depth of the scan, the greater the reserves will be.

The 16-bit scans of modern scanners provide plenty of margin for later corrections. Still, if possible, the black and white points should be set prior to the scan to fully utilize the scanner.

The same sequence as the previous example, but scanned with 12-bit. Here the curve shows hardly any drop-outs.

Nikon Scan Workflow

Scanning Slides Individually and with a Slide Feeder

1. **Change and Save the Default Settings**

 Set ICE to Normal and the color depth to the maximum supported (12-, 14-, or 16-bit). Activate ROC and GEM only if needed. In conjunction with ICE, the suppression of hard edges with GEM is already evident at level 1. Do not use DEE.

2. **Create Preview**

 Under Settings and Automatic Actions, simply inserting the slide triggers the preview.

3. **Adjust Preview**

 Position and adjust the crop, if needed. Set black and white points. Alternatively, use the sliders for Curves. For warped originals, manually set the focus point on a key detail in the image. Set Analog Gain only for severe underexposure or overexposure.

4. **Scan**

 Save the scan as NEF or TIFF.

5. **Post-Process with Capture or Photoshop**

 Finalize cropping, set gray point, and rotate images. Optimize brightness and contrast with Curves. Eliminate color-casts with the gray eyedropper. Balance shadows and highlights with either D-Lighting or Shadow/Highlight.

Special Note for Batch Scanning with Slide Feeder

Skip steps 2 and 3 when batch scanning. After a set of default settings are saved, Slide Feeder Scan will let the scanner run for up to 99 frames. The level adjustment can be performed afterwards in step 5 with Capture or Photoshop.

Nikon Scan: Batch Scanning of Negatives with Filmstrip Adapter

1. Change and Save the Default Settings

Set ICE to Normal and the color depth to the maximum supported (12-, 14-, or 16-bit). Activate ROC and GEM only if needed. In conjunction with **ICE**, the suppression of hard edges with GEM is already evident at level 1. Do not use DEE.

2. Generate Thumbnails, Correct Filmstrip Offset

Automatically start the index scan with Automatic Actions under Preferences. Manually correct the Filmstrip Offset, if needed. Preselect images and manually start the preview for only the chosen images.

3. Assign User-Defined Settings and Adjust Preview

Mark previews on the index and assign settings. Set the suitable crop for each image by hand. Set black and white points. For warped originals, manually set the focus point on a key detail in the image. Set Analog Gain only for severe underexposure or overexposure.

4. Scan

Save the scan as NEF or TIFF.

5. Post Processing with Capture or Photoshop

Finalize cropping, set gray point, and rotate images. Optimize brightness and contrast with Curves. Eliminate color-casts with the gray eyedropper. Balance shadows and highlights with either D-Lighting or Shadow/Highlight.

Do not Assign Settings for the Batch Scan before the Preview!

Only when settings are assigned to the individual images after the preview can they be completely implemented for the scan afterwards. If the settings are already assigned to the thumbnails, the images will reset to the default after the preview. According to the manual, this strange behavior is not a bug, but rather a feature of Nikon Scan.

SilverFast Workflow

Digitizing Black and White Negatives

1. **Generate an Overview Scan**

 Select the desired image from the overview scan; the preview will start automatically.

2. **Adjust PreScan**

 Set the crop and, if needed, rotate or mirror the image. Set the black and white points with either Histogram or Auto Adjust. For warped originals, manually set the focus point on a key detail in the image.

3. **Remove Scratches with SDR**

 SDR requires a second pre-scan. For that, the output resolution must be set to the final value. Set SDR to Expert Mode, and configure Dust and Scratch Removal, as well as Defect Size. Check the preview window for defects (marked in red).

5. **Scan**

 Start the scan in 16-bit grayscale.

6. **Post-Process with Photoshop**

 Fine-adjust Midtones (gray point) with Levels, tune brightness and contrast with Curves. Balance shadows and highlights with Shadow/Highlight.

No Batch Scanning with SRD

Manual scratch removal for each individual image cannot be automated. Therefore, it is not possible to automate batch scans for black and white negatives. Currently, SRD cannot even be used with the JobManager. Alternatively, all images can first be scanned in RAW format, and the RAW data can then be edited in SilverFast HDR. This way, at least for step 2, there is no wait for the scanner.

VueScan Workflow

Scanning Single Slides

1. Set Defaults for RAW Data

Set Crop Size to maximum, deactivate all filters, and for Output set the option RAW File in the 64-bit RGBI mode. Save settings with Save Options.

2. Generate and Adjust Preview

Through Auto Scan in Preview, a preview will automatically be generated when a slide is inserted. Roughly set Black Point and White Point. For warped originals, manually set the focus point on a key detail in the image. In case of severe underexposure or overexposure, set analog gain with Red/Green/Blue Analog Gain.

3. Scan and Save

VueScan automatically saves to hard disk if Auto Save is set to Scan.

4. Load RAW Data

Switch Source to File, and open RAW files from disk. In Batch Mode, with sufficient memory, an entire folder can be opened and placed in a cache. Film profiles should only be set for Kodak; otherwise, use Generic.

5. Process and Save the Scans from the Hard Disk

Treat RAW data like a scan from film: Set Infrared Clean and other required filters, such as Grain Reduction. The Preview window provides feedback. Cropping is most convenient with Crop Size: Auto. Keep the option Auto Rotate active. Save as 48-bit RGB. Save the defaults, to simplify switching between modes.

6. Post-Processing with Photoshop

Fine-tune Black Point, White Point, and Midtones (gray point) with Levels. Tune brightness and contrast with Curves. Rotate and mirror, if needed, with Rotate Canvas. Balance shadows and highlights with Shadow/Highlight, as needed.

VueScan: Scanning Negative Strips with the Filmstrip Adapter

1. Change and Save Defaults for RAW Data

Set Crop Size to maximum, deactivate all filters, and for Output set the option RAW File in the 64-bit RGBI mode. Save settings with Save Options. Leave Batch Scan set to Off.

2. Generate Preview and Correct Filmstrip Offset

Manually generate a Preview for the second image, and manually correct the filmstrip offset. It makes no sense to generate all previews and set the black and white points at this stage, since the current setting always overwrites the values of all the other images. With VueScan, the same default settings apply to the entire filmstrip.

3. Scan and Save

Change Batch Scan to All. Use Scan to start the batch scan. VueScan automatically saves to hard disk if Auto Save is set to Scan.

4. Open RAW Files

Set Source to File, and open RAW files from the hard disk. Select a suitable film profile.

5. Process and Save the Scans from the Hard Disk

Working with scans from the hard disk is fast. Therefore, process and save each image individually for best quality. To do that, set Batch Scan to Off. Set the black and white points. Preferably use manual crop. Set Infrared Clean and other required filters, such as Grain Reduction. The Preview window provides feedback. Save as 48-bit RGB. Save the defaults to simplify switching between modes. Batch process the scan.

6. Post-Process with Photoshop

Fine-tune midtones (gray point) with Levels. Tune brightness and contrast with Curves. Rotate and mirror, if needed, with Rotate Canvas. Balance shadows and highlights with Shadow/Highlight.

Nikon Capture Editor

The photo editor Nikon Capture is part of the Nikon system.
The other two components of the system are Nikon Scan and Nikon
View. Nikon View also includes the simple Nikon Edit program that
provides some very basic editing functions; but proper image
editing is possible only with Capture. The full version of Capture
sells for $99, and a trial version is available for download from the
Nikon support website. Capture has almost no competition among
NEF file editors. No other system allows you to work with scanner
RAW files as conveniently as Nikon. This is the real strength of
Capture, since Photoshop has more powerful tools for TIFF and
JPEG files.

Content

RAW Processing in Capture
The User Interface
D-Lighting: Successor to Digital DEE
Capture NX

RAW Processing in Capture

Differences from Photoshop

*Capture Editor: simple features,
but all essentials are there.*

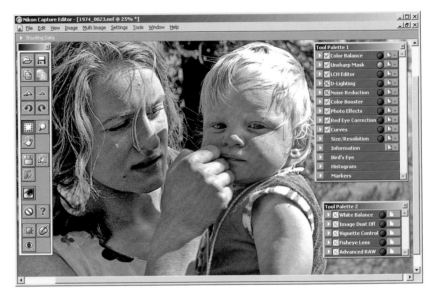

In a feature-by-feature comparison, Capture comes out inferior to Photoshop; but this is not terribly important, since few users actually need all the functions provided by Photoshop. Capture Editor has all the essential tools necessary to put the final touch on scanned images. Its strength is in RAW processing. Indeed, Photoshop can also open and edit NEF files; but after processing, it cannot save those files in NEF format. Instead, Photoshop has to create an additional file when saving. This costs more storage space; moreover, it is somewhat unwieldy to have multiple file versions of the same image.

As mentioned earlier, when Capture is used to save NEF images, the image enhancement settings are saved separately from the original image data. Therefore, there is no danger of ruining the image irrevocably with editing flaws. Photoshop uses a fundamentally different approach. With regular image files, it applies changes directly to the original image data – unless you work on a copy. Actually, Photoshop adjustment layers can be saved, but many viewers cannot display them. With the feature Markers, Capture has solved the problem of managing different versions in a much more elegant fashion. The digital negative in NEF format remains untouched, while several versions can be stored in parallel, in a single file, and conveniently recalled on demand.

Capture was developed primarily for Nikon digital cameras, which is the reason NEF files from the scanner cannot utilize Capture to its full extent – digital camera functions are not supported with scanned NEF files.

Capture provides all basic image editing functions, such as curves, levels, color corrections, and cropping. Unfortunately, Capture does not provide

functions for subsequent scratch and dust removal. Thanks to ICE, this is not a problem for color originals; but for black and white scans, it is a problem. Other image editors (for example, Photoshop) that have tools for scratch and dust removal can be coupled with Capture for additional processing.

For example, directly from within Capture Editor, any image file format can be opened in Photoshop. It is not necessary to save those files first.

Such details show the goal of the Nikon developers: Capture is very well-suited for processing and archiving RAW data, but more sophisticated image editing functions remain out of reach.

This is where Photoshop comes into play with a wide range of features for creative image editing. Ideally, both programs can be combined for full processing. Whenever you reach the limits of using Capture, you switch to Photoshop. Still, the capabilities of Capture are perfectly adequate for processing a vast majority of images.

Apart from NEF, Nikon Capture also supports TIFF and JPEG, although with certain limitations. For example, Capture cannot open a TIFF file that has been created with SilverFast. Photoshop, on the other hand, has no problem doing so.

Upgrade to New Features in Capture with Updates

At this printing, Capture Editor still ships with version 4.1, yet Nikon's support website already has versions 4.2, 4.3, and 4.4 available for free download. Further updates will follow. It is recommended to update your program when a new version comes out. New versions not only fix known bugs, but also introduce new features. This is the way the palettes D-Lighting, Photo Effects, Red Eye Correction, Histogram, and Markers were added – all useful features that make working with NEF files much more convenient.

New features available with the upgrade to version 4.4

Tilted horizons can now be corrected directly in the RAW files with Straighten. Additionally, performance has increased noticeably for working with NEF files: whereas refreshing the view in Multi Image can test one's patience in version 4.1, the refresh function is much faster in 4.4. The same applies to Nikon Viewer.

In version 4.1 it was not possible to achieve a reasonable crop for JPEG or TIFF images: the position of the crop rarely matched the selected image area. In version 4.4 this is no longer a problem; crops from JPEGs and TIFFs are accurate.

Enter Registration Code before Update

To upgrade from version 4.1 to 4.4, first you must have registered version 4.1. Even if you have obtained a registration code for version 4.1, you cannot upgrade to 4.4 before registering the earlier version. The reason is that the length of the registration code changed from version 4.1 to 4.4. Only after you have successfully registered 4.1 can you upgrade to the newer version.

Lossless Rotation of JPEGs

It is somewhat annoying that Nikon Capture compresses JPEG files anew each time they are saved. Because of this, it is impossible to rotate JPEGs without a lossy recompression. Nikon View can do lossless rotation of JPEGs, although this feature does not work for all resolutions. Photoshop is far superior in this regard: with Photoshop, JPEGs can be rotated without new compression.

Nikon View cannot handle lossless rotation of JPEG files at every size.

The User Interface

Capture's user interface is simple and easy to figure out in a short amount of time. It comprises Quick Tools, several palettes, and the Multi Image light box. A beginner can quickly grasp the concepts of editing with Capture, which is not necessarily the case with Photoshop. The modular structure of Capture allows each modification to be reversed. At any time, results in the edited image can be compared and checked against the initial version.

Multi Image Light Box

Multi Image shows an index view of all images in the current folder. It is convenient for selecting images to be worked on. Multi Image is not as suitable for viewing images; for that, Nikon View is faster. Besides preselection, Multi Image is also useful for batch processing. Image adjustments can be copied to the clipboard and pasted into other files with ctrl + V . Clicking on a single

image in the index automatically refreshes the display in the image area. For multiple selections, hold down Shift ⇧ while clicking on the images with the mouse.

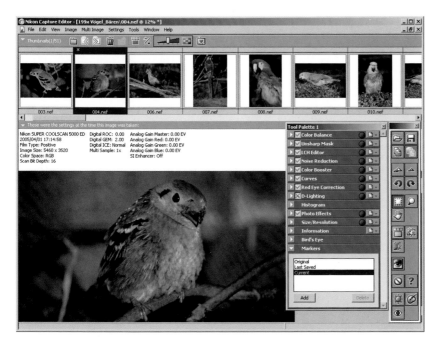

Images are preselected on the Multi Image light box.

By default, the light box is a single row: with the icon Switch Thumbnail List, it can be switched to a multi-row index. This is handy when a large monitor is used for display. In the current version, unusable images can be directly deleted, which was not possible in earlier versions.

Palettes

The editing functions of Capture are organized in palettes. They are, for the most part, identical to Nikon Scan palettes; however, Capture's palettes always remain in the foreground.

Palettes in Nikon Scan, which overlap with the scan window, will jump into the background as soon as you click on the scan window. This becomes annoying after a while. In Capture, on the other hand, you can arrange your own palettes on the screen by using the mouse. For example, you can tidy up the Capture workspace

Deactivated functions are marked with a red "x."

by moving any function that cannot be used with scanned NEF files to its own palette. The program numbers the palettes sequentially. Naming palettes individually would be better, but that function is not supported.

If you want to place a function into its own palette, simply drag it from its current palette. For example, when the function Unsharp Mask gets its own palette, the palette is called Unsharp Mask Palette. Another very useful feature

Find Tool is handy when you can't find a tool right away.

Find Tool	
Name	**Location** ▲
● Color Balance	Tool Palette 1
● Unsharp Mask	Tool Palette 1
● LCH Editor	Tool Palette 1
● Color Booster	Tool Palette 1
● Curves	Tool Palette 1
● Noise Reduction	Tool Palette 1
● Red Eye Correction	Tool Palette 1
● D-Lighting	Tool Palette 1
● Photo Effects	Tool Palette 1
Histogram	Tool Palette 1
● Size/Resolution	Tool Palette 1
Information	Tool Palette 1
● White Balance	Tool Palette 2
● Image Dust Off	Tool Palette 2
● Vignette Control	Tool Palette 2
● Fisheye Lens	Tool Palette 2
● Advanced RAW	Tool Palette 2
Bird's Eye	Tool Palette 7
Markers	Tool Palette 7

Go to tool Close

is that each function can be activated or deactivated individually for a quick before/after comparison. This allows the effects of adjustments to be checked and corrected, if necessary.

The workspace layout can be restored with Reset Tool Positions in the View drop-down menu. At the tool level, current settings can be reused with Copy to Clipboard; with ctrl+V they can then be reapplied to other images.

If you are lost and cannot remember where to find a certain tool, you can get some help from Find Tool. Here. the tools are listed in order and you can directly jump to the palettes in which they are located.

Quick Tools

The Quick Tool palette contains icons for frequently used commands. Double-clicking the icon 📂 instead uf using File ▸ Open or ctrl+O will open files. Double-clicking the Zoom Cursor 🔍 will zoom the image to 100 percent. Double-clicking the Hand Cursor 🖐 will zoom the image to fit the window. These functions work in similar fashion in Nikon View.

Opening Images with Drag-and-Drop

You can easily open images in Capture by drag-and-drop. Simply select the file in Windows Explorer and drag it into the Capture window.

Features of Capture

The following discusses Capture functions that Nikon Scan either does not have at all, or has only in a different form. Functions that are identical between the two are described in the chapter on Nikon Scan.

Cropping

The tool Size/Resolution allows cropping. You can either manually select the crop size by dragging with the mouse, or define a crop size with Keep the Output Size. With NEF, the entire image information is preserved even when the image is cropped. With TIFF and JPEG, this is not the case.

Custom-defined output sizes are easily specified.

For JPEG and TIFF files, the image portion outside the crop will be removed – but only when the file is saved and closed. As long as the window remains open, you still can change the crop and save again, even if it had already been saved. The image information resides in Capture's cache. Only when the modified JPEG or TIFF file is opened again will you find just the cropped image alone. It is different for NEFs. If you open a cropped NEF file with a viewer, you will see only the crop. This makes sense, because in the viewer you want to see the finished image, not the RAW scan. Capture, however, always displays the entire image, plus the cropping border.

Straighten

A new feature in Capture 4.3 is the Straighten tool. Under Image ▸ Rotate ▸ Straighten, there is the option to rotate the image ten degrees in either direction. This function is less powerful than the corresponding function in Photoshop but works well enough to level most tilted horizons. Furthermore, with NEF files, Straighten is fully reversible. With Draw Level, the amount of rotation can be defined by dragging a line over a feature in the image that is supposed to be horizontal or vertical.

Here the camera was jerked during the shot. The maximum correction is ten degrees. For larger angles, Photoshop must be used for the correction.

On the right, is the normal view; on the left, are the lost highlights of the church entrance.

Lost Highlights and Shadows

The term "lost shadows" refers to the portions of the shadows that no longer show detail even though some image information actually exists. With a different image adjustment, some image detail can still be revealed in lost shadows. Before converting from NEF to TIFF, press S to Show Lost Shadows. The same applies to Show Lost Highlights (keyboard shortcut L). As long as lost highlights and shadows are displayed, there will be conversion losses when convert-

ing from NEF to TIFF. This does not have to be the case, since TIFF is basically a lossless file format.

Markers

As a matter of fact, in earlier versions, it has always been possible to save adjustments to NEF files; but it was tedious to do so, since adjustment files had to be saved manually. With Capture 4.3, it is no longer necessary to save adjustment files manually – the feature Markers takes care of this tedious task. Three file versions, Original, Last Saved, and Current, are provided automatically, but the program lets you add more versions and name them as you choose.

Histogram

Histogram charts the distribution levels of the image (or of the current crop if a crop is selected). When a range of levels is selected with the mouse, the corresponding pixels in the image, within that range, will be highlighted by blinking.

The shadow portions selected in the histogram are indicated in the image with inverted colors.

Noise Reduction

Noise Reduction is a feature originally intended for digital cameras that is also available for NEF files from the scanner. For scanned data, however, the function does not engage properly. In my own tests, Noise Reduction showed no noticeable effect on scans from a Coolscan IV and Coolscan 5000.

LCH Editor - Color Lightness

Unlike Nikon Scan, Capture provides an additional feature for correcting color lightness. Individual colors can be made lighter or darker. The operation follows the same rationale as the LCH Editor described earlier. In the sample image, the brightness of the sky color was reduced; therefore, the blue appears more saturated overall.

D-Lighting: Successor to Digital DEE

Only the HQ setting enables separate sliders for highlight and shadow.

From version 4.0 on, Nikon Scan offers a user-friendly solution for selective shadow and highlight recovery with Digital DEE. However, it must be decided prior to scanning whether corrections are needed and, if they are, to what degree. Digital DEE is permanently applied to the RAW data; even in NEF format, adjustments using this function are not reversible.

On the left, is the color-corrected sky; on the right, is the original image.

Capture also included the Digital DEE function in version 4.1, but it was meant for digital cameras. To find the optimum setting, originals would have to be scanned multiple times. Altogether, I found it to be an unsatisfactory solution that did not live up to the idea of a RAW editor. In Capture 4.3, this function has been renamed to D-Lighting. Not much has changed in its basic function, but in version 4.3 D-Lighting can be used for scanned NEF files. Also in this version, the slider for Threshold has been removed; the sliders for Highlight and Shadow Adjustment remain. A slider for Color Booster has been added to allow minor color adjustments that might be necessary after, say, a shadow correction.

The improved integration of shadow and highlight recovery into the RAW editor is a big step forward for the product. With version 4.3, it is finally possible to experiment on a finished scan with different settings without having to resort to time-consuming rescans.

Switch off Digital DEE before the Scan

With the new approach of D-Lighting it is no longer necessary to use Digital DEE for scanning. It is actually better to skip Digital DEE and use the function D-Lighting instead, later in Capture. Nikon Scan's Digital DEE applies corrections to the RAW data that cannot be undone, which is usually undesirable.

Red Eye Correction Now Also Possible in RAW

Flash pictures from compact cameras, in particular, often have a problem with red eyes. Such cameras typically have lens and flash placed closely together. Light from the flash reflects directly off the back of the eye and thereby causes this unsightly red eye effect. For this reason, red eye correction is included as a standard function in conventional viewers. Even freeware viewers, such as IrfanView or the Nikon View editor come with this function. However, scanner enthusiasts with a fondness for RAW were left out in the cold: until recently, Nikon Scan could not remove red eyes. Scanned NEF files would have to be fixed in a separate photo editor, but then the files could no longer be saved in NEF format.

Red Eye Correction was applied to the
right eye, but the left eye remains
uncorrected.

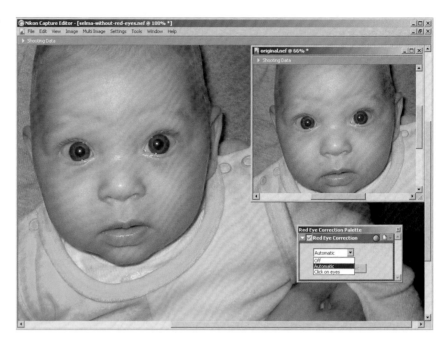

Nikon has increased the functionality of the RAW editor with updates; so now, with Capture 4.3, it is finally possible to remove red eyes from scanned NEF images. This action is reversible; the original scan data are not modified. Capture relies on automatic detection of red eyes. This works fine for properly exposed color images; but for images with a color-cast or images in which the reflection in the eyes is not red, the auto mode fails and Photoshop must be brought to the rescue.

Color Booster

Color Booster is an easy-to-use tool, available in Capture but not in Nikon Scan. Color Booster is identical in function to the curve for Chroma in the LCH Editor, but is easier to use. The intensity of the colors is adjusted with a simple slider. The image below shows how dull subjects can be made more vivid. Especially for pale negatives, the results can be quite convincing. This adjustment is less often needed for slides than for negatives. Capture's Color Booster always affects the entire image. Unlike in Photoshop, it is not possible to limit the correction to selective image areas.

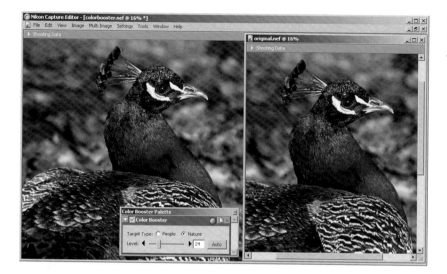

Color Booster brings more color to the image, but also an unwanted color-cast.

Photo Effects

The tool Photo Effects allows RAW files to be converted to Black and White or Sepia. Tinted creates a monochrome tint that can be fine-tuned with the sliders for Cyan/Red, Magenta/Green, and Yellow/Blue.

Capture NX

Nikon Capture was introduced back in 2003 and is already showing its age. In the second half of 2006, Nikon started to ship its long-awaited successor, Nikon Capture NX. The preannouncements of the product sounded very promising; but after installing Capture NX, I was quickly disenchanted with it. While the old Nikon Capture already had you begging for more processing speed, the new Capture NX is even more sluggish. On my test system (Athlon XP 2500+ with 1GB RAM), it sometimes took thirty seconds or more to open one image. In Photoshop CS2, which itself is not exactly a speed demon, it takes only about a third of that time for the same file. At the time of this printing, the current version of NX is 1.01 – one can only hope that performance of the product will improve with future updates.

If you are familiar with the old Capture, you will need to get used to the new user interface in Capture NX with its completely different approach. The palettes of Capture have been replaced by the Edit List, in which one menu item is added each time an editing function is applied. With this new concept, it is easier to keep track of all your changes than with the old Capture. But, less impressive is the new browser, which replaces the old light table. Each time you open an image from the browser, the browser itself vanishes, which is not very practical.

Control Points instead of Layer Masks:
Color Manipulation at RAW Level

With the U Point technology, Capture NX finally has at its disposal some fundamental editing functions that were once found only in programs such as Photoshop. Unlike in Photoshop, nondestructive processing of RAW data is possible in Capture NX. This means that the original state of the file can be restored at any time. Nikon has obtained this technology from the independent plug-in maker Nik Software and integrated it into its own program. Unlike Photoshop, Capture NX does not use the magic wand and mask tool, but uses control points instead. In that respect the Nikon software is more intuitive to operate than Photoshop. This method is faster, especially for processing a large number of images. With control points, you can very selectively control the colors of individual areas of the image. It is easy to use: simply place a Color Control Point in the area you want to change, and you get a color picker that you can freely use to change colors. In the example, the color of the tractor's wheel rim was matched to the color of the hood. Control points also work very well for adjusting skin color in a portrait (for example, giving a slight tan to pale skin). Besides the Color Control Point, a Black Control Point and a White Control Point can be used to control dynamic range. Neutral Control Point is used for color balance; several such points can be placed in a single image. The Red-Eye Control Point is a major improvement over the very basic red eye correction in Capture 4.4. With the NX control point, you can select not only the location, but also the size of the red eyes. Simply click the center of the eye and pull the slider to the appropriate size.

The new control points in NX allow for selective color changes. In the picture on the left, the color of the wheel rim was matched to the color of the hood. On the right is the original.

Grain and Noise; Sharpening and Selection

For the nostalgic digital photographer, Capture NX provides the filter *Add Grain/Noise*. For scanning, it is usually the other way around: you usually want to reduce the grain. For that, Capture NX now uses the revised Noise Reduction, a quite acceptable alternative to GEM in the scanner software. In a fashion similar to using the equivalent Photoshop plug-ins (GEM plug-in, Noise Ninja, and Neat Image), you can freely experiment with noise reduction without having to endure time-consuming rescans. The advantage of Noise Reduction is that all changes are reversible in NEF; this was not possible before Capture NX. However, the correction can be quite rough on image details. More satisfactory noise reduction can be achieved with Noise Ninja. In addition to the well-known *Unsharp Masking,* Capture NX has added the filters *High Pass* and *Gaussian Blur*. The *High Pass* filter allows aggressive sharpening, which is ideal for printing. *Gaussian Blur* does just the opposite: it softens the image. Photoshop has the same filters, but Photoshop works with layers, which Capture NX does not have in this form. In NX, you first configure the filter, and then adjust the transparency for ideal results. This way, Nikon gets around layers as they are used in Photoshop. In a direct comparison between the Photoshop and Capture NX methods, the Photoshop method seems more straightforward, but maybe only because it was the only such method available for a long time. The familiar Photoshop selection tools are also now available in Capture NX: *Lasso, Polygon Lasso, Rectangle Marquee,* and *Oval*. It is very unusual to include tools such as these with a RAW editor; even more unusual is the way these tools operate. They only work in combination with the *Fill/ Remove Tool*, which is used to mask off the area inside or outside the selection. Even simple functions such as cut, copy, or paste are not possible with this tool in Capture NX. Still, for a RAW editor the program is very powerful, since selective image correction is a novelty for RAW editors.

The bottom line is that, in the short run, Capture NX will not replace a full-blown image editor. It is missing a cloning stamp for removing scratches from scans, which is sorely needed. And most important, it definitely is not fast enough.

NEF in NX: No More Backward Compatibility after Saving!

As in previous versions, Capture NX also writes all changes directly to the NEF files. Unfortunately, this has the very unpleasant side effect that files written with Capture NX can no longer be opened with the old Capture. Because of the many limitations of Capture NX (version 1.01), for now it is advisable to work on copies only.

Correcting with Photoshop and Photoshop Plug-ins

Adobe Photoshop is the gold standard for professional image processing. The program has useful tools, not only for creative image manipulation, but also for correcting typical flaws in scanned images. It allows you to straighten tilted horizons, perform perspective corrections, and remove red eyes. There are a number of tools in Photoshop for scratch removal in black and white film: a part from SilverFast, no other scanner program has suitable tools for that. Plug-ins make Photoshop particularly useful for sophisticated special jobs, such as grain removal or color restoration for faded originals.

14

Content

Dust and Scratch Removal

Under Filter ▸ Noise, Photoshop offers the filter Dust and Scratches. It affects the entire image, unless it is used with a selection or a mask. The only parameters available for the filters are Threshold and Radius. The preview shows how the weakest setting reduces the image sharpness. The effects of scratch removal are acceptable if the correction is limited up to a radius of 1. Larger radii lead to unacceptable loss of quality. The filter is acceptable for fine scratches, but is not suitable for deep scratches. From my own experience, for quality reasons, I can hardly recommend this method. The Clone Stamp or the Polaroid plug-in is better.

The noise filter "Dust and Scratches" is a tool with noticeable side effects.

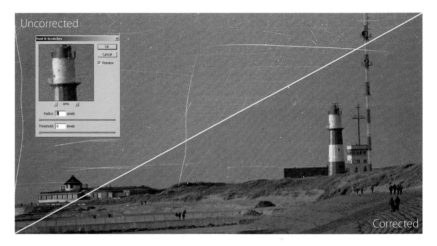

Removing Scratches with the Clone Stamp

A commonly used retouching tool in Photoshop is the Clone Stamp. To use this tool, first pick a suitable source region and copy the pixel pattern from that region to patch up the damaged areas. The size of the stamp is adjustable – it is possible to perform corrections down to a single pixel. In scanned images, scratches rarely occur in isolation; usually, many small scratches must be dealt with. Add to this the usual fine dust and fibers that are picked up by film, and you see there can be serious need for corrections, even with carefully handled film. If you are a quality fanatic, you can remove all such defects using the Clone Stamp with excellent results. However, it is enormously time-consuming to do that. Because the Clone Stamp transfers 1:1, you must take great care in selecting your source area; otherwise, you will impair the texture and color of the target area. The Photoshop Healing Brush is more flexible; but, when used properly, the Clone Stamp is hard to beat for quality. Even ICE costs you some sharpness, which is not the case with the Clone Stamp.

Cloning is much too cumbersome for regular dust and scratch removal after the scan. It is not practical for high-volume scanning.

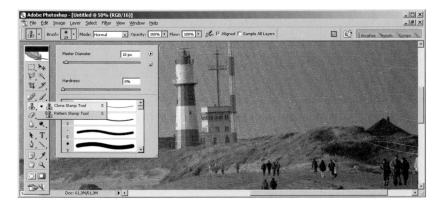

Removing scratches with the Clone Stamp is very cumbersome and time-consuming.

Healing Brush and Spot Healing Brush

Besides the Clone Stamp, you can also use the Healing Brush 🖌️ for correcting dusty and scratched image regions. You still have to pick the source region yourself, but Photoshop calculates automatically what to use to fill the spot.

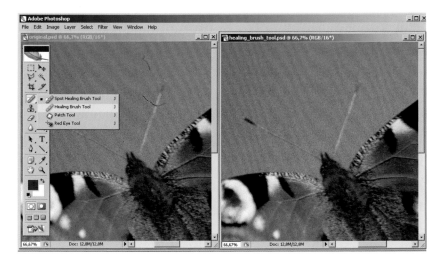

The Healing Brush is simpler to use than the Clone Stamp.

Occasionally, you will get some unwanted results from the brush, such as having a color from a neighboring area pulled into the correction by mistake. In such cases, you can go back to the Clone Stamp. With the Alt key pressed, you first click on the area you want to use as the source for the corrections. Based on these data, Photoshop will calculate the correction. Then you can brush over the defective areas. The smaller the brush radius, the more precise the correction will be; but also, the more time-consuming the job for the whole image will be. In the sample image, I have only bothered to remove the vertical scratch. If this method were used to remove every single speck of dust – and

the harsh LED lighting of the Nikon scanners captures a lot of them – retouching with the Healing Brush would be very laborious. However, fixing a small number of image defects with the Healing Brush is typically quick and easy.

New in Photoshop CS2: Spot Healing Brush

Both Healing Brush and Clone Stamp always require manual input of the source area. This time-consuming step is no longer needed with the new Spot Healing Brush: You simply activate the tool and immediately start to work. Spot Healing Brush is therefore an ideal retouching tool for big dust and scratch removal jobs.

Dust and Scratch Removal Plug-in from Polaroid

You can download a free plug-in for dust and scratch removal from Polaroid at www.polaroid.com/service/software/poladsr/poladsr.html. The plug-in is installed under Filter ▸ Polaroid ▸ Dust & Scratch Removal. Because it lacks before-after comparison and a preview for the entire image, it is not very user-friendly. However, you can get used to it,; and it is, after all, a freeware tool. The job it does on dust removal for black and white films is also excellent.

Even with only minimal configuration, the dust across the entire image will be eliminated. There is no need to mark the affected areas. The plug-in automatically detects areas of dust. With a weak setting, you can apply the filter to the whole image by activating the switch Light Dust. The scratch removal is not as powerful, but most software-based tools have a problem with scratch removal anyway.

Unfortunately, the position of the preview window of the Polaroid plug-in cannot be chosen freely. However, there is a little trick that can help matters: Simply select a particularly dusty area with the Rectangular Marquee – the selected part of the image will be displayed in the little preview window. If the selection is too large, the preview will only show the upper left corner of the area. When making a selection, note that the filter works for the selected area only.

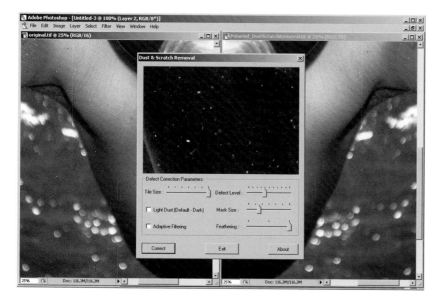

Dust and Scratch Removal is very well suited for automatically removing fine dust.

This is especially useful when you try to get the hang of this plug-in, since you can see the difference between the corrected and uncorrected portions of the image. For dusty black and white film, this tool is a great help; it is much faster than the cloning method. But, for long scratches, some rework with the Clone Stamp will still need to be done.

Image Corrections

Correcting Perspective Distortion

Perspective distortions happen when the camera is tilted upwards or downwards during shooting. For architectural photography, this is difficult to avoid, since the photographer usually stands on the ground and points the camera upwards. The distortion that is generated gives the impression that the building is tapering off toward the top. In most cases, you do not want this effect, and therefore, you have to fix the image on the computer.

Nikon Capture does not allow perspective correction at RAW level, but in Photoshop it can be easily done with the Crop tool. For automatic correction, Photoshop needs the frontal view of a rectangular object that exhibits keystone distortion. The example shows a building with the walls becoming narrower toward the sky. Of course, in reality, walls and towers are rectangular.

First, draw a rectangular frame around the entire wall with the Crop tool. Then activate Perspective in the option bar. Now pull the corners of the rectangle to match the inclined walls. (To restrict the mouse movement to horizontal or vertical only, hold down the ⇧ key.) When that is done, Photoshop knows which area is supposed to be rectangular and what the actual shape of the area is. Next, enlarge the crop to cover the entire image by pulling on the mid-points of the crop border. Finally, double-click in the crop area. This gives the corrected image a trapezoidal outline; simply crop again to get a rectangle.

Selectively Correcting Shadows and Highlights

Under Image ▸ Adjustments ▸ Shadow/Highlight, Photoshop offers a tool for selectively improving shadow and highlight areas. This feature is functionally identical to AACO from SilverFast, and DEE and D-Lighting from Nikon. In the extended options, any of the three basic parameters Shadows, Highlights, and Adjustments can be tuned separately. Photoshop goes well beyond the capabilities of Nikon Capture in this regard.

The above image shows a backlight shot with blown-out highlights and pronounced shadow areas. The corrected version on the right clearly shows more detail in both areas. As usual in Photoshop, the correction is permanent; it cannot be undone at a later session. This can be a bit awkward if you are still trying to find the best setting for the correction. Nikon Capture is more user-friendly in this regard.

Straightening Horizon

With the tool Measure 📏 (under the eyedropper 💉 pull-down menu) and the command Rotate Canvas, Photoshop offers a simple way to straighten inclined horizons. First, take the Measure tool and draw a line along the horizon. Next, go to Image ▸ Rotate Canvas and select the option Arbitrary. Photoshop takes the angle from the measuring line and enters it into the field for rotation. Click "OK" and the image rotates. Unlike Capture, Photoshop allows you to rotate any angle.

The Crop tool ⌗ offers another way to rotate the image. First, select the whole image or a smaller crop. Then, left-click outside the crop frame and rotate it freely with the mouse.

The Measure tool allows you to determine the angle the horizon should be rotated. Photoshop takes this value for rotation with Image ▸ Rotate Canvas ▸ Arbitrary.

Photoshop Plug-ins from Applied Science Fiction

The plug-ins introduced here come from Applied Science Fiction (ASF) and can be found at www.asf.com. The free trial versions are fully functional, but they put a watermark into the image. If some of the filters are grayed out, this indicates that the image was probably opened in an unsupported mode. Older versions of ASF plug-ins support only 8-bit, but the newer versions also support images with 16-bit color depth, which makes them fully compatible with Photoshop CS and SC2.

Grain Removal with Digital GEM

This plug-in is available in the versions Digital GEM, Digital GEM PRO, and Digital GEM Airbrush PRO. All versions deliver the basic functionality to remove film grain from an image. The plug-in Airbrush PRO belongs more to the artistic field. With the airbrush function, portraits can be modified to make people look like flawless creatures with porcelain skin.

Corrections using Nikon Scan's GEM are fixed into the image file. Any adjustments attempted later require a rescan. It is more convenient to work with the Photoshop plug-in, which allows you to experiment with different settings.

Digital Fill-Flash with SHO

This plug-in comes in the versions Digital SHO and Digital SHO PRO. The PRO version is interesting because of its additional adjustment controls. Digital SHO corrects blown-out highlights and underexposed shadow areas by optimizing contrast and exposure. You can do the same thing with *Curves*, but not as easily. Digital SHO works just like DEE, D-Lighting, or Photoshop's *Shadows/Highlights*. Since Photoshop has already integrated the function *Shadows/Highlights* from version CS on, this SHO plug-in is worthwhile only for those who use older Photoshop versions.

Restoring Colors with Digital ROC

This plug-in is used to restore colors in scans from faded originals. It too comes in two versions: Digital ROC and Digital ROC PRO. Only the PRO version supports 16-bit color depth. Also, Nikon Scan uses ROC (see chapter 7). VueScan and SilverFast offer comparable functions. Compared with other scanning programs, the Photoshop plug-in has the advantage that you can experiment with different settings without the need for a new scan each time. In addition, the plug-in has finer controls for color correction than the scanning programs.

With the ROC plug-in, fresh colors can be extracted from faded film.
The corrections can be set finer in the plug-in than in the scanner programs.

Removing Color-Casts

Images that have the pure color tones black, white, or neutral gray are easy to correct. In each case, simply click with the corresponding eyedropper for color correction. The real world is different however, since you rarely shoot color charts in a laboratory. Therefore, you really need to consider applying Photoshop's color correction tools. To name them all would go beyond the scope of this chapter. In the appendix, there is a list of recommended Photoshop guidebooks that describe these techniques in detail. Before a color-cast can be corrected, it first must be identified. Here *Info* (second tab in the *Navigation* toolbox) can be immensely helpful. In the photo, the cursor is on a white mussel. According to the RGB principle, the three color channels should have roughly identical values for a pure white. This is not the case with the picture of the mussels; it obviously has a color-cast. In most cases, you can improve it simply by adjusting the levels of each individual color channel. This makes the whole image more contrasty and eliminates the color-cast for the most part. Unfortunately, that adjustment does not work for all subjects. In the example, the RGB color values changed from 191/212/229 to 219/229/235. They moved closer together and the color-cast is almost gone. For further improvements, use *Color Balance* and *Selective Color*. Note that it can take quite some practice to get the hang of *Color Balance*.

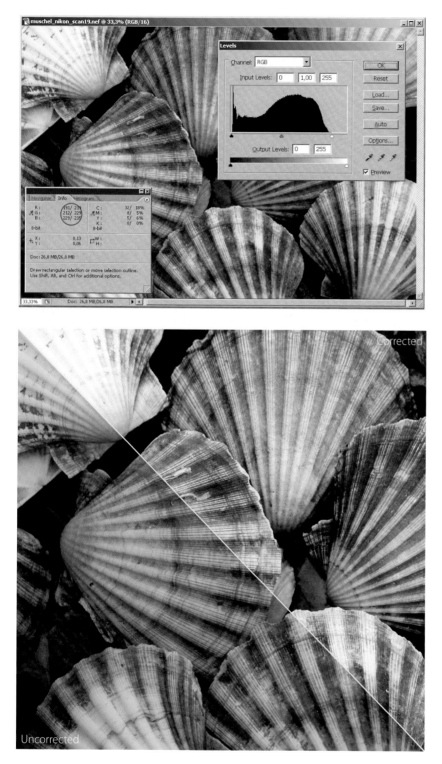

Adjusting the levels for each color channel separately eliminates the color-cast.

The rather unsightly RAW scan becomes a usable image only with the help of some post-processing.

Match Color

Another useful tool in Photoshop CS2 for removing color-casts is Match Color. Originally, this feature was developed to get consistent colors among the pictures in a series, but it also works for removing color-casts. To do that, select the tool and click the checkbox Neutralize. In theory, the color-cast is supposed to be removed automatically, but in most cases, the correction still requires some manual adjustments, which are not too much trouble to perform. With the slider Fade, you can adjust the intensity of the correction to your needs. It can sometimes happen that the colors have been overly affected in color-cast correction; with Fade, this can be fixed. Overall, Match Color is a useful tool for selectively correcting color-casts without having to deal with the different color channels.

The uncorrected image has an obvious yellow cast.

With the slider Fade, you can tune the strength of the correction.

Noise Reduction with Noise Ninja

Noise Ninja is a program for noise removal. It comes as a standalone program and as a Photoshop plug-in. Licenses cost between $35 and $80 – these are available at www.picturecode.com. The functionality of the tool is basically comparable to GEM, but Noise Ninja is gentler on the texture of the image. Especially with grainy slides, the erratic sprinkle of color dots often leads to unpleasant images after scanning. On the PictureCode website, there are many ready-to-use profiles for the grain patterns of popular scanners; but these are to be used with caution, since the profiles depend, not only on the scanner model, but also on the combination of scanner and film. The noise reduction often works very well, but its effectiveness depends very much on the image. Different sources on the Internet consider Noise Ninja to a better choice than GEM, but I do not fully agree with that evaluation. Each method has its own characteristics, which you either like or don't like. As already mentioned, Noise Ninja is gentler on the texture of the image, but in all cases, corrections using GEM suffer a loss of detail as a side-effect.

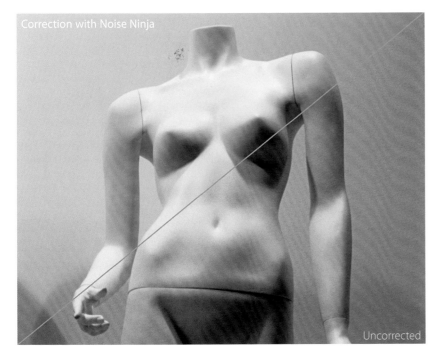

Correction with Noise Ninja

Uncorrected

The correction mostly removes the unwanted sleety grain texture.

Noise Reduction with Neat Image

Another way to combat image noise aside from GEM and Noise Ninja is to use Neat Image. The Photoshop CS2 Reduce Noise feature offers an integrated function similar to Neat Image; but, in my tests, I found this filter rather useless.

Neat Image is available from www.neatimage.com for between $30 and $75. Its functions and results differ only slightly from those of Noise Ninja. Neat Image also allows you to apply scanner profiles, but the selection of scanner models on their website is somewhat meager. Much better are the profiles for cameras, for which this program has an excellent selection. The resulting pictures of Neat Image and Noise Ninja are basically alike, since they both do less harm to the film's texture than GEM. In my tests on Nikon scanner files, I found that Noise Ninja usually gives better results than Neat Image. My general impression is that Neat Image reduces image sharpness more than Noise Ninja does. Then again, this effect depends heavily on the scanner model and the film material.

Neat Image removes noise from digital image files.

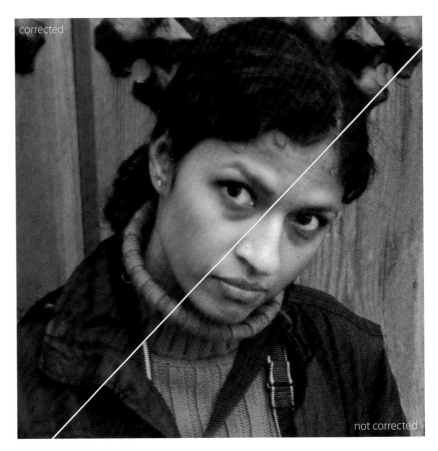

Backup

It sounds trivial to say that you need to backup your images. But in reality, this message does not sink in with most users – sometimes not even with computer-savvy users. Contrary to popular belief, certain storage media, such as DVD, are not at all suitable for storing valuable image data. This chapter examines common backup methods and media for their suitability as a digital image archive.

If you have several thousand images, even with a well maintained filing system you could easily lose track of your image collection. IPTC data help to bring order to the deluge of pictures.

15

Content

Saved Does Not Automatically Mean Safe

Each file created on the computer is basically saved to the hard disk first. Now the file has been saved, but it is not *safe*. If a virus, a disc crash, a program error, or user error damages the file, it is gone. For scanned data, this may not be fatal, since the analog source is usually still available; but the time needed for rescanning can be considerable. In this case as well, backup is mandatory.

Backup and management must be economical, simple, and effective. The more complicated the backup, the more likely it is to be neglected. Problems with backup can usually be traced to user error or infrequent use due to awkwardness.

Backup to Hard Disk

Any backup is better than no backup at all. On closer examination, the way backup is often done is usually less than ideal, (for example, backing up on a local drive). Backup may be convenient, but in most cases it is not really secure.

Backup to the Same Partition

Backing up files by duplicating them on the same hard drive partition as the original files gives no protection in the event of:

- ▶ Hard drive crash
- ▶ Computer theft
- ▶ Accidental formatting of the partition or the entire hard drive
- ▶ Virus attack on the local computer

Therefore, local duplication is merely a compromise for quickly saving an intermediate state. Backing up to a different partition on the same hard drive offers slightly more security, but it is still not a proper way to securely backup files.

Backup to an Additional Hard Disk

Somewhat better is backing up to a separate internal hard drive. However, this still does not protect files in the event of:

- ▶ Computer theft
- ▶ Virus attack on the local computer

The aforementioned applies to permanently installed internal hard drives, so they are still not ideal for backup. Removable hard drives that are connected to the computer only during backup are better. This type of backup also reduces the risk of theft, as long as the hard drives are stored in a different location from

the PC. Also, the risk of a virus infecting a removable hard drive is lower than that for an internal hard drive. This risk can be further reduced if appropriate access rights are set at the operating system level.

Additional hard drives can be mounted either with a swappable drawer system inside the PC or with connections as external drives.

Image: Western Digital

External USB hard drives are, by far, the least expensive storage solution considering their capacity. 400 GB drives are standard now, and even 750 GB drives are already available.

External disks can be connected with USB 2.0 or FireWire without measurable performance degradations. Unlike a drawer-mounted hard drive, an external drive can also be connected easily to other computers. Even using two or three external hard drives dedicated for backup is still less expensive than an equivalent solution using backup tapes. A hard drive's mechanism is sensitive to shock; but with adequate care, this is not really a problem.

Hard Drive as Removable Storage

External hard drives currently offer the lowest cost per GB of storage. They are as reliable as internal drives when treated with care. If necessary, several hundred GB can be backed up in reasonable time without having to swap media.

Archiving on Removable Media

There are many different types of storage media for all kinds of purposes. To make the backup process more manageable, ideally, the image archive should fit onto a single data carrier. With today's typical high-resolution scans, a total capacity of 100 to 200 GB for the entire image archive is rather low. Among other media, there are no optical discs available yet in this capacity range, and tape drive offerings are rather sparse.

Optical Media: CD and DVD

Optical media are cheap and easy to record, so they are ideal for removable storage. One problem is their relatively small storage capacity, at least for storing files from a film scanner. For example, a roll of thirty-six exposures scanned at 2900 dpi in 12-bit RAW format requires over 2 GB of storage space. A regular DVD with 4.7 GB capacity lets you store just two rolls of film at that resolution.

Image: HP

DVDs from your own burner are badly undersized for large image archives. They do not score high on data security, either.

Regular tests in related magazines show that DVD recording technology is not yet fully matured. Current DVD burners show progress in burning speed; but with respect to data security, many burners and blank disks are not worth recommending. They are not suitable for reliably archiving your images. DVDs are more useful for data exchange, since they are inexpensive and almost all current computers can read them. They are also good for mailing. There are no reliable findings on the long-term stability of recordable CDs or DVDs. For backup, they are neither safe enough nor do they have high enough capacity.

Image tape

LTO Ultrium 3 streamer with 400 GB uncompressed capacity. From a technical standpoint this is ideal for backing up image archives, but is not inexpensive.

Image: HP

Because of their enormous storage capacities of 100, 200, and 400 GB, LTO tapes are seemingly good candidates for maintaining large image archives. Unfortunately, the costs for such systems are enormous, too: Good drives start at around $1,200 and tapes are around $40 each, which is not exactly a bargain.

Image Management

For managing a large number of digital images, simple image browsers such as Nikon Capture or Photoshop are not sufficient. Programs such as ThumbsPlus or iMatch offer far more powerful cataloging functions.

Setting Up an Image Database – Folder and File Structures

The first step in setting up an image database in a meaningful way is to construct a logical folder structure. If you scan slides as well as negatives, the directory tree on your hard disk should factor in the structure of your analog archive. This will help you to associate a file easily with the analog original. For a rescan, you will not have to search very long to find the correct slide or filmstrip. The following information can help simplify retrieval:

▸ Year of shooting (e.g., 2005)
 Month and day of shooting (e.g., 08-27)
 Unique naming of the film with sequential numbering (e.g., F001)
 Film strip number or position in the slide tray (e.g., 36A)
 Occasion (e.g., Wedding André/Dani)

Dust and Scratch Removal is very well suited for automatically removing fine dust.

This type of information should be reflected in the folder tree of the hard disk, the IPTC information of the images, and the filing system of the physical film archive. A well structured filing system speeds up your search. In addition to the logical directory structure, you can include key information such as date in the file name. If you move or copy files, this type of naming convention makes it easy to reconstruct the origin of those files. With this method, you will notice errors immediately when moving files. A file name such as *2004-10-Film01-Cliffs-Neg12.nef* is much more descriptive than *IMG12.nef* (as is generated by default in Nikon Scan).

A chronologically structured file system simplifies retrieval in Explorer.

Cataloging with IPTC Data

Some labels can be applied to an image with appropriate file naming conventions based on file and folder structure. However, quite often, there is a need for additional information about images, such as:

▸ Who the photographer is; who owns the image rights
▸ Where and when the picture was taken
▸ What film type was used; what camera equipment was used

This list of metadata – data about data – could be extended infinitely. Metadata describe the image in as detailed a fashion as possible. For this purpose, text information is added to the image information and stored in the image file. The *International Press and Telecommunication Council* has adopted the IPTC-NAA standard, or IPTC for short. Not all image file formats support this metadata entry. Suitable image databases, such as iMatch, offer quick searching of large numbers of files for a particular image.

IPTC metadata prepare images for the image database.

The quality of the search depends on the quality of the IPTC metadata. A keyword search works only if each image file has the corresponding entry in its IPTC header. Many viewers and most image editors support IPTC for the standard formats JPEG and TIFF. The support for NEF format, however, is not as good. IPTC data can only be edited by programs that have full access to NEF, such as Nikon Capture Editor.

Batch Editing IPTC Information

To manage a large number of images, it can be tedious to enter IPTC image data for each image one-by-one. In an image sequence, much of the data can be repeatedly used for several images. With Nikon Capture, information for multiple images can be filled out at once. This function is somewhat hidden under Edit/Copy Image Adjustments. It allows the IPTC entries of one image to be copied and subsequently applied to the target images with ⌨ctrl + V.

Organizing Images with ThumbsPlus

The first time ThumbsPlus opens a folder, it generates thumbnails of the images inside.

In order to manage a large number of images efficiently, you need a good viewer with a thumbnail-indexing function and its own image database, such as ThumbsPlus. Common viewers lack these functions. Nikon View, for example, generates the thumbnails anew each time it opens a folder. If you frequently jump between folders, the long wait required to generate thumbnails will test your patience. Especially for large scan files, the wait is considerable. ThumbsPlus solves this problem by generating the thumbnails only once – when the folder is opened the first time. To do that, ThumbsPlus searches for all image files on the hard disk, generates thumbnails, and stores them in a separate database. This process takes some time, but it runs in the background while other work continues on the PC.

Once the thumbnail index is complete, you can open a folder and immediately see the thumbnails. If you delete a file with ThumbsPlus, it updates the thumbnail database accordingly. If you delete images with a different program, such as Windows Explorer, ThumbsPlus needs to regenerate the index to keep the database up-to-date.

RAW Support in Viewer Applications

Only a few viewers support RAW in their basic version. To display NEF files in ThumbsPlus, you need the Digicam RAW Plug-In. This plug-in for ThumbsPlus is noticeably slower than Nikon View for full-screen display of NEF files. If you use ThumbsPlus for managing NEF files, but use Nikon View for viewing individual images, you can combine the advantages of both programs quite nicely.

Batch Renaming Files: LupasRename

If you reorganize your folder and file structure, you may have to rename multiple files. With Windows Explorer this can be tedious, since you have to do it one-by-one.

LupasRename is a lean tool for simple batch renaming. This freeware is available at http://rename.lupasfreeware.org. It helps if the files are already numbered sequentially. The names should contain a number which corresponds to the analog original. For example, Negative #21 would best be saved as IMG21. tif, so that you can keep the default names during scanning. Once the final name is found, you can rename it with LupasRename. This tool supports all data formats, since it does not write into the file itself.

Glossary

AACO – "Auto Adaptive Contrast Optimization" from SilverFast. See also DEE.

Black Point – The darkest pixel in the image. In the levels curve, it is at the left end.

Brightness – A measure of the amount of reflected or directly emitted light. See also Luminance.

CMYK – Subtractive color model. Mixing the primary colors cyan (C), magenta (M), and yellow (Y), theoretically results in a deep black. However, in practice, this rarely works because the primary colors used are not absolutely pure. For that reason, the color black is added (the "K" stands for "key," which is short for "key plate," a term from the printing press). Printers work in CMYK mode.

Colorimeter – Device to measure color characteristic. Used, for example, to measure the color reproduction of monitors for the purpose of generating individual ICC profiles.

Color Management – A color management ensures consistent color representation across different devices. The monitor is supposed to display exactly the colors read by the scanner, and the print is supposed to look exactly like the monitor display.

Color Saturation – A highly saturated image appears colorful. Low saturation makes the image look flat due to the high content of gray.

Color Space – See Gamut

Color Temperature – Reference to the temperature (in Kelvin) of a heated black body radiator, the hue of which is compared to the light of an incandescent lamp. High Kelvin values appear cold, and low Kelvin values appear warm to the human eye.

ColorSynch – The color management system of Apple Macintosh computers.

DEE – "Digital Exposure Extender" – tool for selectively correcting highlight and shadow areas. Suitable for recovering overblown highlights and brightening shadows.

Device-Dependent Color Space – Color space for a specific device (e.g., Scanner-RGB in Nikon Scan).

D-Lighting – Similar to DEE (see above), but applied to NEF RAW files afterwards. D-Lighting is fully reversible.

DPI (or dpi) – Dots per inch. Meant for printing, but also commonly used for monitors and scanners.

FARE – "Film Automatic Retouching and Enhancement" – hardware-based dust and scratch removal system of Canon scanners.

Gamut – Color range of an image or a color space. The gamut is the entirety of visible colors that a device (such as a monitor, printer, scanner, or film) can reproduce.

GANE – "Grain And Noise Elimination" – system from SilverFast. See also GEM.

GEM – "Grain Equalization and Management" – from Applied Science Fiction. Also used by Nikon Scan.

Grain Reduction – Grain reduction system from VueScan

ICC Profile – The basis for color management systems, ICC profiles define the device-independent representation of colors.

ICE – "Image Correction and Enhancement" – hardware-based dust and scratch removal system from Applied Science Fiction. Also used by Nikon Scan. ICE relies on the infrared light source of the scanner.

ICM – "Image Color Matching" – the integral color management module of current Microsoft operating systems.

Infrared Clean – Hardware-based scratch removal system from VueScan.

iSRD – Similar to SRD (see below). Unlike SRD, iSRD uses the infrared light source of the scanner to detect dust and scratches.

IT8 Target – A standard test target for profiling devices, such as scanners. SilverFast ships with an IT8 target in the form of a slide.

LCH – "Lightness, Chroma, Hue" – a color model describing colors in terms of the three optical parameters lightness, chroma, and hue.

Luminance – Brightness or intensity of a color (in the context of this book).

PPI (or ppi) – "Pixels per inch" – used for images displayed on monitors.

Printer Profile – Profile describing the color response of a particular printer with a specific paper and a specific ink. It is used to produce prints with accurate colors.

Restore Fading – VueScan's equivalent to ROC. See ROC.

RGB – "Red, Green, and Blue" – in the (additive) RGB color model, all colors are generated from red, green, and blue.

ROC – "Restoration Of Colors" – a system from Applied Science Fiction for restoring the colors of faded film. Also used by Nikon Scan.

Scanner Profile – An ICC profile describing the color characteristics of a particular scanner to allow a correct interpretation of the colors of the scanned image.

SRD – "Smart Removal of Defects" – a software-based system for dust and scratch removal from SilverFast.

Working Color Space – Color space describing the colors of the image independent of the device used (e.g., film scanner, monitor, and printer). The working color space used for photos is usually Adobe RGB (1998) or sRGB.

White Point – The brightest level in an image (not necessarily the color white). When setting the white point to a particular input level, this level will be corrected to become the highest possible output level. All higher input levels will be lost, since the corresponding pixels change to the color of the white point.

Resources

[1] filmscanner.info

On Patrick Wagner's homepage, you can find test reports for most current film scanners from his online shop. This is great for getting an overview of the current scanner market.
www.filmscanner.info/index_eng.html

[2] Depth of Field Calculator

This webpage from Erik Krause contains several interesting tutorials for image processing, as well as a depth of field calculator.
www.erik-krause.de

[3] scantips.com

Website about various scanning techniques, with tutorials. This is great for beginners, but the advanced user will not learn much.
www.scantips.com

[4] SilverFast – The Official Guide

In this book, Taz Tally summarizes information that you can already get from SilverFast PDF documentation. Print quality and images are not up-to-date.
www.sybex.com

[5] The Photoshop CS2 Book for Digital Photography

This book by Scott Kelby guides you step-by-step through many different digital photography techniques without burdening you with any theory. It's ideal for teaching yourself Photoshop (learning by doing). Kelby doesn't go deep into the basics, but it is a good book for using Photoshop to turn your scan into a pretty picture.
shop.scottkelbybooks.com

[6] Adobe Photoshop CS2 for Photographers

This is heavy stuff (700 pages, $45), but Martin Evening gives you a very deep and thorough introduction to Photoshop. It is not as easy to read as Scott Kelby's book, but it teaches you not only what you have to do but also why you do it.
www.photoshopforphotographers.com/pscs2/index2.htm

Index

Thanks

for the equipment:
www.quato.de, Intelli Scan 5000
www.nikon.de, Coolscan 5000 with slidefeeder
www.epson.de, F-3200
ww.colorvision.ch/de, Colorimeter Spyder 2 Pro Studio
www.hamrick.com, VueScan Professional Edition
www.silverfast.de, miscellaneous Silverfast software
www.adobe.de, Photoshop CS2

for feedback and useful hints:
Mr. Kuhnen-Burger, www.quato.de; Erik Krause, www.erik-krause.de
Annette Völkel, PC Professionell; Wilfried Bittner, Jürgen Gulbins,
Winfried Schwolgin, Gerhard Rossbach and everyone at dpunkt.de

for old slides, negatives, photos and image themes:

Cliffs of Moher, Ireland · Peter Steinhoff · Vibulah Thevarajah · Angela Kubsch · Siegfried Gromotka · Daniela Kubsch · Bianca Born · Ralf Kocandrle · Jettamobil (R.I.P.)

This DVD contains

Scanning Software
Vuescan (Linux/Windows/Mac)

Picture Editing
Photoshop CS 2 (Windows/Mac)
Silverfast HDR (Windows/Mac)
Photoshop Plug-ins
 (Windows/Mac)

Image Database/Viewer
Irfanview (Windows)
ThumbsPlus (Windows)
IMatch (Windows)

Samplescans Filmscanner
Braun Multimag SlideScan 4000
Microtek Artixscan 120TF
Nikon Coolscan 5
Nikon Coolscan 5000
Plustek OpticFilm 7200i
Quato IntelliScan 5000
Reflecta ProScan 4000

Samplescans Flatbedscanner
Canon 9950F
Epson 4990
Epson F3200
HP Scanjet 8200
Microtek i900
Plustek OpticProST64+

rockynook

Alain Briot
Mastering
Landscape Photography

The Luminous-Landscape Essays

> "You don't take
> a photograph,
> you make it."
>
> ANSEL ADAMS

Alain Briot
Mastering Landscape Photography
'The Luminous Landscape Essays'

Mastering Landscape Photography consists of thirteen essays on landscape photography by master photographer Alain Briot. Topics include practical, technical, and aesthetic aspects of photography to help photographers build and refine their skills. This book starts with the technical aspects of photography; how to see, compose, find the right light, and select the best lens for a specific shot. It continues by focusing on the artistic aspects of photography with chapters on how to select your best work, how to create a portfolio, and finally concludes with two chapters on how to be an artist in business. Alain Briot is one of today's leading contemporary landscape photographers. He received his education in France and currently works mostly in the southwestern part of the United States. Alain Briot is a columnist on the highly respected Luminous Landscape website.

November 2006, 256 pages
ISBN 1-933952-06-7, Price: $39.95

Rocky Nook, Inc.
26 West Mission St Ste 3
Santa Barbara, CA 93101-2432

Phone 1-805-687-8727
Toll-free 1-866-687-1118
Fax 1-805-687-2204

E-mail contact@rockynook.com
www.rockynook.com